"When you change the way you look at things, the things you look at change"

KOOS EISSEN & ROSELIEN STEUR

SKETCHING product design PRESENTATION

B/S

BIS Publishers
Building Het Sieraad
Postjesweg 1
1057 DT Amsterdam
The Netherlands
T +31 (0)20 515 02 30
F +31 (0)20 515 02 39
bis@bispublishers.nl
www.bispublishers.nl

ISBN 978 90 6369 329 9

PREFACE

After our books "Sketching" and "Sketching, the basics", we were encouraged to write a book about the context of design presentation, a fascinating issue that concerns every designer.

One of the most interesting aspects to this subject is to look for communication-related rules: what makes presentations effective. The book also intends to be an inspiration for students in the field of (industrial) design. We managed to get design cases from internationally renowned design studios. Although this is not purely a book on sketching and drawing, we are convinced of the incredible power of sketching in design presentation.

We wish to thank all the designers, who were kind enough to share their insights into design presentation at different levels of the design process in an overview of their inspiring cases.

We would also like to thank Rudolf and Bionda from BIS Publishers and the text editor Sarina Ruiter-Bouwhuis. A special thanks goes out to our graphic designer Sandra van der Putten for her constant keen eye. We were so happy with her consistent workflow and quality.

We hope you, as a (future) designer, will find inspiration for your own presentations.

Roselien and Koos, October 2014

www.sketching.nl

CONTENTS

CHAPTER ONE
Your reptilian brain

Our perception mainly takes place in our brain, largely in the 'reptilian' part of our brain. This introductory chapter establishes a framework and a starting point for the discussion of various theories on perception and the display of information. It offers a perspective for working with the chapters that follow.

CHAPTER TWO

Design communication and Gestalt principles

The theory of Gestalt is defined by means of principles derived from experiments on how people perceive certain visual information. A brief overview of influential gestalt principles is provided and discussed within the context of product design.

CHAPTER THREE

Visual Semantics

All visual information appears to refer to one meaning or another. This meaning will not be the same for everyone, as it depends on factors such as cultural differences. Especially in this era of global entrepreneurs, it is important for a designer to be aware of this.

CHAPTER FOUR
Visual Rhetoric in design communication

A designer communicates a variety of content. In some cases his presentation is informative, communication, shape, progress or technical assembly information, for instance, and in other situations the presentation requires a more convincing or persuasive character. This is where Visual Rhetoric plays an important role.

CHAPTER FIVE
Holistic approach to Perception

A presentation, especially a visually complex one with a combination of text, photographs, sketches and renderings, can have an impact on a person at various perceptual levels. This chapter discusses the creation of a visual presentation with an integrated approach, considering the position of the viewer.

INTRODUCTION

The subject of this book is the visual language, as applied within the context of (industrial) product design. A designer, especially an industrial designer, will spend a significant amount of time communicating his or her ideas to others. At various moments in the design process a presentation of some kind is necessary. This book discusses a variety of these visual presentations. For instance, early progress reports, presentations to support the decision-making process for selecting from suggested concepts, presentations for fundraising, presentations to inform engineering, final presentations on the outcome or transfer of a project, etc. These moments in the process largely determine both the content and the character of a presentation. Additionally, the audience of a presentation (design chief, client, stakeholder, etc.) may require a specific approach regarding the manner in which the design is visually communicated to them.

The audience can be internal to the design studio, such as co-workers, colleagues or management. On other occasions, the audience will consist of the client, the manufacturer or the user. The message of a presentation differs in each situation; you may present your ideas for fundraising purposes, or in order to transfer the design to engineering. It can be the communication of an innovative idea, a functional shape, an instructional drawing or a manual for usage.

In short, these different audiences and different messages need specific approaches to communication.

An image, as referred to in this book, is taken to mean visual information in 2D. This can be a sketch, a rendering, a photo or combinations of those, eventually with some text added such as short remarks or descriptions.

In our previous books, we focused on the act of sketching itself, demonstrating various techniques – both old-school and digital-including their applications in the global field of industrial design. Now, we are excited to show the powerful effect of sketches and drawings in presentations. Most design cases presented will display sketches in ideation. Ideation involves a variety of choices, plus analysation and evaluation. However, this book covers a broader approach to sketching within visual communication, also looking at the visuals on websites of designers.

The Design Cases of a range of international design studios show a variety of practical examples of visual perception theory being applied professionally, and often intuitively. We placed each case at the end of the chapter we considered most relevant to it, but we encourage you to find more principles of Gestalt, visual semantics and rhetoric in each of the cases to gain a better understanding of these aspects within the context of product design.

Throughout this book, we have used thumbnails to visually refer to the cases demonstrating the aspect discussed at that point. We also placed commentary/contemplative NOTES throughout each case study, pointing out the specific aspects described in more detail throughout the previous chapter. You will find our notes in a more moderate font, as we tried not to interrupt the design story itself.

We will demonstrate the importance of the reptilian brain theory, the Gestalt theory, visual semantics and visual rhetoric, after which we will conclude with briefly touching on visual perception itself. An overview of influential gestalt principles is offered and discussed within the context of product design. The chapter on Visual Semantics discusses visual information, and how it refers to meaning, which is never the same for everyone. In the chapter on rhetoric we will discuss how to persuade your viewers and the importance of knowing one's audience. In our final chapter, we will wrap up by considering a more holistic approach to visual perception.

If you are familiar with scientific research on visual perception, you will most likely recognize the 'standard' visuals commonly used to illustrate the most famous principles discussed in this book. Our intention is to explain visual perception within the context of product design, as used in day-to-day presentations/communication by professional designers.

Theories on visual communication are highly useful tools for reflecting on and discussing images. On the other hand, intuition plays a role in creativity that is not to be underestimated.

Henri Bergson *(Introduction à la métaphysique, 1903)* defined intuition as a simple, indivisible experience of sympathy through which one is moved into the inner being of an object to grasp what is unique and ineffable within it. The absolute that is grasped is always perfect in the sense that it is perfectly what it is, and infinite in the sense that it can be grasped as a whole through a simple, indivisible act of intuition, yet lends itself to boundless enumeration when analysed.

Design Case

Audi Design, China

A car for Beijing, design student Ma Ke, Beijing University of Technology

Three designers from Ingolstadt founded Audi Design China in the summer of 2011. Trend scouting, talent scouting, networking and establishing a design infrastructure were its main goals. The first month of our start-up occurred in cooperation with the China Central Academy of Fine Arts (CAFA) and Beijing University of Technology. We scouted there for talent and the first Chinese designers were hired at our office. 'A car for Beijing' was the first design project we did. Ma Ke, finishing his degree in Industrial Design at Beijing University of Technology, got the chance to do this assignment as a graduation project in the newly opened Chinese Audi Design studio.

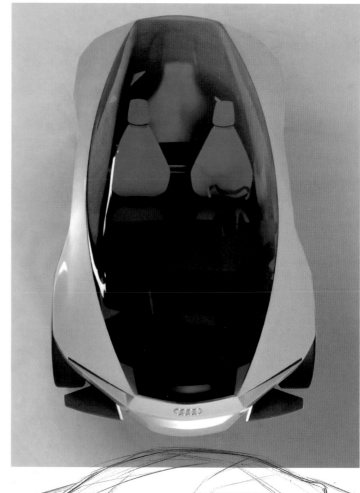

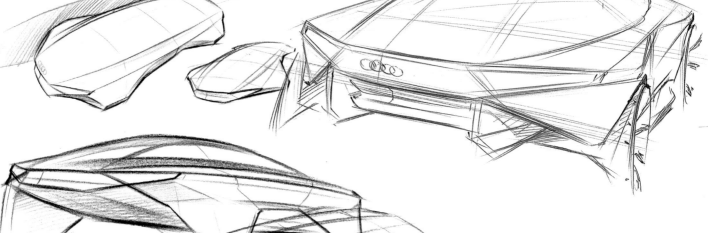

The Concept
As a concept for A car for Beijing, Ma Ke created a basic frame for the car which could easily be customized and altered by the owner. The car can change over the course of the day to fit different needs. At the dealership, it would be even possible to quickly change the entire character of the car; you could turn your limousine into a Coupé or even into an Avant. The car should accommodate two adults and a child.

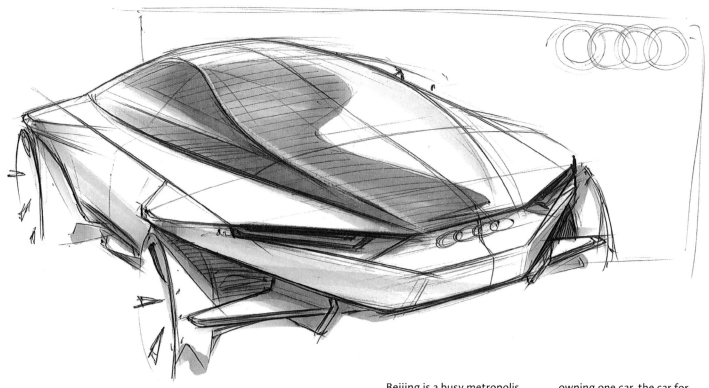

Beijing is a busy metropolis. Air pollution and heavy traffic jams are big issues in the news. Nevertheless, possessing a car in China remains a symbol of status and success. The Beijing government is now limiting the number of new cars in the city. New number plates can only be obtained through a monthly lottery. The chance of winning a number plate is slim; only one in fifty gets lucky.

As most people in Beijing will only have the possibility of owning one car, the car for Beijing must cater to many of these different needs, which was a big challenge for this project.

When Audi started in China, our cars were perceived as cars for the establishment and the conservative. Nowadays, this image is shifting towards a more modern and cool image. "I want to emphasize this even more," Ma Ke stated "I want to design an Audi especially for the young fashionable people in Beijing".

Initial ideation; looking for a shape, trying out possibilities

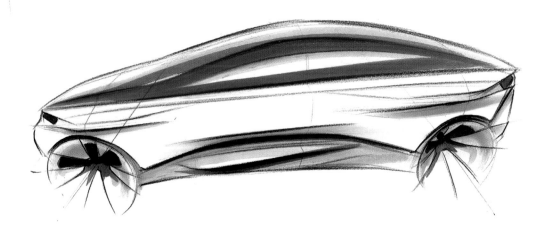

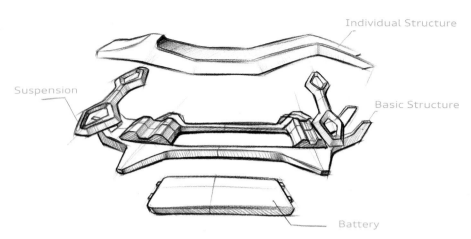

Layout of the car, showing the separate, individual structure

The Design

Audi is famous for its so-called Bauhaus design. Form follows function; clear and simple forms that follow highly logical rules. This is something that Chinese customers also greatly appreciate, because Chinese culture and architecture also likes to follow strict rules. We like to compare and find similarities between our two cultures. During the design process, we were looking for a new form language for Audi; we called it the Chinese Bauhaus. Sharp lines and straight surfaces create a volume of harmony and elegance.

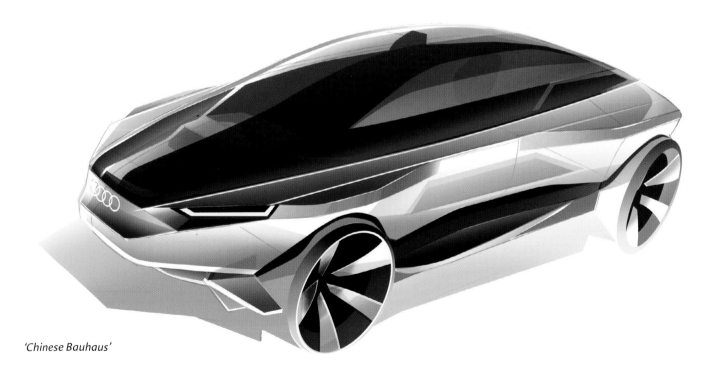

'Chinese Bauhaus'

The drawings made during the design process were leading for communication purposes inside the team. We presented weekly progress reports and in return received feedback to speed up the process. Sometimes the drawings were used as an underlay for sketching adjustments.

In addition, we sent project developments for a presentation to Ingolstadt, Germany, in order to obtain a budget for a 1:4 size model of the interior and the exterior. The CAD model was created so we could make the physical model.

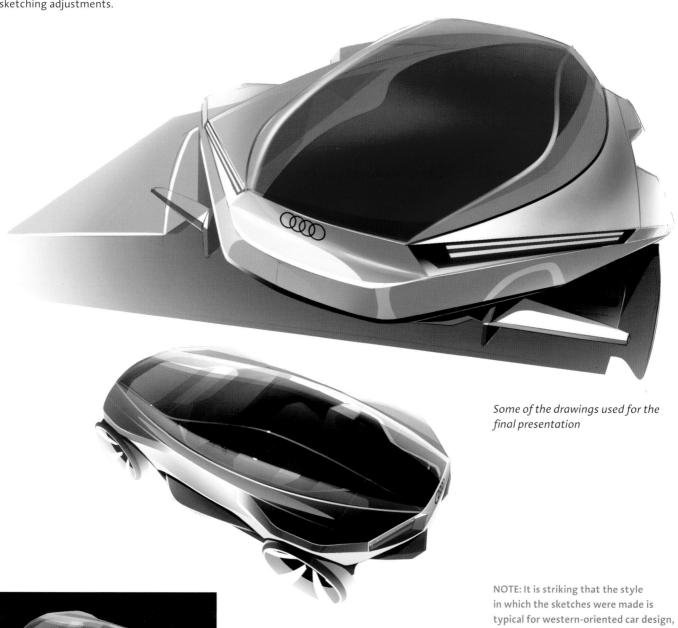

Some of the drawings used for the final presentation

NOTE: It is striking that the style in which the sketches were made is typical for western-oriented car design, reflecting a typical western sketching style rather than a Chinese one.

The designer wants to emphasize that the design should fit modern, young and fashionable people, who are most probably internationally oriented. He therefore deliberately chose not to focus on the traditionally driven cultural expression.

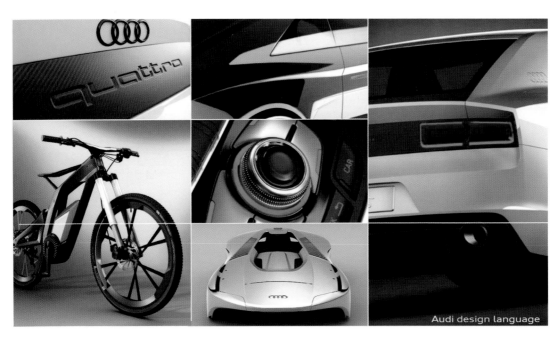

An Audi design language collage by Ma Ke to better understand the Audi brand identity

Normally, confidentiality agreements bind us to keep all information and imagery of our projects inside the design team. Nothing is communicated to the outside world.

However, because this was a more open project due to the fact that it was the first try-out project to help convince Audi Germany that China offers a talented designer pool, we were lucky to be able to work together with external Chinese model makers and paint shops. We were also fortunate to experiment with and test the IT connection with Ingolstadt, used for communicating different aspects during the process of the design project.

The 1:4 model was shown at the graduate exhibition of Beijing University of Technology. Furthermore, it was presented to the board of Audi Germany and the international press at the opening of the R&D Centre of Audi China.

The positive responses that we received, especially to the 1:4 model, have contributed to a successful start of Audi Design China.

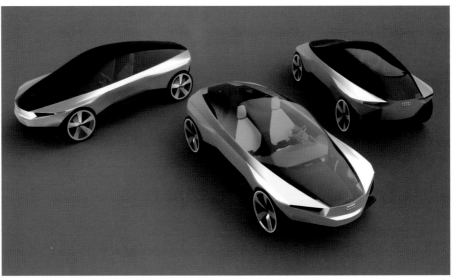

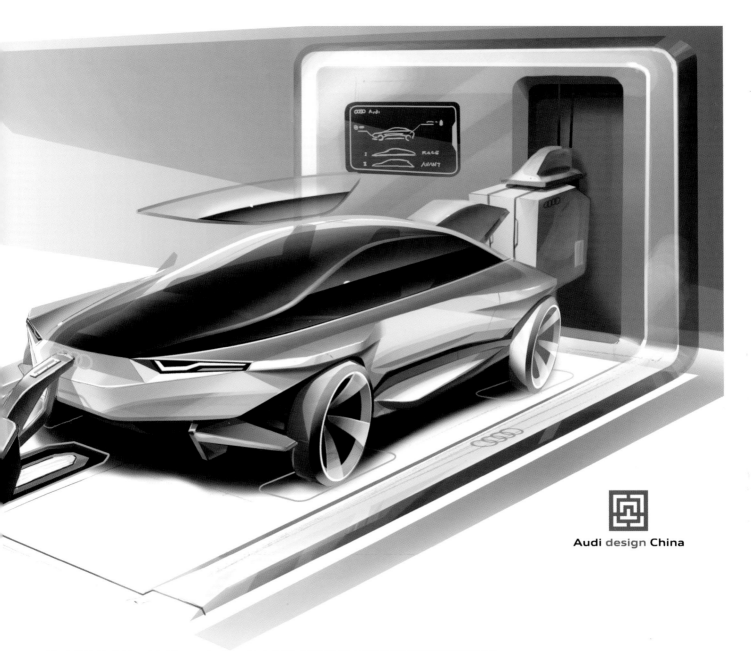

Audi design China

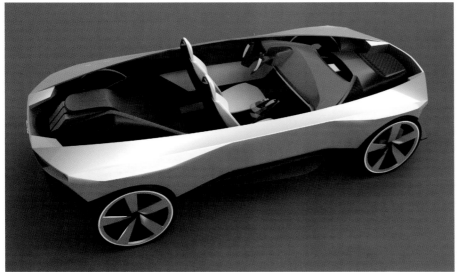

In the meantime, we have now (2014) grown into a 10-person studio and we have plans for further expansion. Both western and Chinese designers now work together on a daily basis on conceptual and series projects of Audi.

The cultural differences between the Chinese and westerners are numerous... The greatest difference may be the work attitude of 'everything is possible' we have here in China!

CHAPTER ONE
Your reptilian brain

Our perception mainly takes place in our brain, and an important part of it is formed in our so-called 'reptilian' brain. This introductory chapter establishes a framework and a starting point for discussing various theories on perception and the display of information. It offers a perspective for working with the chapters that follow.

1.1 **Our three brains**

Our brain has evolved over millions of years. And even up to today, the functioning of the brain can only be understood by considering its evolution. We can distinguish 3 brain levels: the old brain, the midbrain and the new brain [1.1]. Another, quite similar, distinction used is to divide our brain into a visceral, behavioural and reflective level [1.2].

The basic idea is that the new brain constitutes its latest development and represents the conscious part of your brain, responsible for reasoning and logic (i.e. reflection). The midbrain mainly processes emotions, which is related to behaviour, and the old brain is there to help you survive both as an individual and as a species. The latter controls (unconscious) bodily functions, such as your heartbeat and breathing, and its impulses are instinctual, in support of e.g. survival (the fight or flight mechanism, for example), physical maintenance, hoarding, dominance, personal grooming and mating. It works unconsciously – at our visceral level – but has a great impact. Your old brain causes you to drive slower near a traffic accident, as it warns you against danger; it helps you survive as a species, ensuring you notice attractive people; and it makes you crave and search for food to support your daily sustenance.

It is this old, reptilian brain – your smallest brain, yet very powerful – that plays an important role in perception. This section of the brain is referred to as 'reptilian' because it resembles the brain of present-day reptiles. It is almost impossible to remain unaffected by it, but luckily the reptilian brain does not function on its own. Thankfully, the other two brain levels also play a role in how you choose to respond to triggers from your reptilian brain. It is only when we are out of control due to rage, for example, that our reptilian brain overrides our other brain components. Similarly, when people claim that they 'reacted from their heart instead of their head', it is likely that they acted upon their (primitive) emotions – their old brain.

Because the old brain plays such a strong subconscious role, the use of danger, food and sex is an effective way to get people's attention. In advertising, for example, this principle is used extensively. This so-called 'neuromarketing' tries to evoke 'gut-level' actions and this results in big business.

Our brain has slowly evolved into a brain with three distinct levels, each processing (visual) information in another manner: viscerally, behaviourally and reflectively.

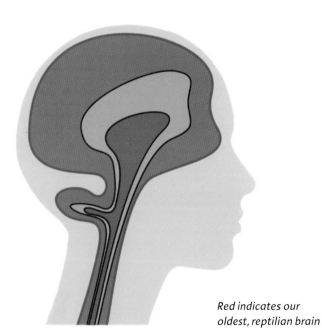

Chameleon on a branch

Red indicates our oldest, reptilian brain

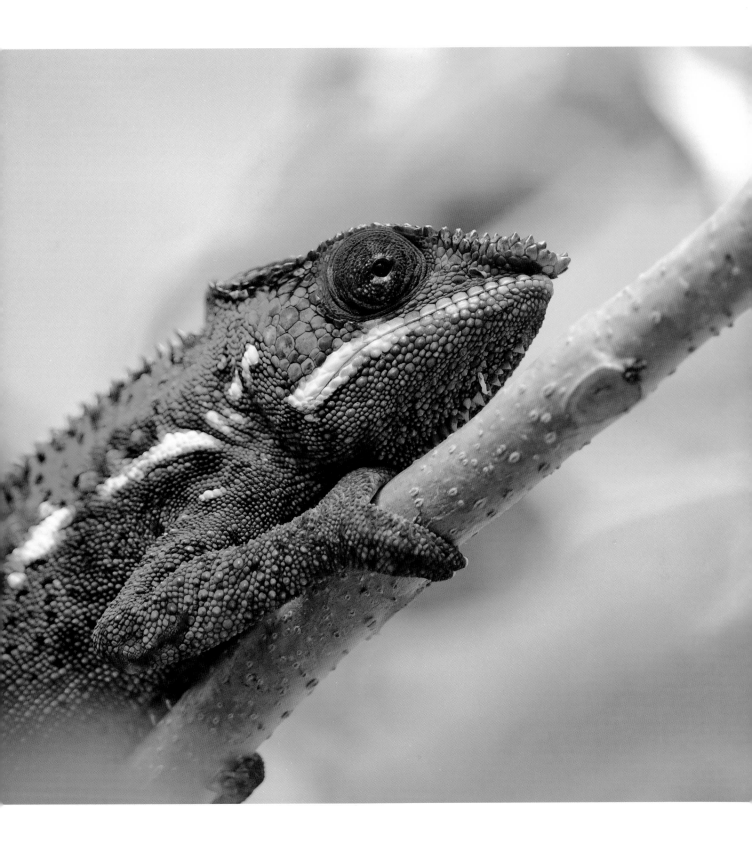

The sequence of reaction mimics the brain's evolution itself and even mirrors people's learning curves; children start off with their basic old brains calling the shots, after which gradually the other two levels gain more influence.

Eventually, the three levels end up interacting and modulating each other, either top-down or bottom-up.

1.2 **The visceral level**

What we call the visceral level is connected to our 'old' or 'reptilian' brain level. At this level automatic and rapid judgments are made, unconsciously. This is what we call our gut feeling. It is a reaction to external appearances, causing us to label something as 'pretty' or associate a colour with a mood, for example. This level determines how something affects us and from this response emotions arise.

The behavioural level has to do with effectiveness of use and can enhance or inhibit both other levels. The third, the reflective level, is the one that rationalizes and intellectualizes. It has no direct sensory input, but guards and tries to bias the behavioural level. It is especially this level at which cultural differences become clear; opinions are formed which then influence and alter our behaviour.

The visceral level is pretty much the same for all people; it works through pattern matching. Even though our original cave habitat has made way for city and country dwellings, our old brain is still actively looking for patterns that were programmed at an early stage in evolution.

Patterns

We can distinguish positive and negative patterns. Examples of positive patterns are, for instance: bright, highly saturated colours; warmth; symmetry; round, smooth shapes; sensuous shapes. Negative patterns would be: unexpected bright light; darkness; bare, flat terrain; too dense environment; big crowds of people; misshapen human bodies; looming objects; sharp objects. Note how well this fits in with primitive survival; flowers and fruits have bright, saturated colours and are symmetrical. To ensure our safety, we have to watch out for sudden changes in light or sharp objects, etc.

p. 22

p. 125

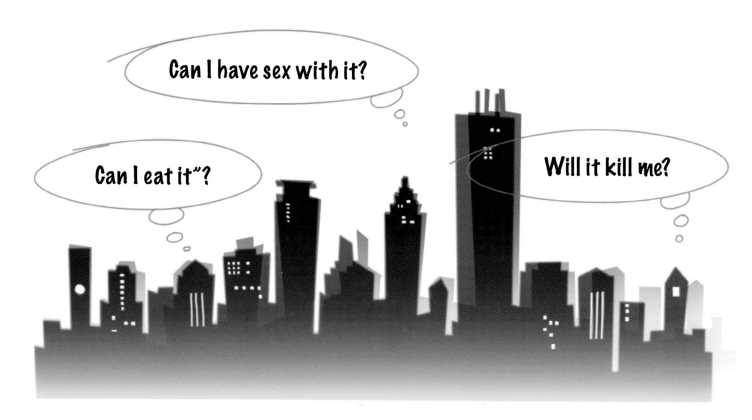

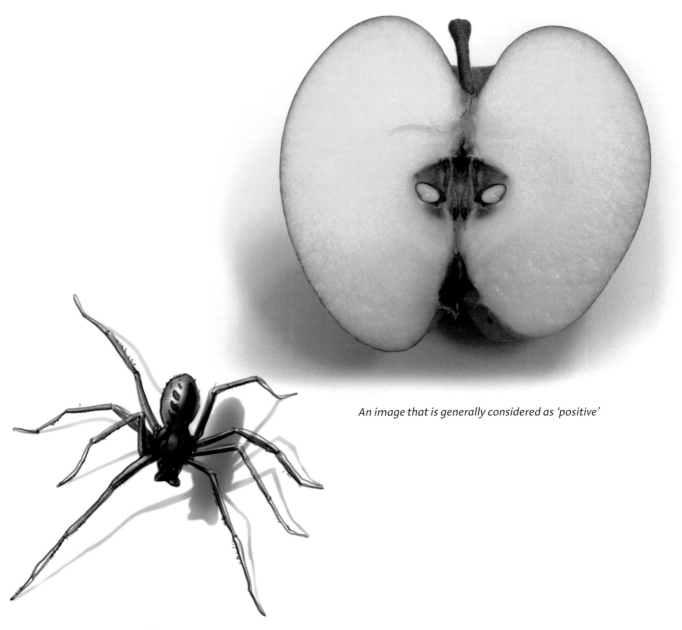

An image that is generally considered as 'positive'

An image that is generally considered as 'negative'

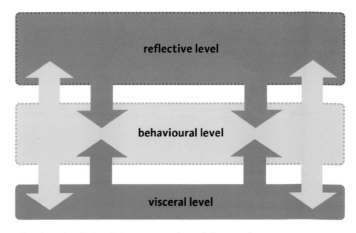

The three brain levels interact and modulate each other, either top-down or bottom-up

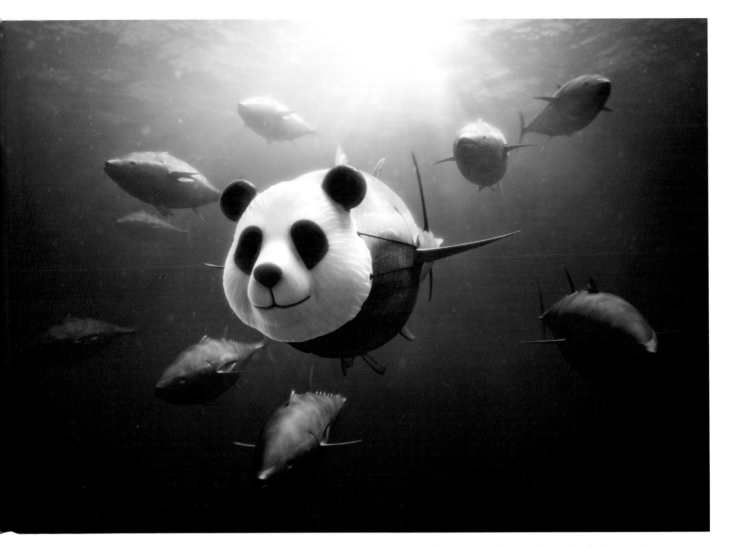

WWF advertisement "Red Tuna" Campaign by Ogilvy, France

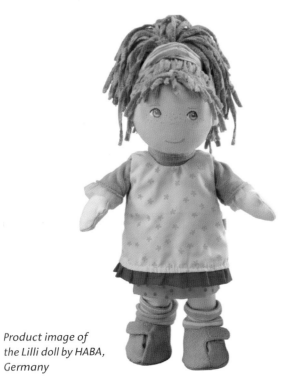

*Product image of
the Lilli doll by HABA,
Germany*

References

[1.1] 100 Things Every Designer Needs to Know About People,
 Susan Weinschenk

[1.2] Emotional Design, Donald A. Norman

1.3 **Acquired taste**

In evolution, the brain started out as a reptilian brain, then evolved to contain a midbrain, and eventually developed a reflective brain. If we compare this to the development of people from child to adult, we can see a similarity in the sequence in which the various brain levels are used. Little children mainly use their old brain; their visceral (survival) level. Therefore, young children's toys often display visceral principles.
As we grow older, we tend to explore experiences beyond this level. We start using our behavioural and our reflective brains, which can eventually override visceral responses. Things that are viscerally negative can become reflectively positive. For instance, we get

used to (or overcome our fear of) crowds or noisy cities. Another example is that many delicious and rich dishes include a bitter taste. Additionally, our colour preferences get richer and subtler. The exploration and appreciation of things beyond the limitations of the visceral level is referred to as an 'acquired taste'.

As we develop ourselves more, the behavioural and reflective level will gain increased influence.
The behavioural and reflective levels are sensitive to training, education, (sub) culture and fashion (trend). This explains why certain viscerally pleasing/positive patterns, such as symmetry or highly saturated colours, are not considered pleasant by all people, as we will see in the Gestalt chapter.

Advertisement makes clever use of visceral responses:
"Don't talk while he/she drives" Campaign for the Bangalore Police Dept. by DDB Mudra Group, India

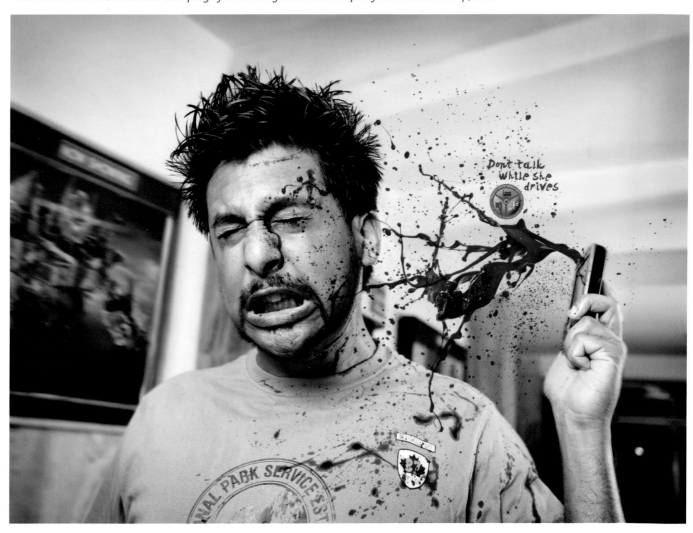

Pelliano, The Netherlands
Suits, accessories and packaging

Pelliano helps guys dress better by designing and selling smart clothing by means of an exceptional relationship. We are not afraid to let go of established fashion conventions and use all of today's technological and economic possibilities to do this. The brand promotes a playful, youthful attitude, combined with a respect for classic style. It's positioned as a smart menswear brand for men ages 20-40.

Abstract concepts

In our design and development process visual communication plays a significant role. Sketches, such as the examples below, are regularly used for quickly making abstract concepts tangible. For instance in team meetings, discussing the best approach to negotiating a deal, and even in planning sales proposals, when it comes to what to present and how to present it. A combination of quickly drawn images and words (in shorthand) works well enough: the goal is not to be accurate, but to solidify ideas in order to see how they work together.

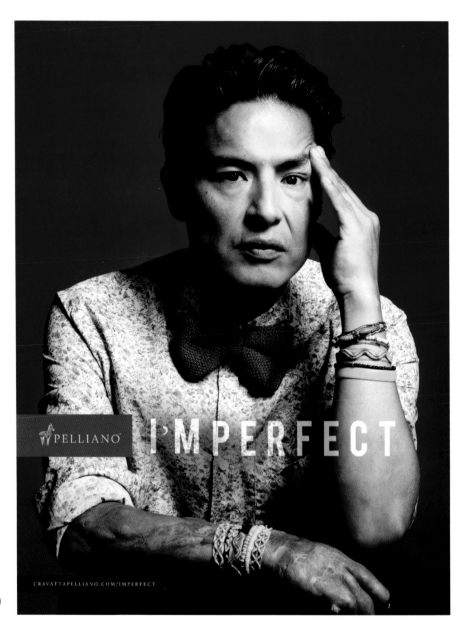

I'm perfect campaign photo

Business model

Negotiation strategy

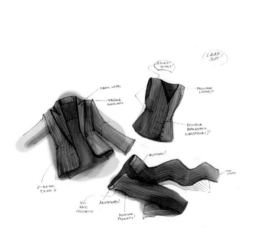

BELT!

BUTTON FLY

WAIST LIKE A JEANS

PAGODA SHOULDER?

COOL CASUAL STITCHING ON EDGES

UNLINED

WHAT KIND OF POCKET!

EASY TO FOLD

PATCH POCKETS

TAPERED LEG BELOW KNEE

PLAY SS13

Suit, blazer and tie development

The sketches on the left are made for the manufacturer in order to highlight specific details and wishes and hence have a much more technical and detailed feel to them, while still partially demonstrating the quality of the materials.

They differ from sketches made for internal use (among our designers or the Pelliano team), as they are more elaborate in their expression of colour and material. The sketches are not intended as a medium for communicating to the end user either, which usually tends to consider clothes much more holistically in a user-related context.

SAMPLE BULK

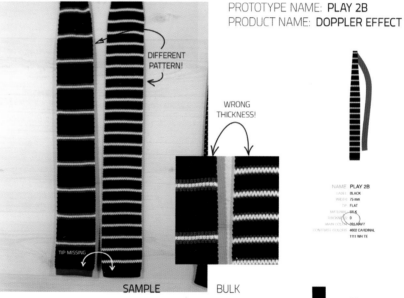

DIFFERENT PATTERN!

WRONG THICKNESS!

TIP MISSING

SAMPLE BULK

PROTOTYPE NAME: **PLAY 2B**
PRODUCT NAME: **DOPPLER EFFECT**

NAME **PLAY 2B**
LABEL BLACK
WIDTH 75 mm
TIP FLAT
MATERIAL SILK
THICKNESS 9
MAIN COLOR 391 NAVY
CONTRAST COLORS 4602 CARDINAL
1111 WHITE

To provide feedback on the results from the manufacturer we use photographic images. Those are created by simply drawing and typing over a number of photographs. Above all, the goal of these images is to provide absolute clarity in communicating production errors in a series of samples. This approach is much more effective and direct than sending an email

describing the products, with the images attached.

NOTE: In fact, nearly all visual communication applies a high degree of realism. The imagery demonstrates great consistency in terms of look and feel, and is made as realistic as though you could touch it. This aptly engages the viewer in experiencing the designs.

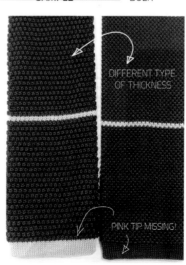

DIFFERENT TYPE OF THICKNESS

PINK TIP MISSING!

NAME **CHARM 1**
LABEL BLACK
WIDTH 70 mm
TIP FLAT
MATERIAL SILK
THICKNESS 9
MAIN COLOR 391 NAVY
CONTRAST COLORS 808 SHOCKING

PROTOTYPE NAME: **CHARM 1**
PRODUCT NAME: **BAD ACID**

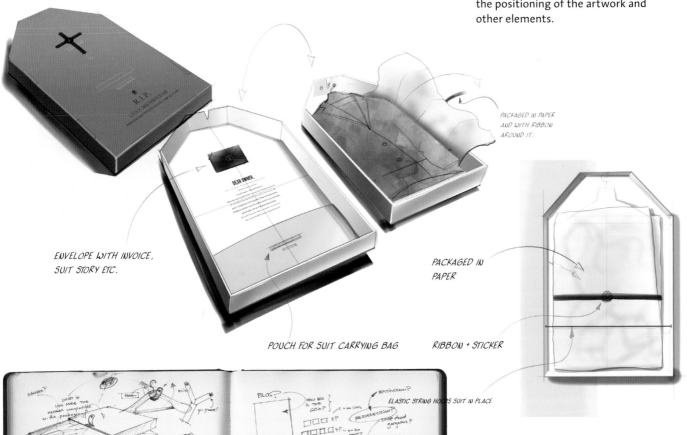

outside front outside back inside front inside back

elastic string
for holding suit in
it's place

ENVELOPE WITH INVOICE,
SUIT STORY ETC.

POUCH FOR SUIT CARRYING BAG

PACKAGED IN PAPER
AND WITH RIBBON
AROUND IT.

PACKAGED IN
PAPER

RIBBON + STICKER

ELASTIC STRING HOLDS SUIT IN PLACE

Suit box development

Pelliano packaging is always designed from a standpoint of experience and thus has different modes. To explain these to team members, partners and the manufacturer, the perspective sketches – made in Adobe Photoshop – are intended for expressing the feel of the packaging, both closed and open. The side view expresses yet another mode: that of the suit still wrapped while the box is opened. Finally, the side views above have the function of drastically reducing ambiguity: clear dimensions, the positioning of the artwork and other elements.

NOTE: The variety of the imagery use offers a well-chosen combination of both 'feel' and 'clarity'.

The packaging of the newly purchased suit refers to a coffin in an iconic manner. This suggests you should throw away your old garment after you have bought a new one.

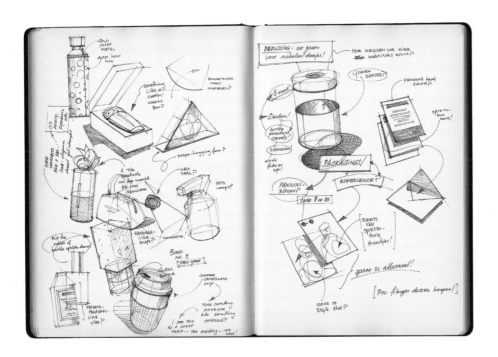

Packaging development

Initial sketches are made either designer ideated independently or in consultation with the members of the packaging partners. The rough fineliner sketches in the sketchbook (always kept at hand, should the need arise to jot down ideas) are used for quickly penning down form or interaction ideas.

The photograph shows a mock-up of what an embossed logo should look like on the final package. The actual logo is a vector file, transformed to fit the three-dimensional photograph. These digital additions are used to create a rough impression of the embossment on the box.

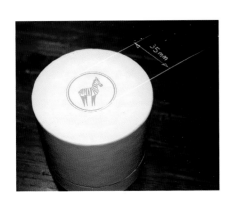

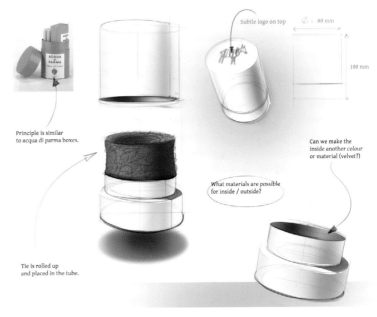

Principle is similar to acqua di parma boxes.

Subtle logo on top

Can we make the inside another colour or material (velvet?)

What materials are possible for inside / outside?

Tie is rolled up and placed in the tube.

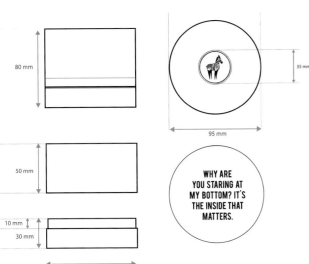

80 mm

50 mm

10 mm

30 mm

95 mm

35 mm

95 mm

WHY ARE YOU STARING AT MY BOTTOM? IT'S THE INSIDE THAT MATTERS.

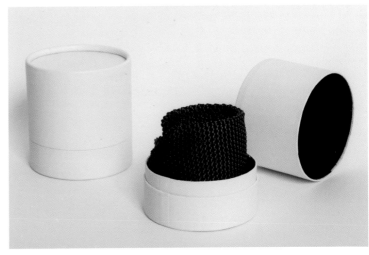

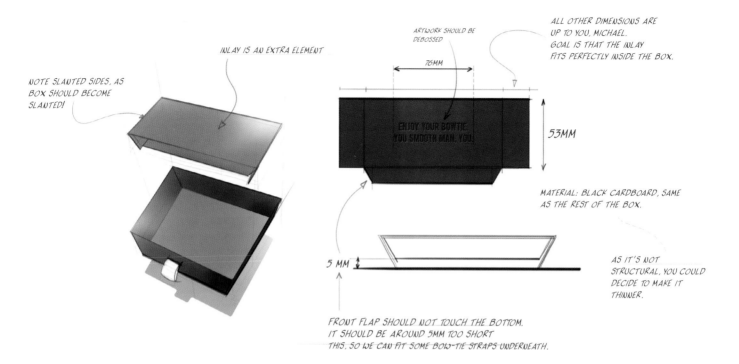

NOTE SLANTED SIDES, AS
BOX SHOULD BECOME
SLANTED!

INLAY IS AN EXTRA ELEMENT

ARTWORK SHOULD BE
DEBOSSED

ALL OTHER DIMENSIONS ARE
UP TO YOU, MICHAEL.
GOAL IS THAT THE INLAY
FITS PERFECTLY INSIDE THE BOX.

76MM

ENJOY YOUR BOWTIE,
YOU SMOOTH MAN, YOU.

53MM

MATERIAL: BLACK CARDBOARD, SAME
AS THE REST OF THE BOX.

5 MM

AS IT'S NOT
STRUCTURAL, YOU COULD
DECIDE TO MAKE IT
THINNER.

FRONT FLAP SHOULD NOT TOUCH THE BOTTOM.
IT SHOULD BE AROUND 5MM TOO SHORT
THIS, SO WE CAN FIT SOME BOW-TIE STRAPS UNDERNEATH.

Bow tie box development

When we revise prototypes with a manufacturer on the other side of the globe, it is effective to use clear images. Partly because you're not physically there to point at something and say "I want this edge to be sharper", but also because of possible language and cultural barriers. These images were digitally edited to highlight or emphasize certain aspects. The goal here was not to have perfectly Photoshopped images, but to create an effective and fast manner of communicating what the box should look like.

In the original picture of the white box with its dimensions indicated, the sides are vertical and the image was transformed to have slanted sites (note the reflection!). The text added makes the imagery more self-explanatory.

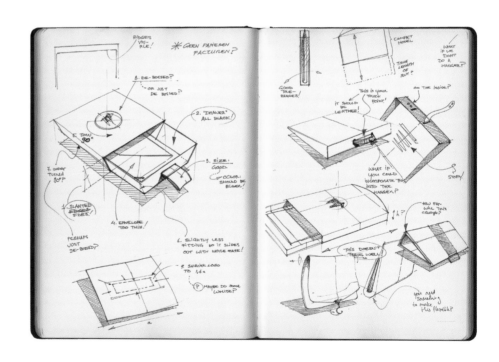

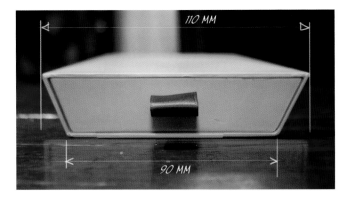

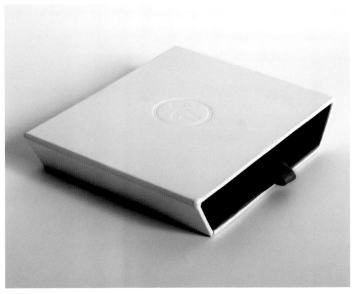

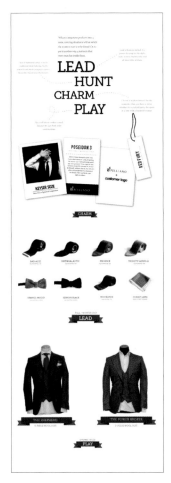

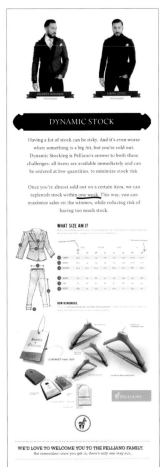

Sales leaflet

After a visit with clients, our Pelliano salespeople leave a sales leaflet with them. Even if the client's representative is impressed, they will often not be the final decision-maker. Usually there are colleagues or bosses, back at the office, who also need to be convinced. In order to achieve this, the sales leaflet conveys the Pelliano story and brand image, shows the products in a clear and unambiguous manner and finally provides answers to the most important questions (terms of delivery, product sizes, etc.). For the storytelling and brand image part of the sales leaflet, it is important that its visual language reflects the language of Pelliano employees in real life: playful, elegant and with a love for the products. Telling fun stories, while still being crystal clear.

Design communication and Gestalt principles

"These boxes are definitely plotting something"

Gestalt theory is defined by means of principles based on experiments on how people perceive certain visual information. This chapter offers and discusses an overview of nine influential Gestalt principles within the context of product design sketches and presentations.

The Gestalt principles can help make visual information more efficient and create more unity. Out of over 140 Gestalt principles, we will focus on: prägnanz, closure, figure/ground, proximity, similarity, continuity, experience, uniform connectedness and symmetry.

Using the Principles of Gestalt, we will discuss:
– creating a focal point
– creating visual balance
– creating a visual hierarchy

In evolution, reading emotion is essential for survival. Because of this, we have the tendency to read emotional responses into anything, animate or inanimate. This is called 'anthropomorphism', projecting human motives and feelings onto animals (pets) and inanimate objects.

2.1 **Introduction to Gestalt**

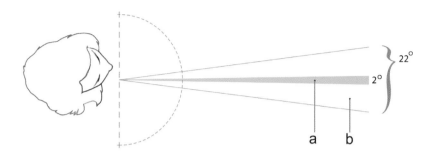

One of the illusions of eyesight is that you may think you are actually able to see everything in front of you. In reality, this is not true; all you 'actively' see is just a small portion of your field of vision. This is called the foveal vision field and can be represented by a vertical angle with a 2-degree angle (!). It is surrounded by the parafoveal vision field, with which it makes up a vertical angle of about 22 degrees [2.1][2.2]. Coincidentally, this area roughly equals the area covered by your hand when you stretch out your arm in front of you and open it up; your hand now covers your active vision field. Quite small, isn't it?

How did we get the idea that we see everything in front of us? Well, because our eyes do not usually stare, they move at great speeds, mapping all that is in front of us allowing our brain to match up all the pieces of the puzzle. The brain thus receives millions of sensory inputs per second and tries to make sense of those. While we look with our eyes, the brain makes associations with tastes, smells, etc. It compares current observations with our previous experiences. **Our brain looks for 'meaning' in and connections between the various things it sees: it interprets**. This is what we call perception.

These eye movements are called saccades and the times at which our eyes rest briefly are referred to as fixations. These fixations do not happen randomly, but are concentrated in specific locations. As early as the 1890s, this phenomenon was studied by scientists. In the 1950s and '60s, the Russian psychologist Alfred L. Yarbus studied fixations in observations of images of faces. He discovered that the fixations of the test subjects' eyes centred around the eyes and mouths in the pictures, which are important areas for face and emotion recognition [2.3].

The most widely known study on human perception is the Gestalt theory of visual perception (Max Wertheimer together with Wolfgang Köhler and Kurt Koffka, Germany, 1920s). This profound analysis of perception

resulted in some useful insights, referred to as Laws or Principles.

With these Principles we can analyse how people 'read' sketches and presentations. More importantly, they provide us with guidelines for influencing the way people perceive visual information, so that you can communicate your ideas more effectively. Researchers have found that we not so much focus on the separate elements we see, but rather have the tendency to group them together into something greater, which may be very different from the elements themselves. *The whole is different than the sum of its parts*. The act of reading, for instance – as you are doing right now – supports this Gestalt principle; you do not perceive the individual letters, but rather process the words they form, as those have meaning to us.

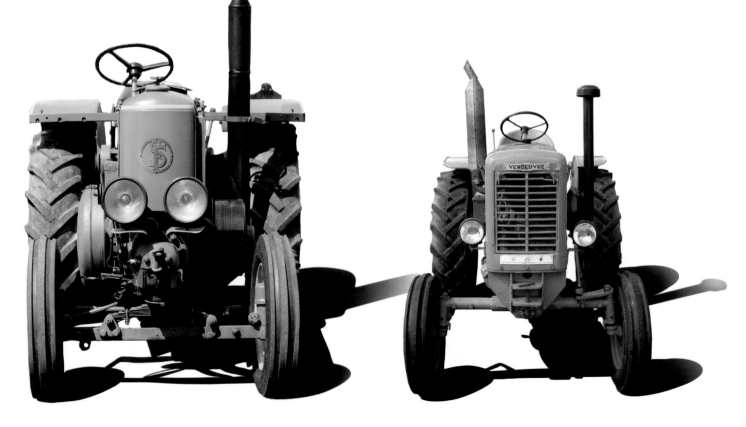

We look for meaning and also tend to look for a relationship between the elements we see. As a result, we generally find harmonious images more pleasant to look at than those without harmony. On occasion, you may even find yourself recognising shapes where they do not exist, such as seeing clouds shaped like an animal or a face in the moon.

This chapter will not cover all of the (over 140!) Gestalt laws or principles, but will explain some that can be considered useful in product presentations. They are listed separately, but in reality they will virtually always work together simultaneously. As you will find out, many Gestalt laws are already applied unconsciously. Although the principles do not prescribe how best to present your visual info during a product presentation, they do indicate the manner in which this info is perceived.

We are sensitive to faces; we prefer things with a face and look for faces in things

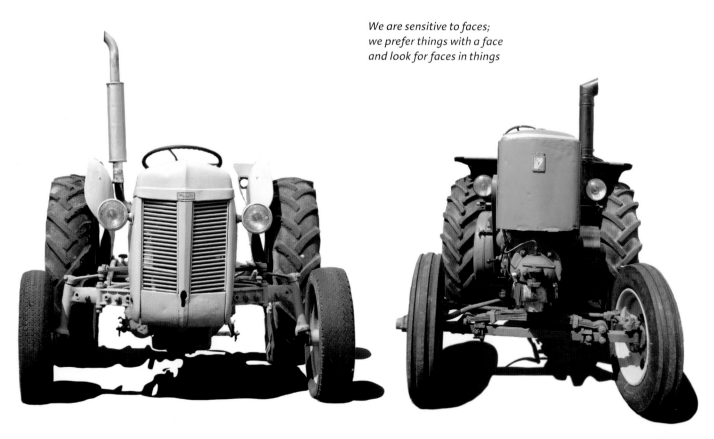

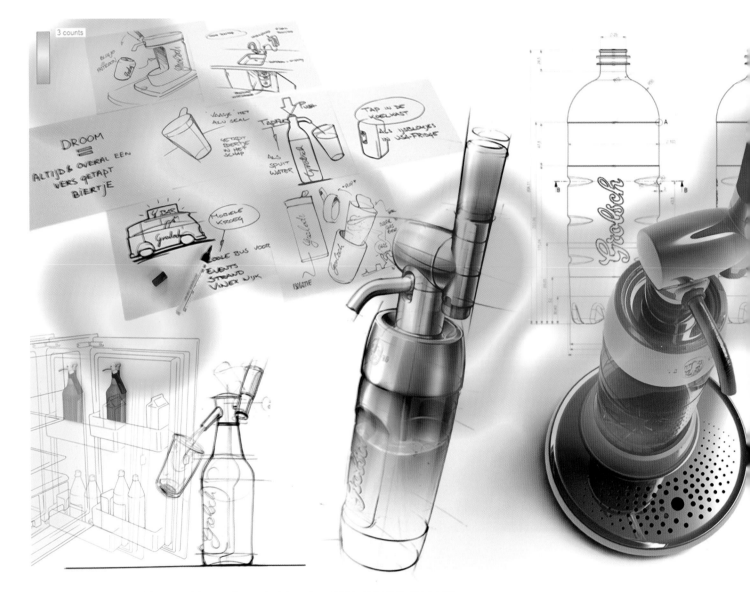

Design presentation of the Brand design for Grolsch beer by FLEX/theINNOVATIONLAB®

2.2 **Eye tracking**

Through modern sciences such as MRI scans and eye-tracking technology the viewer's responses to images, websites or advertisements can be measured and researched quite precisely. The first non-intrusive eye trackers were built by Guy Thomas Buswell in Chicago (1922) and have been revived for optimizing present-day websites and advertisements [2.3]. The results can be interpreted quite well with the use of the Gestalt principles.

At web-page layout speed, quick results are important. Gestalt plays an important role in influencing the perception of the viewer.

For reliable eye-tracking results, it is important to create circumstances in which people view an image without prejudice. For example, do not inform the test panel that they will be shown a commercial and certainly don't mention the brand name. This kind of foreknowledge might create

expectations, and thus cause the subject to selectively search for these expected characteristics in a commercial. People may no longer look at an image from an unbiased point of view if they know that it is an advertisement. In some cases test subjects are informed in advance. This drastically disturbs the findings from the eye-tracking results.

We did some eye-tracking experiments ourselves. The image on the left displays a presentation of a home keg tap for a beer brand and the eye-tracker result: the main information is visually balanced and brief attention is paid to the environmental information, i.e. sketches, context and technical drawings.

The image below of the industrial plant shows an entirely different outcome. Why is there so much attraction to the vanishing point? Is it because our reptilian brain tells us "beware of the possible dangers from far away" or is it because we are in principle interested in the unknown?

Or is the viewpoint, with its vanishing point near the centre of the image, testimony to the fact that we naturally focus and rest our eyes there, scraping together bits of information?

The example with the sketches of the circular saw shows that the points of interest are concentrated around certain parts of the machine in several sketches. It seems that one viewpoint is not enough for grasping the object, leading the brain to gather more information by looking at (combining) several sketches.

Images with eye-tracking results displayed as heat maps

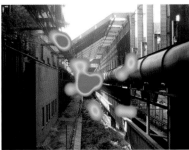

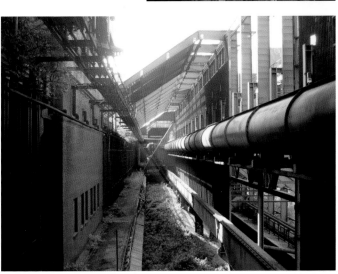

2.3 Nine influential Principles of Gestalt

2.3.1 The Principle of Prägnanz (concise)

According to this principle, we will try to organize or reduce
visual information to the simplest form possible [2.4], i.e.
more regular, symmetric and orderly. It is a strong principle
that may even be applied to our general sense of perception,
rather than just visual perception. We look for simplicity and
meaning in the things we perceive. Even in complex shapes
we try to see something simple and meaningful. We look for
clear, uncomplicated (symmetrical) shapes and as few of them
as possible. That is why we see the teddy bear (below) before
we see the objects in the image it is made from. That is why we
first see the shape of the sausage instead of the separate food
items in the HEMA advertisement.

This and most Gestalt principles describe a certain pattern
recognition which helps us make sense of the information
overload from our surroundings. The brain does so without
much conscious effort: it continuously closes the gap between
observation and knowledge. That is the 'cognition' part of
perception. What your eyes record is not what your brain
perceives. We simplify, select and interpret. We do so through
mechanisms established by means of evolution and personal
experience.

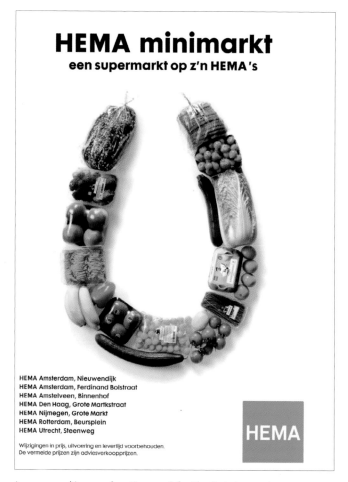

*Image used in an advertisement for the Dutch warehouse
HEMA, famous for their smoked sausages, advertising their food
department*

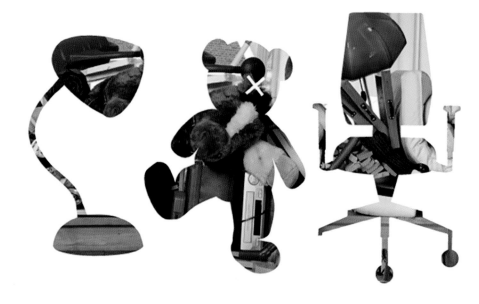

*Image used in a public
awareness campaign for
separating household
refuse and recycling in
the city of The Hague, the
Netherlands, by Noclichés*

Drawing by a child, age 3

Prägnanz in sketching

Young children intuitively apply this principle; what they sketch does resemble the original, but most attention is given to what it means. Lacking the ability to sketch in perspective, they initially sketch more or less in plan view, focusing mostly on the meaning of things rather than their form. They choose the view that contains most meaning: an animal, for example, is drawn from the side, so you can best see its overall shape. Its face is then sketched looking towards us, so we can directly see its eyes and mouth. Flowers and plants are drawn in a manner that best displays their colours and leaves. The sky is blue, shapeless, placed above everything and at the upper edge (which signifies a great height, or maybe endlessness).

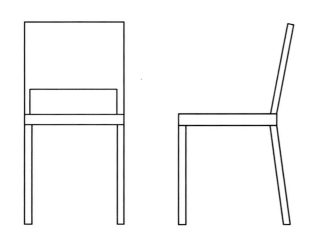

The side view on the right represents most of the chair's shape characteristics

In general each object has a side view that contains most of its shape information or meaning, which is referred to as the 'most informative side'. Note that the principle does not dictate that we should only sketch side views. If we did, we would mainly communicate the meaning of 'car' and lose the shape or form of the car.

Most objects have a side that is most representative of its shape characteristics

In our sketching sequence, you can also find an application of the Prägnanz principle. We sketch from large to small, starting with the big shapes and working our way down to the details. This reflects the way a sketch is perceived and also comes in handy in case of time pressure; the sketched object will be easily recognizable in no time, and can then be made more detailed (realistic) depending on the time available. The opposite would be what we call knitting, which focuses on details and is therefore less efficient with regard to sketching. In perception – and your judgment of the sketch – the whole is of greater importance.

When we see a shape drawn in perspective, it is most easily recognizable when we have a good view of its 'most informative side'. So when we (as grown-ups) sketch, it is this side that must be sufficiently recognizable. In choosing a viewpoint for your sketch that makes this side the least foreshortened, you create an informative view of the object.

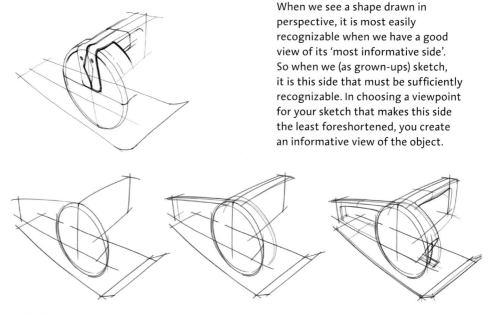

Sketching method 'knitting' (top) versus 'from large to small' (steps below)

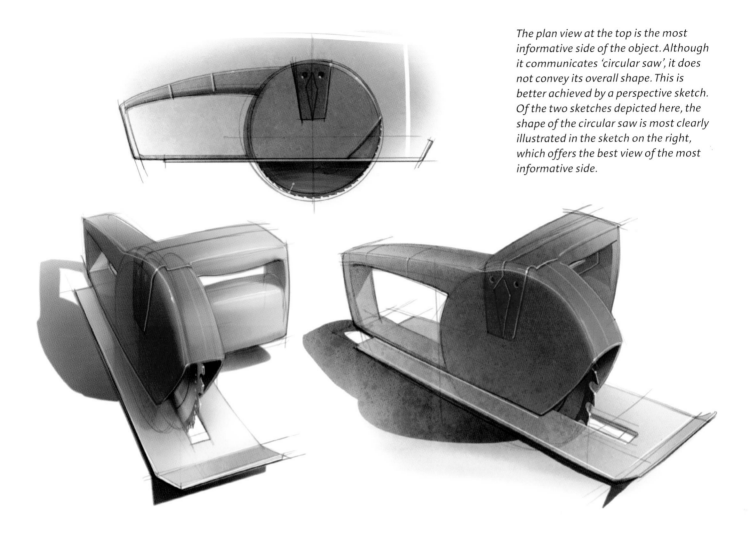

The plan view at the top is the most informative side of the object. Although it communicates 'circular saw', it does not convey its overall shape. This is better achieved by a perspective sketch. Of the two sketches depicted here, the shape of the circular saw is most clearly illustrated in the sketch on the right, which offers the best view of the most informative side.

p. 80

p. 122

p. 189

Prägnanz in presentation

Using the Gestalt principles, we derive patterns and form realistic images, which our brain then compares to what we know. This is how we identify the things we see. It takes the brain some effort to distinguish the relevant info from the visual 'noise'. Information, especially complex information, that is presented to us unorganized leads us to search and puzzle. Gestalt helps us organize visual information and avoid this constant puzzling. When we are aware that in our perception we look for connections and simple and few shapes, we can turn the principle around and present visual information this way; straightforward and with only few elements. If we present the brain with orderly, simplified visual information, we actually save the brain some work. This workload of the brain is also referred to as its 'cognitive load' [2.5]. When an image is designed to make information more easily accessible, it will reduce the cognitive load of the viewer and thus make it easier to understand.

The Prägnanz principle can also be helpful on a content level: strip things down to "what do I need?" All redundant elements should be left out.

Simplification is a very helpful guide in complex situations, but when it is overused it can also make a presentation far too easy to read and, even worse, boring. As goes for everything, some detailing/puzzling is necessary to keep things interesting. Obviously, other factors also play a role and the principle of Prägnanz is not the only guideline.

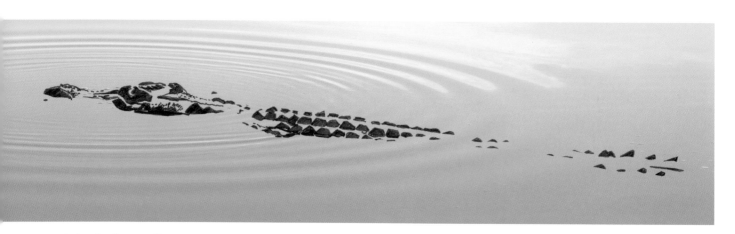

In evolution (and survival) is essential to recognize predators. Therefore, so we connect the separate elements instantly.

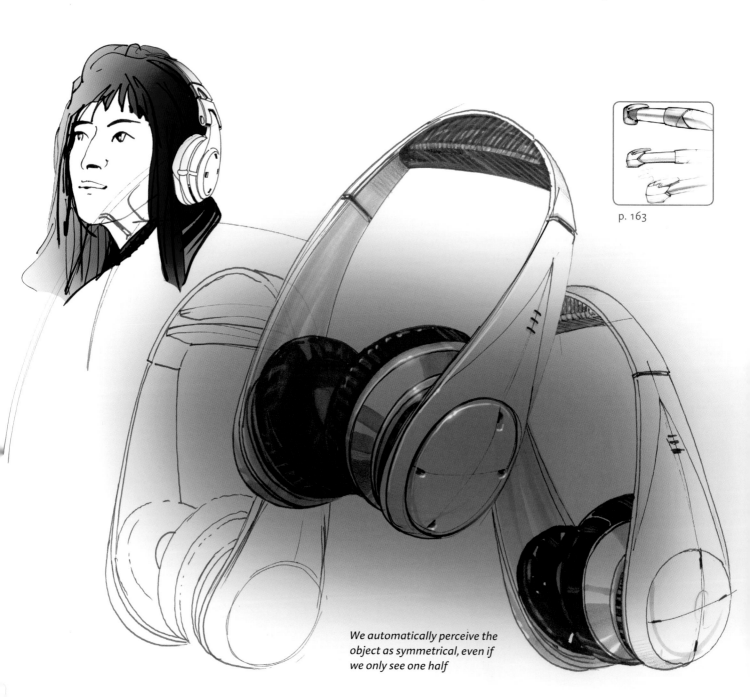

p. 163

We automatically perceive the object as symmetrical, even if we only see one half

2.3.2 The Principle of closure

According to this principle, we complete incomplete images or objects in our brain. "We perceive a complete or incomplete part or whole so as to attain maximum stability, balance or symmetry in the entire configuration" [2.7]. We fill in the visual gaps, so to speak, to create a logical or meaningful overall image. In our early evolution, this was essential for survival. Many predators would skulk and only partially be revealed to us. Needless to say, it was of the utmost importance for us to quickly recognize them instead of having to waste time trying to make sense of what the exposed body parts of the animal signified.

This principle is also very strong and important for visualization. For instance, it is much used in logo design.

Closure in sketching

The part of a sketch or contour we do not see is automatically created in our brain. This happens quite naturally, for instance when sketches overlap each other (interposition).

When combined with the principle of symmetry, the principle makes us interpret the plan views below as complete headphones. We assume the object to be symmetrical, until demonstrated otherwise. This also holds true for perspective sketches in general. We assume that the side not exposed to us will be similar to the one we see. Note that the plan view shows a bit more than half of the object, in order to underline its symmetrical appearance.

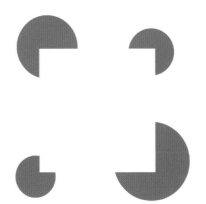

This image actually contains no circles and no square

p. 9 p. 165

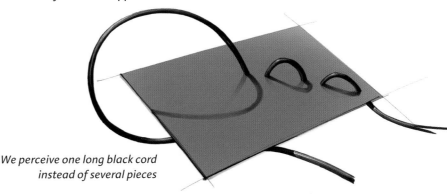

We perceive one long black cord instead of several pieces

2.3.3 The Principle of symmetry

Symmetry in sketching

We tend to perceive objects as being symmetrical. Most objects can be divided into two virtually symmetrical halves. When we see two symmetrical objects, we unconsciously group them into one coherent shape. [2.11]

The principle of symmetry is a greatly misunderstood one and needs to be considered with care. If we have the tendency to connect two objects that look like each other's mirror image to form one object, does our desire for symmetry then mean that we always prefer images that are already symmetrical...?

[]{ }[]

We tend to perceive three symmetrical bracket shapes, instead of 6 individual brackets. Even grouping them by proximity is overruled by our need for symmetry

2.3.4 **The principle of similarity**

We have the tendency to group together elements or objects that have similar features; that look alike. The feature that connects them can vary: colour, value, texture, size, position, etc. For example, brand identity is based on this principle, among other things. So the manner in which a store's less expensive house brand mimics another established, usually more expensive, brand. In the case of crisps, we can find a similarity in the colour used for the classic ready-salted flavour. Red can be found in the packaging of ready-salted crisps almost anywhere on the globe. Other flavours are not signified with the same colour globally, which has to do with local taste preferences. Not all varieties are available everywhere, and there are probably differences in colour and taste at a local level as well.

The fact that we search for similarity does not mean we always appreciate it. Too much similarity can be regarded as quite unpleasant. For instance, mass production can feel utterly impersonal. After having used mass-produced products for an extensive period of time in our western culture, we are now starting to appreciate the irregularities in handmade craftsmanship again. An example of how to bring back these irregularities is found in the Stratigraphic Manufactury project by the Belgian Design Studio Unfold: it explores how 3D-printed objects created from identical digital files can be as varied and unique as handmade objects.

p. 110

p.126

p. 116

p. 194

Ready-salted crisps can be found in red packaging almost everywhere

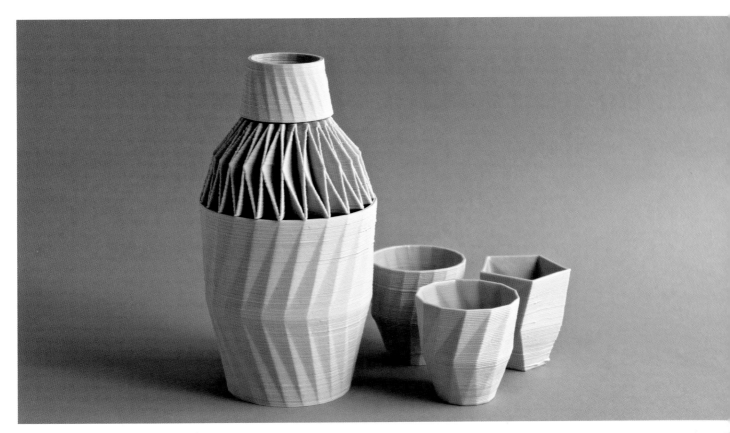

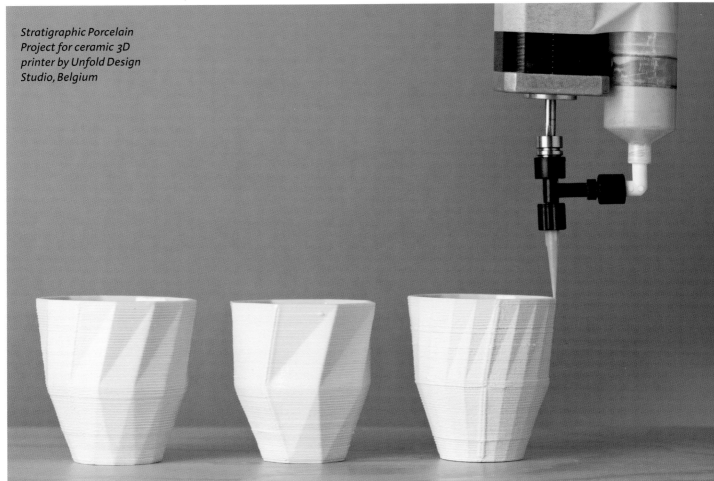

Stratigraphic Porcelain Project for ceramic 3D printer by Unfold Design Studio, Belgium

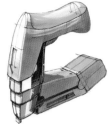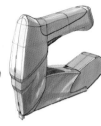

Sketching with an underlay, creating similar looking concepts

Similarity in sketching and presentation
When comparing different product concepts, it might be your goal to present them 'objectively'. In visual presentations this can be done by introducing them through sketches of the same size, viewpoint and level of detail. To do so, an underlay can be used for sketching. We can make various quick design proposals using the same underlay, ending up with many similar looking sketches, both in size and viewpoint.

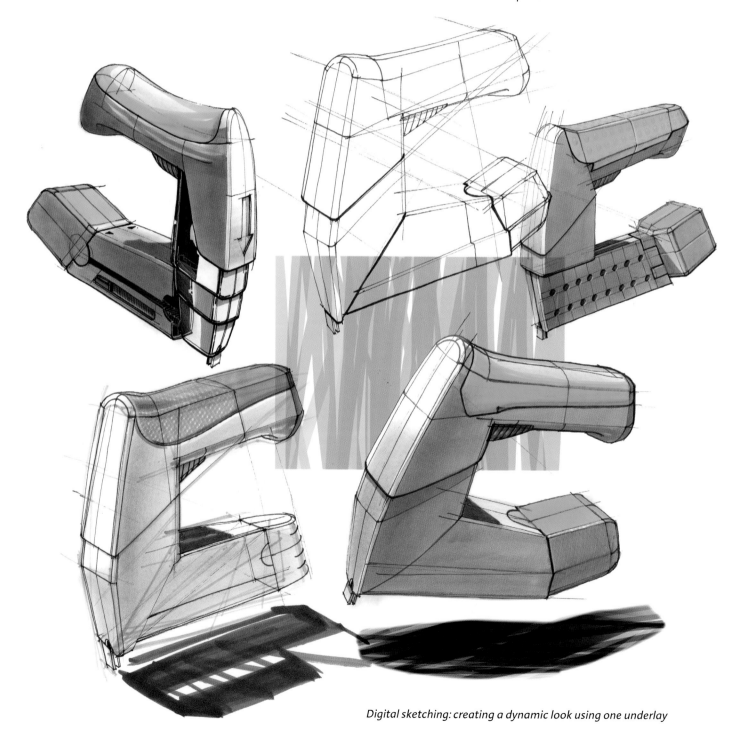

Digital sketching: creating a dynamic look using one underlay

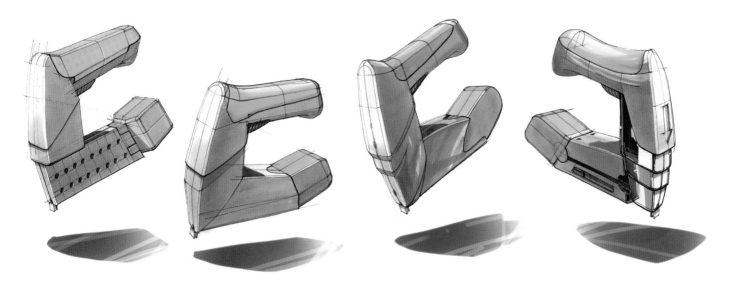

Sketching with an underlay, creating a less static look by rotating and mirroring

This might sound like an ideal situation, but there is also a disadvantage to great similarity. We might well have ended up creating boring and static images, especially when not only the size and viewpoint are similar, but other visual characteristics – such as the colour contrast value – are too. The end result may offer too much repetition, which takes away from the overall appeal of the sketches.
A way to overcome this static feel and create a more dynamic look is to use different colour and shading values for the sketches or to rotate your underlay or even mirror it (if possible) each time you start a new sketch. The sketches can then be kept similar, while the end result itself will be more dynamic.

In ideation, the use of an underlay can come in handy in situations where product dimensions are set according to the interior mechanism of the product, or when a complex product is restyled. In general, an underlay can greatly speed up the sketching process. However, too much similarity is even less desirable in ideation.

In the process of creating, much dynamism is preferable and a great variety of other visual aspects, such as overlap, colour contrast and detailing, can override the similarity of viewpoint. Of course, in digital sketching the size can also easily be varied. Alternatively, one can also apply this principle the other way around, i.e. making dissimilar sketches in order to emphasize them. We can abandon similarity and thereby direct attention to a specific point; this is referred to as a focal point.

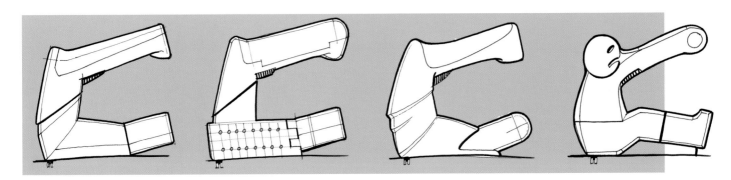

The figure on the right attracts attention through its dissimilarity and becomes a focal point

2.3.5 **The Principle of proximity**

This is the perceptual tendency to group
visual elements that are in each other's
proximity together, whereas elements
further apart are seen as independent,
or not connected. This has to do with
relatedness and causes us to perceive
groups or chunks rather than unrelated,
independent objects. Although this
principle sounds quite obvious, it is not
always so easy to apply it.

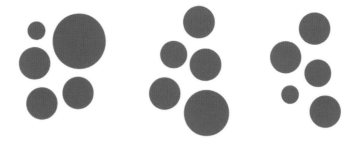

Instead of many circles, we perceive 3 groups of circles

1 terminal
2 corrugations
3 copper core
4 casing
5 ceramic insulator
6 gasket
7 insulator nose
8 centre electrode
9 ground electrode
10 thread

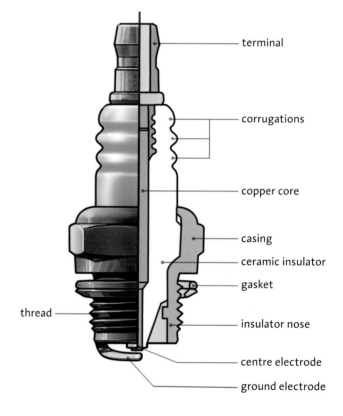

Spark plug with part description close to the parts

Proximity in sketching and presentation
Placing an image and a caption close
together, such as demonstrated throughout
this book, is an example of the proximity
principle. However, the example on the
left breaks with the proximity principle
by indexing the product's parts. Technical
drawings traditionally make use of a legend,
which may explain this. The image now
requires extra effort from the reader. The
image above applies the proximity principle,
which makes it easier to understand.

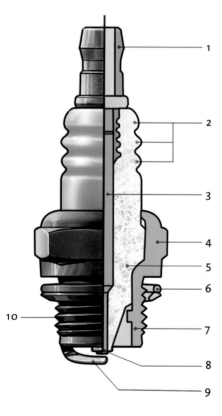

Spark plug with indexed parts

Proximity in sketching and presentation is basically used for creating coherence. If you sketch ideas for a project and place the (relatively small) sketches far apart, the sketches will not automatically belong together. If they were meant as part of the same project, this is counter-productive. Apart from the sketches being very small, the layout on the right seems rather dull. When we use the same drawings in different compositions, the transfer of information also changes. A certain degree of proximity, or even overlap, can be opted for in order to create unity in the sketches. A pleasant side effect to this is the visual dynamism that then occurs.

p.87

p.125

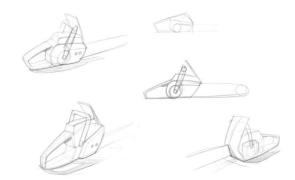

Sketches are less coherent

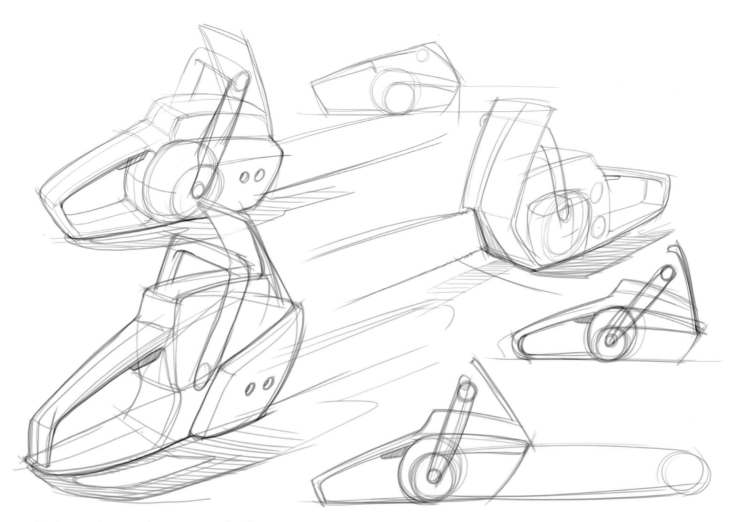

Sketches are close together or even overlapping

2.3.6 **The Principle of uniform connectedness**

This principle implies that elements sharing uniform visual properties are perceived as being closer related than elements that do not.

Uniform connectedness in sketching

Some simple yet effective ways to group elements used in sketching is to form a group by providing them with the same background or frame, or applying equal contrast in shading or colour. This principle is an extremely effective one, and overrides many others, such as the principle of proximity.

The larger dots are perceived as a group

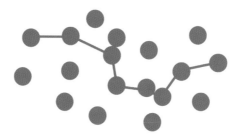

The connected dots are perceived as a group

p. 122

p.191

p.158

p. 132

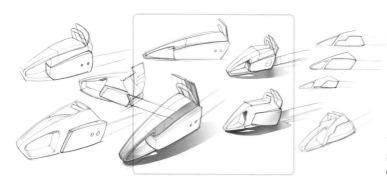

The sketches inside the rectangle stand out as a group

The sketches with light and shading stand out as a group; the principle of similarity is involved here, too

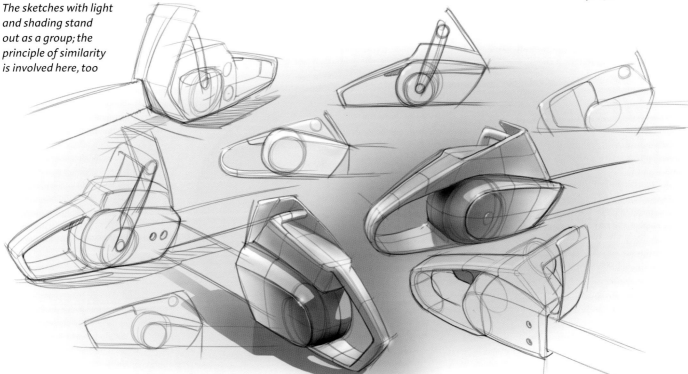

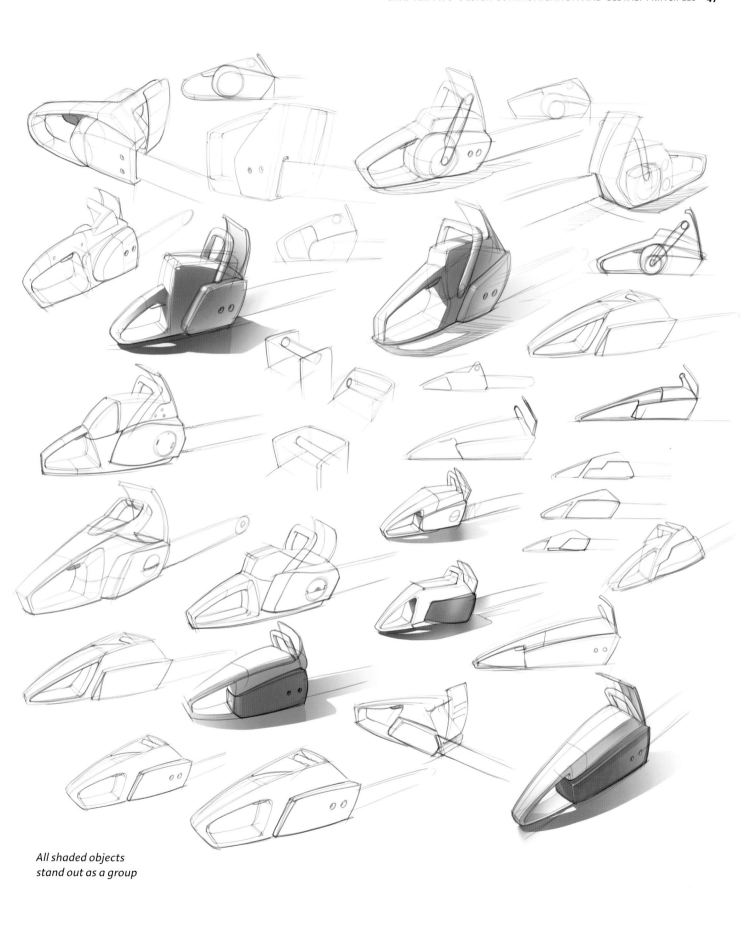

*All shaded objects
stand out as a group*

Uniform connectedness in presentation

An exploded view is the kind of sketch
in which both proximity and uniform
connectedness play an important role.
As these visualizations can get very
complex, the principles of Gestalt can
help organize visual elements in order to
make the image easier to understand.

A common means of doing so is the use of
explode lines. These lines can connect and
group parts or indicate their disassembly
sequence.

p.113

p.154

p.26

*Exploded view in which parts
are organized logically,
according to the (dis)
assembly sequence and using
Principles of Gestalt*

p. 173

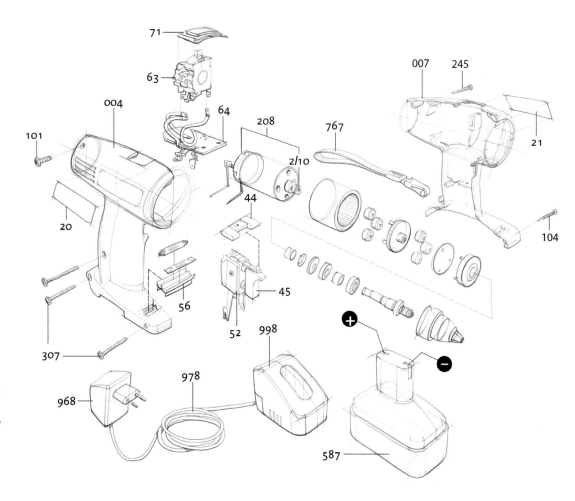

Exploded view in which parts are organized less orderly, leaving the product involved a bit more obscure at first glance

A good start is to have product parts both placed close enough and organized logically, so that the product concerned is recognized at first glance. Organizing parts logically usually means 'exploding' them according to their disassembly sequence. After this first impression of the complete product, the viewer's eye can wander about to investigate the separate parts. If the parts are too far apart or organized more randomly, the coherence of the entirety is lost, and with it its guidance to the viewer regarding where to look. Eventually the image will function, conveying all the information needed, but requiring much more effort. The viewers' first impression of the image will be puzzling and it will take them some work to figure out that which they were looking for. Their attention might even be lost, ultimately abandoning the image.

However, if the parts are organized logically, but placed too closely together,

the readability of and shape information from the individual parts could then be lost. So the correct proximity of the parts lies somewhere in between. Slight variations of proximity can be repeated in order to distinguish sub-assembly groups. In this manner, the information overload caused by the excess of parts is remedied by organizing them into smaller subgroups that are easier to grasp, while their relation to the whole remains instantly visible. This image on the left demonstrates this at the centre of the sketch. From left to right we see the head of the cordless drill, 2 groups of parts, and the electric motor.

The principle of uniform connectedness can, by means of the exploded lines, organize parts according to their disassembly sequence. Even a bent line can do the trick. Especially in a visually complex situation, these exploded lines will help you read the hierarchy of product parts. Moreover, a clever application of these lines can keep

the layout compact. The image on the right provides an example, as the central image is organized differently than along one straight line.

The image on the right is clearly organized in order to keep its layout as compact as possible. That may also be an important issue. Be aware that the perception of the viewer, and his/her effort to understand the image, has to be considered carefully. In a simple situation disregarding Gestalt principles will have less dramatic consequences than one involving a complex product. Highly complex subjects need a higher degree of organization according to the principles of Gestalt, to provide the viewer with better access to the information given.

The principle of uniform connectedness also allows us to understand which parts of the (perpendicularly) organized plan views belong together, forming one object.

2.3.7 **The Principle of continuity**

The principle of (good) continuity, continuation or linearity captures the idea that elements following a consistent direction are perceived to be connected to each other. In this manner, the brain can perceive lines, even if they are not really there. Because of this we can, for example, read road maps easily or make a distinction between the 'figure' and the 'ground' [2.3.9].

Continuity in sketching and presentation
But there is more. The principle of continuity also plays a significant role in the perception of perspective; linear perspective. Especially in situations where the 'lines' are just blurry edges, or not even all that straight, we tend to disregard the irregularities and perceive lines. In linear perspective we see lines that recede towards the horizon, converging.

In sketching, for instance, lines are not always perfectly straight. When a sketch aims to represent something that needs to be utterly smooth and straight, not being able to draw such straight lines is not as problematic as you may think. If drawn line is supposed to look straight, it doesn't actually have to be in order to be perceived as such.
Looking closely at the architectural sketch shown here, the 'straight' lines are not at all perfectly straight, yet still we perceive flat, rectangular surfaces.

Other tendencies that result from this principle, is that we prefer the smoothest path [2.4][2.8], or continue shapes beyond their end points [2.9]. In addition, upon introduction of a series, the brain tends to perpetuate the series [2.10].

We 'see' a path, although logic informs us it's improbable

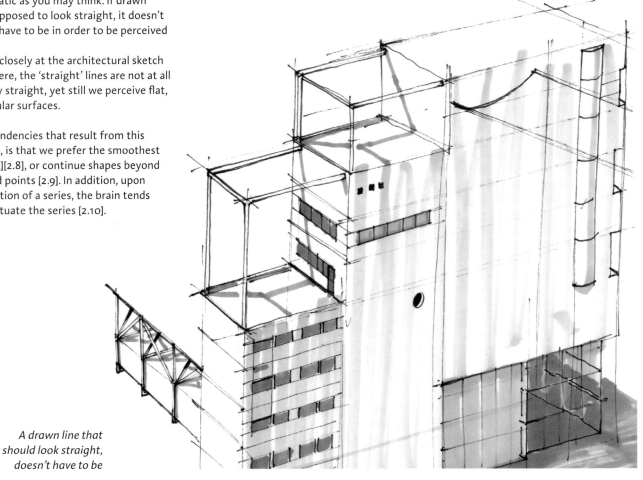

A drawn line that should look straight, doesn't have to be

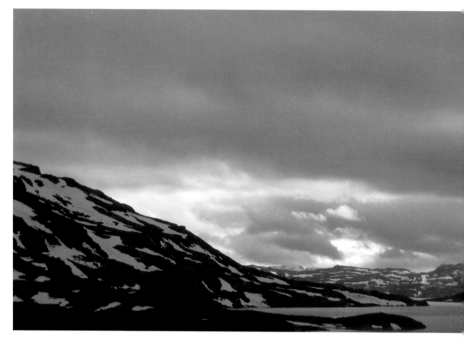

We derive information quicker from the graph on the right, which is organized in a way to suggest continuity

Continuity makes us believe the entire surroundings look like this

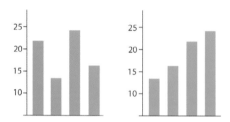

p.78 p. 191 p.113 p.76

Continuity is also applied in product redesign, or for creating brand identity

2.3.8 The Principle of experience

We automatically compare things we perceive with what we already know. Designers of icons have made grateful use of this principle. Reference to a letter or a rubbish bin will still be understandable when it is done by means of an envelope icon that stands for email and a trash can that stands for 'delete'.

Experience in sketching and presentation
This principle also means that it is convenient for a viewer to have information presented in a familiar manner; in the same manner as before, so to speak. Today's newspaper maintains the same sequence, placement and grid as yesterday's, so that we expect certain information in its fixed section and do not have to search so much. This also applies to layout grids for books, portfolios, websites or presentations.

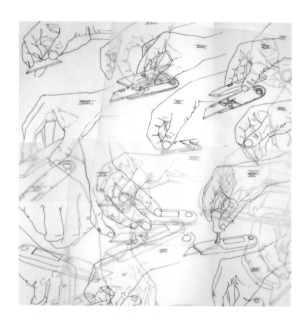

In the west, we read left to right, top to bottom. Information presented otherwise will confuse us

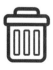

Icons by Designmodo

We (in the west) read text from left to right, top to bottom, and this is also how we 'read' visual instructions

2.3.9 The Principle of figure/ground

The eye distinguishes objects from their surrounding. Objects such as silhouettes, forms or shapes naturally become the 'figure', while the surrounding area becomes the background or 'ground'.
In sketching, this basically means that objects drawn with (contour) lines are perceivable representatives of reality. Although obvious in principle, this may be the most important principle in the perception of drawings.

p.170 p. 122 p.129

This principle also dictates that when the viewer has to make the mental choice between two interpretations, this is impossible, as he or she can see only one. Usually the second interpretation is seen somewhat later, and having switched to the second, trying to see both simultaneously appears to be impossible. This is called the Gestalt switch.

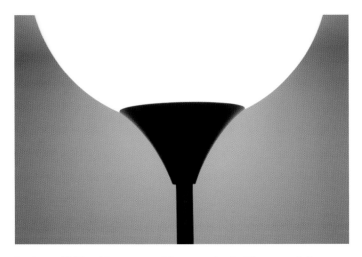

Boring-still-life-objects-turned-into-erotica by Blommers Schumm

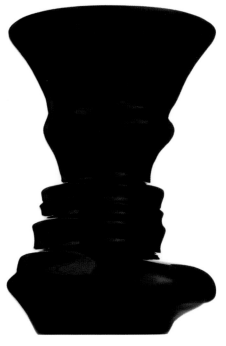

The Heroes of The Invisible vase by FAT (Fashion Architecture Taste) is a vase formed from the profiles of Mies van der Rohe and Marconi; two historical figures who explored the idea of the invisible in different ways. The 70 cm high vase is formed in the gap between their profiles. It has a high-gloss baked-on finish. The vase is based on the Rubin's vase, developed around 1915 by the Danish psychologist Edgar Rubin.

2.4 **Visual Balance**

Now that we have covered nine influential principles of Gestalt that affect visual communication in product design, it is time to put them into perspective. One cannot simply apply all of these principles and be guaranteed of a good image, as there are other important factors to be considered.

2.4.1 **Focal point**

Usually the viewer is attracted to a certain area in a composition. Such an area, point or element is referred to as a focal point. It is interpreted as the image's most important area. This can be the 'figure' (as opposed to 'ground') in a sketch, or a dominant visual element such as in the bright area in the image below. Either way, it is recognizable as such, or from the maker's view intended as such.

If visual information – especially a great amount – is presented without a focal point, the viewer is not given a hint as to which part of the image is most important, and which is less important. In such cases, the viewer is not be visually stimulated to explore, as it is unclear where to begin and the meaning of the image may leave too much to be guessed at by the viewer. Therefore, the image might be disregarded as uninteresting or meaningless. As viewers have their own personal preference or interpretation, the meaning the maker of the image had in mind will most likely be lost. In the context of product design, this is an undesirable situation, as the designer usually has something specific to communicate with a sketch or presentation. In that case, it is helpful to guide the reader through the visual information by using focal points. The Gestalt principles are of great help in creating such focal areas.

If visual information is presented with too many focal points, it will become overwhelming and the viewer will not be encouraged to keep on looking.

This sheet of ideation sketches has no clear focal point

A consistent pattern, such as that on regular wallpaper, has no focal point

This layout has no distinct focal point, but two equally significant ones. Looking at this image is a bit like watching a game of tennis

Outlines and focal point

Designers normally communicate ideas. Therefore, highlighting certain aspects or parts of something is often more appropriate (and effective) than providing a completely finished and realistic drawing of the whole. There are various ways to highlight a part of something, one of which being emphasizing contour lines. Using more distinct contour lines around a specific part of a sketch, will automatically attract the viewer to the scenery inside these sharper lines. In the example below this is the interior of the car. Inside the interior, the focus is on the (coloured) chairs. The body of the car is only necessary for providing the context, and is thus depicted with the use of lighter lines.

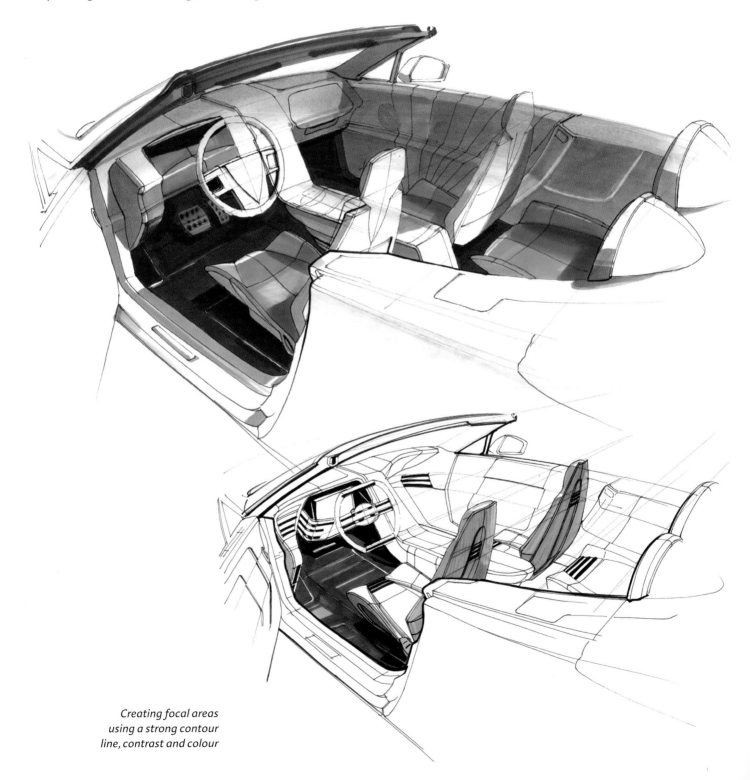

Creating focal areas using a strong contour line, contrast and colour

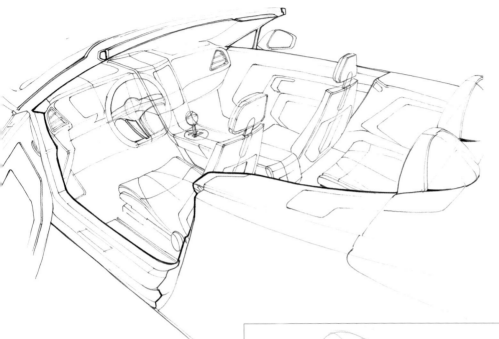

The downside to using a thick contour line to enclose a perspective sketch is that it looses some of its depth. Lines that are usually kept brighter because of light/shading effects will now be much darker. However, it is a highly effective way to attract attention to the most important part of the image. Of course, you could make the contour lines nearer to you a bit darker to bring back depth. This will slightly reduce the flattening effect.

Using darker outer lines to direct the viewer's glance is commonly accepted (and much-used) in brainstorm sketches. It's and easy manner to indicate the more important outcomes.

p. 88

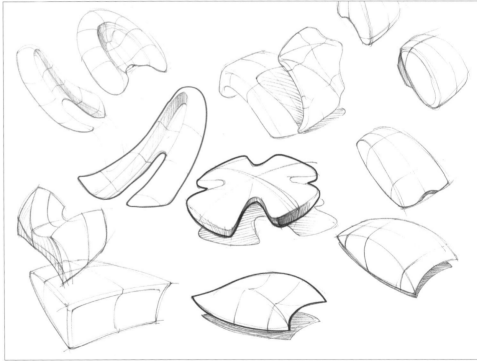

Creating focal areas using a strong contour line and arching

p. 11

p. 150

2.4.2 **Visual hierarchy**

If you take another close look at all the cases in this book, you will find that many layouts have more than one focal point. You will discover that these focal points have to be organized with care, as they cannot all get the viewer's attention at the same time. This would either cause conflict, or make the image appear unorganized.

A visual hierarchy is required to guide the viewer towards the most important elements in the layout, and to make a visual distinction between the most important element(s) and the less important ones. Between the headlines and the more detailed information, so to speak. There are various ways in which one can direct the viewer's glance towards a certain area or point in a composition. Effective and widely-used methods for creating a focal point (in sketching) are through contrast and through colour. It is common to have one main focal point, accompanied by some less important focal points, known as accents. The viewers will start off by looking at the main focal point, after which their eye will wander towards one accent, and then towards another. In this manner, the viewer is guided through the elements of the presentation in order of importance. This creates a pleasant experience for the viewer and a visually interesting presentation. It holds the viewer's attention, guiding him or her and offering the information in chunks, and keeps the viewer actively involved. In general, instead of experiencing this as being taken by the hand, the viewer will have the feeling that he/she has discovered all the information by him- or herself.

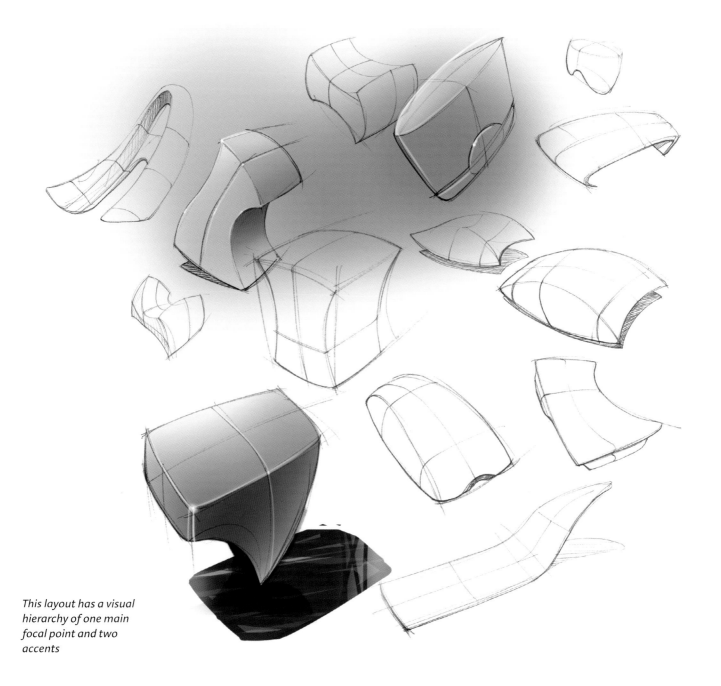

This layout has a visual hierarchy of one main focal point and two accents

2.4.3 Rhythm and repetition

When (a great amount of) information is presented with the use of multiple pages, screens or slides, is it convenient for the viewer to have the information presented in a familiar manner, i.e. consistently. We generally expect continuity and similarity, and we are by nature reluctant to change our habits. The use of a grid creates a constant rhythm and structure.
In layout, rhythm and repetition are used frequently.

Repetition means that elements are repeated, even when this is done randomly. Creating a rhythm is closely related to repetition, but rhythm – as in music – is more predictable. It can create unity, as it creates a predictable continuation. This can be achieved in various manners: through size, through position in the layout, etcetera.

The layout of this book has also been based on a grid to create coherence. However, it is also important to vary the layout of the pages, as the content of the pages may require a different order. In addition, variation is also very important because too much similarity will inevitably result in a boring reading experience.

p.111 p.115

p. 166 p.169

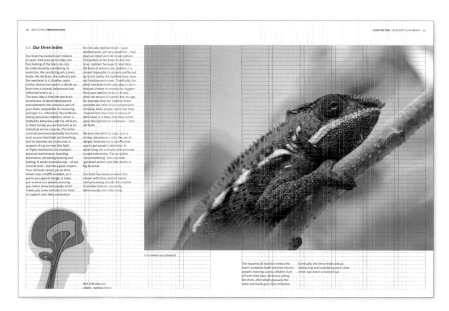

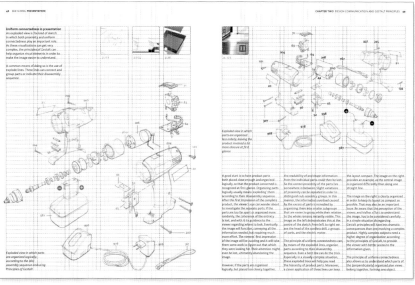

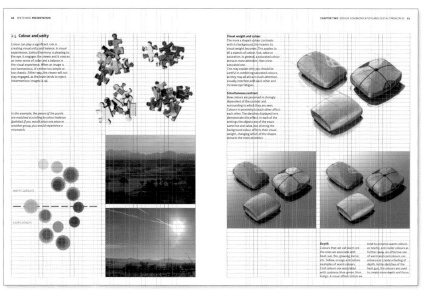

The layout of this book applies a grid to create coherence: continuity/ similarity in the pages

Golden Ratio

If we use symmetry in organizing information, it will be more easily accessible than non-organized information. Therefore, in arranging complex information, the principle of symmetry can help the viewer to understand the contents quicker and more easily. For instance, websites with a high click rate frequently display centred elements that can be perceived quickly. We naturally look at and for the centre of an image, which means that when information needs to be communicated quickly and clearly it can best be placed at the centre. However, when it comes to the composition of images and/or sketches in general – in which case the complexity will not be extremely high and speed of communication will not be the issue – aiming at symmetry can also have a great disadvantage. A symmetrical, centred arrangement of visual elements, also known as a bull's eye composition, immediately directs the eye to this centre, holds it there and thus makes it less likely to explore the rest of the image [2.12]. This effect is demonstrated in the eye-tracking examples of the centre perspective earlier on in this chapter.

Especially if the object at the centre of the image has little complexity or when no other compositional elements invite eye movement, the eye doesn't sense a distinct direction to follow. This causes the viewer to quickly be done with the image, losing interest in it and wanting to move on to another.

If you wish to keep the viewer's attention, or invite the viewer to examine more of an image than just its central subject, further action needs to be taken. Using an off-centre layout with the aid of, for instance, the Golden Ratio or the rule of thirds guideline has proven very helpful for creating interesting imagery and avoiding the static effect of bull's eye compositions.

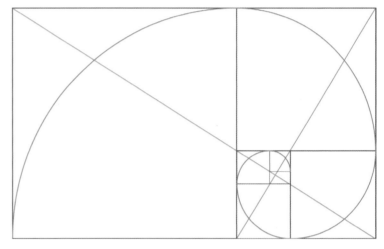

The golden ratio, or divine proportions Phi, represents an aspect ratio that has been found to be aesthetically pleasing to the human eye. These proportions are much-used in art, architecture and photography. The golden ratio has fascinated western minds for over 2400 years

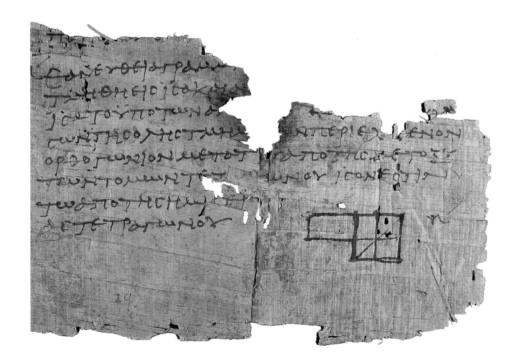

Fragment of Euclid's Elements, displaying the earliest recorded description of the Golden Ratio theory, Greece, approx. 100 BC [2.13]

*Example of
a bull's eye
composition*

*Example of
an off-centre
composition,
with golden
ratio lines
added*

A person not trained in visual composition
will generally take a picture that neatly
places the object at the centre. A trained
photographer, however, will often look for
an off-centre placement of the subject,
creating a more dynamic composition.

Some elements in an image carry greater weight than others; there is a hierarchy, or order

2.4.4 **Visual weight and balance**

As demonstrated in the previous section, elements of a composition can be made to stand out to a greater or lesser degree. Another way to approach this, is to say that all elements in a composition have a so-called visual weight. Some colours, for instance, are perceived as more dominant ('heavier') than others. A bigger sketch carries more weight than a small one, and so on. Various kinds of visual aspects can alter the visual weight of an element.
The aim is to balance these elements.

Measuring the visual weight of all elements in a composition, visual balance can basically be achieved in two ways. The traditional option is symmetrical balance. This is also known as 'formal balance' or 'classic balance', because of the significance of symmetry in Greek and Roman architecture. It generally has a stable and permanent feel to it, and is associated with classic or traditional.

In the sketch of the red coffee maker, the viewer is attracted to the red section in the middle, which holds his/her attention. The viewer is not automatically encouraged to explore the rest of the image. Nonetheless, this exploration will most likely take place anyway, but not automatically (or smoothly), and it has to be initiated by the viewer. Luckily, the sketch is not 100% symmetrical, so there is some tension there.

Another way to achieve balance is known as asymmetrical balance. This creates a more dynamic appearance. It is associated with movement and may be more appropriate for an innovative context to product design. In the example of the blue handheld device the visual weight is distributed unevenly across the composition and the focal point is not at the centre, but has shifted to the left.

p. 25

p.192

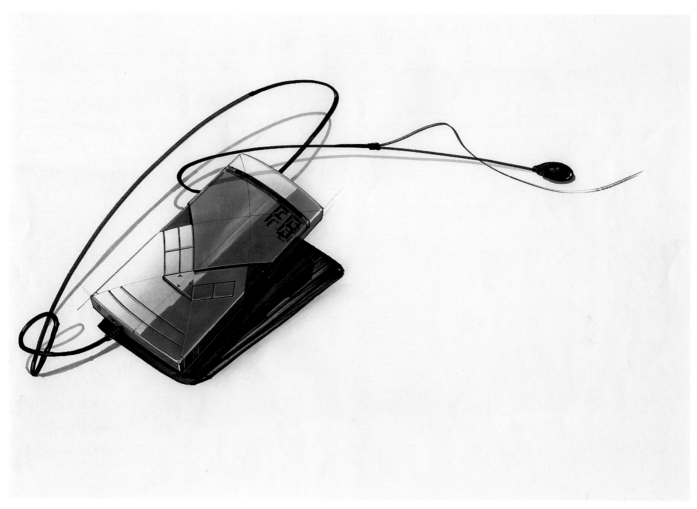

*Example of asymmetrical
balance*

*Example of symmetrical
balance*

Example of imbalance: top-heavy and depth conflict

More balanced

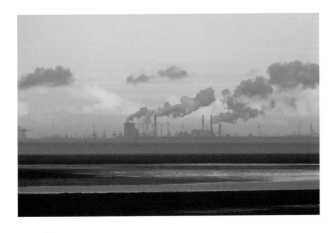

Depth

If an overall image or presentation is visually unbalanced, it may have an uneasy effect; things seem to be falling, there is too much positioned to one side of the image, etc. In the upper left sketch, an imbalance is caused by a conflict in the depth perception of the composition. The focal point is positioned towards the back of the image field and not nearby, towards the front, where we would expect it. The plan views are associated with distance, whereas the perspective sketch is associated with proximity, which makes it more appropriate to place the perspective sketch lower in this composition. The warm background colours, which are associated with proximity, and the cold background colours, which are associated with distance, now also better match the layout of the sketches.

Visual weight in terms of colour, contrast, size or other visual aspects is one thing. In addition to this, the meaning of an element to the viewer is also significant. A certain visual element – say an image with a dominant meaning – can be displayed very small in comparison to the rest, but still attract attention because of its significance. For example, a face, a text, or – even stronger – something related to sex or danger, appealing to the old brain, can be very effective.

Top-heavy

A commonly occurring visual imbalance is known as top-heavy. An unbalanced image is referred to as top-heavy when it displays excessive colour fields or too dark colour values in the upper section of the image. This evokes uneasiness as it opposes our natural view of the world, in which the sky above us is always brighter, even on an overcast or gloomy day.

It feels more natural to have darker colour values in a lower section of the layout, the subject below the middle and the brighter colours above. The arrangement of tonal values as observed in reality can be applied in a similar manner to sketches.

p. 191

Lighter parts higher in the composition and darker, heavier parts lower in the composition, achieving more balance than the other way around

Example of imbalance: top-heavy

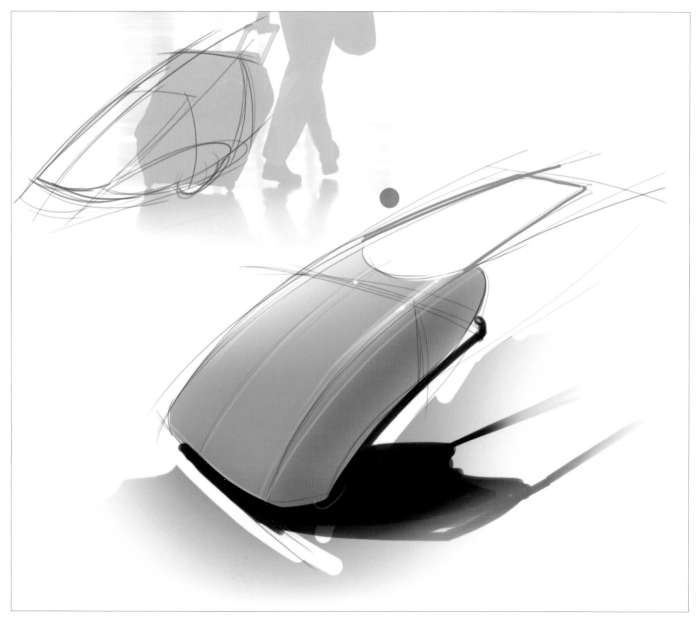

2.5 **Colour and unity**

Colour can play a significant role in creating visual unity and balance. In visual experiences, (colour) harmony is pleasing to the eye. It engages the viewer and it creates an inner sense of order and a balance in the visual experience. When an image is not harmonious, it's either too simple or too chaotic. Either way, the viewer will not stay engaged, as the brain tends to reject inharmonious images [2.14].

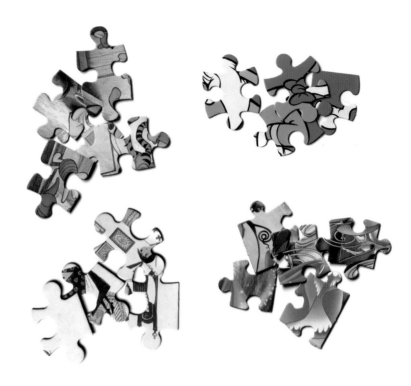

In this example, the pieces of the puzzle are matched according to colour balance (palette). If you would place one piece in another group, you would experience a mismatch.

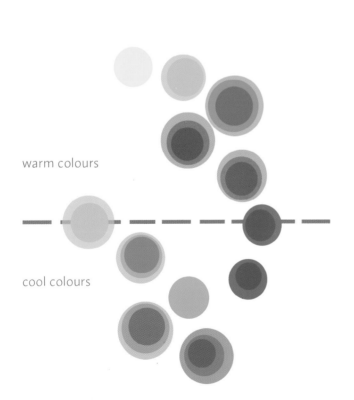

warm colours

cool colours

Visual weight and colour

The more a shape's colour contrasts with its background, the heavier its visual weight becomes. This applies to all 3 aspects of colour: hue, value or saturation. In general, a saturated colour attracts more attention than a less saturated one.

This may explain why you should be careful in combining saturated colours, as they may all attract much attention, visually interfere with each other and increase eye fatigue.

Simultaneous contrast

How colours are perceived is strongly dependent of the context and surrounding in which they are seen. Colours in proximity to each other affect each other. The sketches displayed here demonstrate this effect. In each of the settings the objects are of the exact same hue and value, but altering the background colour affects their visual weight, changing which of the shapes attracts the most attention.

Depth

Colours that we call warm are the ones we associate with heat; sun, fire, glowing metal, etc. Yellow, orange and red are examples of warm colours. Cold colours are associated with coolness; blue-green, blue, indigo. A visual effect is that we tend to perceive warm colours as nearby, and cooler colours as further away. An effective use of warm and cool colours can enhance or create a feeling of depth. In the sketches of the heat gun, the colours are used to create more depth and focus.

Here the sense of depth associated with the colours is in conflict with the spatial depth of the objects. Although the (warm) red object is furthest away, its colour attracts the most attention and brings it to the front.

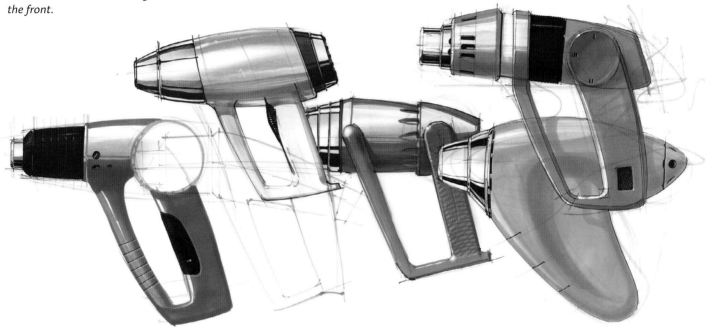

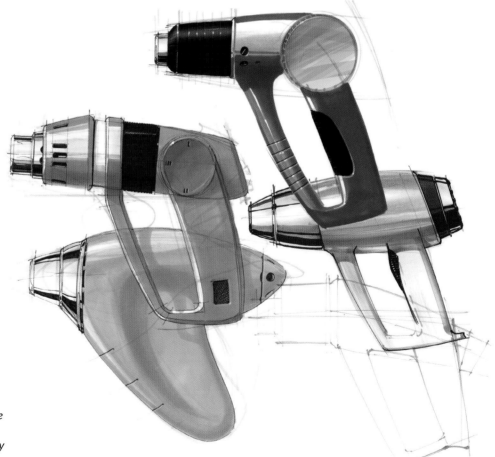

Using more saturated colours on the objects in the front enhances the sense of depth. Objects further away have less saturated colours.

Colour theory

In the much-applied Munsell colour theory, all colours are expressed in terms of their hue, saturation and brightness [2.15]. Using the colour theory can help you identify and choose a colour scheme.

Here are some widely used colour schemes to create unity:

– Monochromatic: 1 colour hue, various shades and tints.
– Analogous: colours next to each other on the colour wheel. Differences in saturation can be applied. This scheme is generally perceived as calm and serene.
– Complementary: colours opposite each other on the colour wheel. Generally, this is perceived as dynamic and active. Desert and sky.
– Triadic: colours derived from the colour wheel as a triangle. The best-known example of this is the primary colour combination, which is very appealing to children (Sony did this in their My First Sony product line).

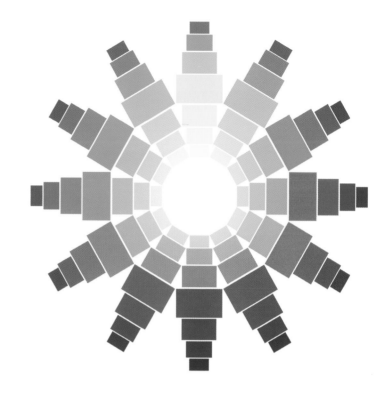

An image with an analogous colour scheme only has small colour contrasts. Of course, contrasts such as dark versus bright can exist when various shades and tints (or values) are applied. The image of the catamaran shape uses this colour scheme; the colour wheel next to it shows which colours have been used.

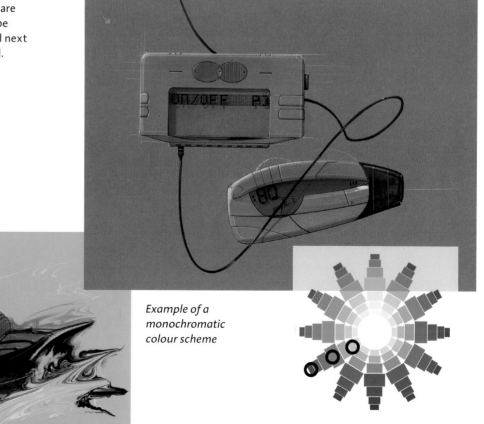

Example of a monochromatic colour scheme

Example of an analogue colour scheme

Tip 1
Natural colour schemes are generally perceived as harmonious.

Tip 2
Limit the number of different colours you use. Just 2 or 3 colours will suffice, after which you can play with their shades, tints or saturation.

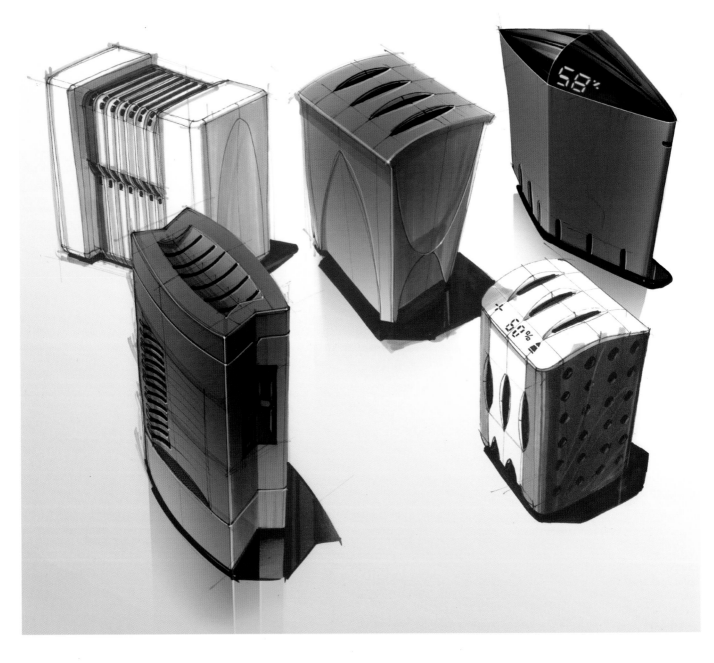

p. 89

p.125

Although it may not be obvious at first glance, the sketch of the shoe applies a triadic colour scheme. The green/yellow and blue are used in a less saturated shade or value. The background and the dark blue of the shoe are actually derived from the same hue. The red attracts most attention, as it is the warmest and most saturated colour.

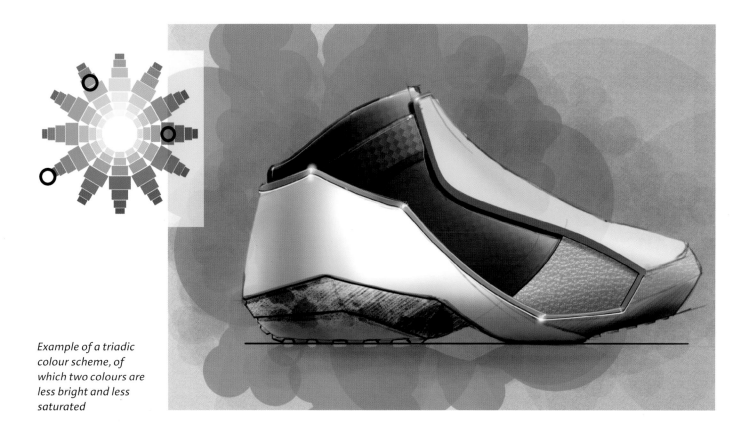

Example of a triadic colour scheme, of which two colours are less bright and less saturated

2.6 **Variety and complexity**

Many of the Gestalt Principles are about simplicity and unity. As stated before, the principles describe cognitive mechanisms involved in how we perceive information, and they are not meant as a ready-made solution regarding on how to present information. Knowing the principles of Gestalt just makes you aware of certain phenomena. These phenomena exist and can be made use of in different manners. The principle of proximity does not dictate that everything should be close together; the principle of symmetry does not mean that everything should be symmetrical. These principles only indicate that we are visually sensitive to proximity and symmetry. Much of this sensitivity can be connected to our evolutionary background. We use Gestalt in our daily lives to quickly and better understand the complex world around us.

The application of Gestalt Principles is therefore not an absolute must, but has to be put into perspective. Sometimes, a bit of sinning can cause surprising effects. However, in order to do so, you need to know what principle you are breaking and what effect this will have.

Variety and complexity are the opposites of simplicity and unity, yet necessary ingredients in visual communication. Without variety and complexity, images may end up static or uninteresting visuals. At its extreme, simplicity will disengage the viewer, leading the human brain to reject under-stimulating visual information. However, too much variety won't work either; a presentation can become overwhelming, overdone, and so chaotic that it also disengages the viewer, similarly leading the human brain to reject what it cannot organize or understand [2.13].

Using the Gestalt principles, we identify and derive patterns from realistic images, which our brain compares with what we know. It takes the brain some effort to distinguish the relevant information from the visual 'noise'. If we present the brain with orderly, simplified visual information, we actually save the brain some work. This workload of the brain is also known as cognitive load. The cognitive load that is caused by visual communication needs to be balanced. Therefore, there is a difference in our approach to complex visual information and simple visual information. Overly complex compositions need to be organized and benefit from a visual hierarchy, whereas overly simple compositions need to be made more interesting.
In addition to Gestalt principles, colour also has a big influence.

The previous chapter on our brain demonstrates that people not trained in visual composition or accustomed to processing visual information tend to be more attracted to viscerally positive images, whereas visually educated and trained people tend to find more quality in subtle colours or manipulation of visual balance. Deliberately presenting a slight tension in a visual invites viewers to fill in the gaps and gets them more involved. By doing so, you can create the right kind of tension: dynamism.
You will find a similar development in the evolution of visual language (from classic symmetry towards asymmetrical balance), as well as in a person's learning curve during which he or she first sticks to e.g. symmetry and eventually explores and appreciates more subtle balances found beyond.
So the manner in which visual information is perceived (and thus the manner in which you present visual information) also depends on the audience the image is presented to, which brings us to the next chapter.

References

[2.1] Cairo, Albert, The functional art, NewRiders, 2013

[2.2] www.read.uconn.edu/PSYC3501/Lecture02/-prof. Heahter Read

[2.3] Yarbus, Alfred L., Eye movement and vision, 1967

[2.4] www.psychology.about.com/od/sensationandperception/ss/gestaltlaws_3.htm

[2.5] Cooper, G, Cognitive Load theory as an aid for instructional design, paper in the Australian Journal of Educational Technology, 1990

[2.6] www.quicksprout.com/2013/08/01/7-conversion-optimization-lessons-learned-from-eye-tracking/

[2.7] King, D. Brett, Max Wertheim & Gestalt theory, Transaction Publishers, 2006

[2.8] www.andyrutledge.com/gestalt-principles-3.php

[2.9] www.facweb.cs.depaul.edu/sgrais/gestalt_principles.htm

[2.10] www.blog.xlcubed.com/2008/05/gestalt-laws-charts-and-tables-the-way-your-brain-wants-them-to-be/

[2.11] www.interaction-design.org/encyclopedia/gestalt_principles_of_form_perception.html

[2.12] Ensenberger, Peter, Focus on composing photos, Elsevier, 2011

[2.13] www.math.ubc.ca/~cass/Euclid/papyrus/papyrus.html

[2.14] www.colormatters.com/color-and-design/basic-color-theory

[2.15] Munsell, A. H., A pigment color system and notation, 1912

fuseproject, California

Nivea design language and packaging for Beiersdorf AG, Germany

Design Case

"… Nivea is an iconic company, and it has been so for 100 years. Affordable skincare for everyone, on a global level, was unlocked by Nivea's invention of a natural emulsion (that made the cream last on shelves and at home), and its revolutionary blue tin packaging.

Nivea invented skincare for all of us, and grew to the ubiquitous presence it has on store shelves, with 1600 products in 170 countries, and in the lives of 500 million women who use a Nivea product each day. With this success came some brand and design confusion as well: too many packaging forms, too many brand expressions, and too many graphic languages.

Nivea came to fuseproject because of our record of innovative sustainability efforts and the work we have done in design-led brand transformations. But for design to be truly effective, it must be deeply integrated into all levels of the development process. To accomplish this, fuseproject collaborated closely with an internal Design Management team that was established at Beiersdorf to outline a comprehensive design strategy and a cohesive design language that would define NIVEA.

With more than 200 people involved, the Design Management team included all departments at Beiersdorf – from marketing to sales, packaging development to supply chain. As strategic partners, the team worked with fuseproject's experts in design and innovation to formulate a design brief with clear, shared objectives focusing on renewing all aspects of the NIVEA brand.

How can Nivea simplify a proliferation of shapes and logos on shelves? How can we create and edit bottles, tubes and jars to an efficient set of essential designs? How do we rethink the logo and graphics across the entire portfolio? How do we use design to reach sustainability goals now and in coming years?

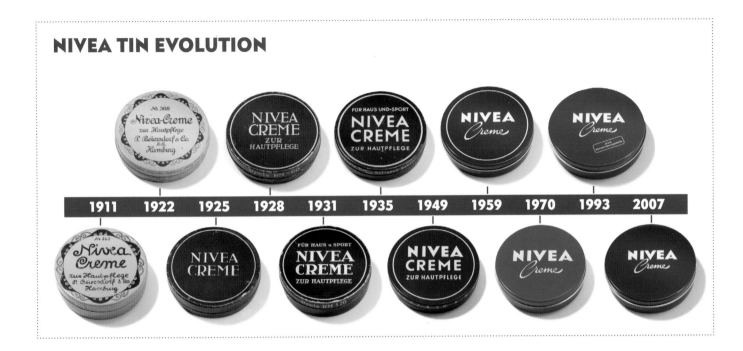

NIVEA TIN EVOLUTION

1911 · 1922 · 1925 · 1928 · 1931 · 1935 · 1949 · 1959 · 1970 · 1993 · 2007

These questions approached the idea of design with the right goals. At the same time, considering the size and complexity of a global operation, these issues take on a different scale of difficulty and become a very real challenge. On the fuseproject side, an important set of questions is often on our minds: What is the role of design in a mass-market environment? How do the design intents of efficiency and sustainability, of uniqueness and emotion survive when mixed with complex operational, logistical, marketing and deployment demands?

Our early thinking was to reduce the complexity of the current form languages, edit the numerous packaging types to a minimum set and eliminate the proliferation of logo variations and typographic expressions.
We believe simplifying the Nivea visual language will offer a stronger and clearer expression of the brand values. We based the design and graphic language on solid ground: the heritage tin and its classic white Bauhaus-era lettering.

Caps and closures are rethought in the blue Nivea color, with the redesigned logo embossed on the material. Top areas are given an angle facing the customer, a gentle slope reminiscent of a hand offering a service. This branded design element has a dual purpose: to anchor the Nivea graphic on the bottle and to increase brand recognition on the shelf.

The symmetrical 3-D forms have wide bases for stability, with a pure geometry that joins the closures as perfect circles. Finally, the Nivea circle logo was sized to be the icon it deserves to be: un-mistakable and beautifully balanced. We "recognized its iconic status and refined what was there," says Steve Heller, the respected design writer and historian.

Extensive market research was used to test and understand consumer reactions. It was crucial to know if the new packaging design conveyed the NIVEA brand values, achieved the goal of easy recognition, and was a successful visual experience. That information helped the team devise a smooth timetable for the introduction and transition of the new design language in each category.

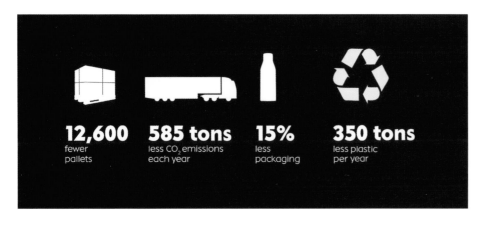

80% non-fossil ingredients

23% less label material usage

The opportunity for material reduction and sustainability has been followed throughout the design process in close cooperation with the NIVEA team. The drastic reduction of bottle and packaging shapes has created new efficiencies within the company. At the same time, the geometry of the new design allow for improved functionality and less material used overall by up to 15%. The weight reduction of the packaging combined with a label reduction of 23% (by switching to a different material and liner), as well as transportation optimization due to tighter packing are contributing to the overall 2020 goals of Beiersdorf to reduce its carbon footprint by 30% per product. In addition, all

materials used are fully recyclable and all formulas have an average of over 80% non-fossil ingredients.

And this is just the beginning. The new design language and logo will be applied to 1,600 products and to as many as 13,000 country adaptations, in partnership with the Nivea Design Management team. Nivea will continue to build on its century of history, its Bauhaus heritage and the belief that design is both the company's past and its future..."

Then and Now, Nivea Design Continues
—Yves Behar, Design Director at fuseproject, CA

Waarmakers, the Netherlands

Be.e; frameless biocomposite electric scooter

The objective of this project was a production-ready, improved version of Vaniek Colenbrander's graduation project in 2008 at the Delft University of Technology, the Netherlands; a frameless scooter with a monocoque frame of flax and bio-resin.

This project was set up as collaborative team effort of various parties: Inholland University of Applied Sciences, Nabasco-NPSP Composites, Van.Eko (electric scooter firm) and Waarmakers. In this set-up, Inholland students were involved in the project as part of their curriculum.

We took a design brief made by Inholland students as a starting point. However, considering the innovative nature of the biocomposite frame, a more thorough design was made instead of just restyling, as the briefing suggested.

Initial sketches were made on A3 paper

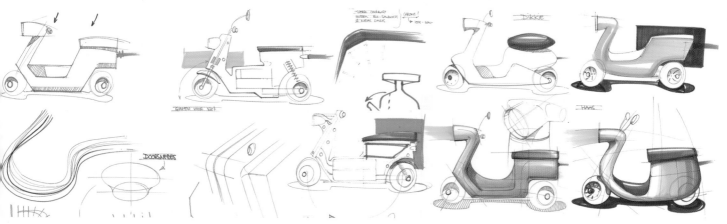

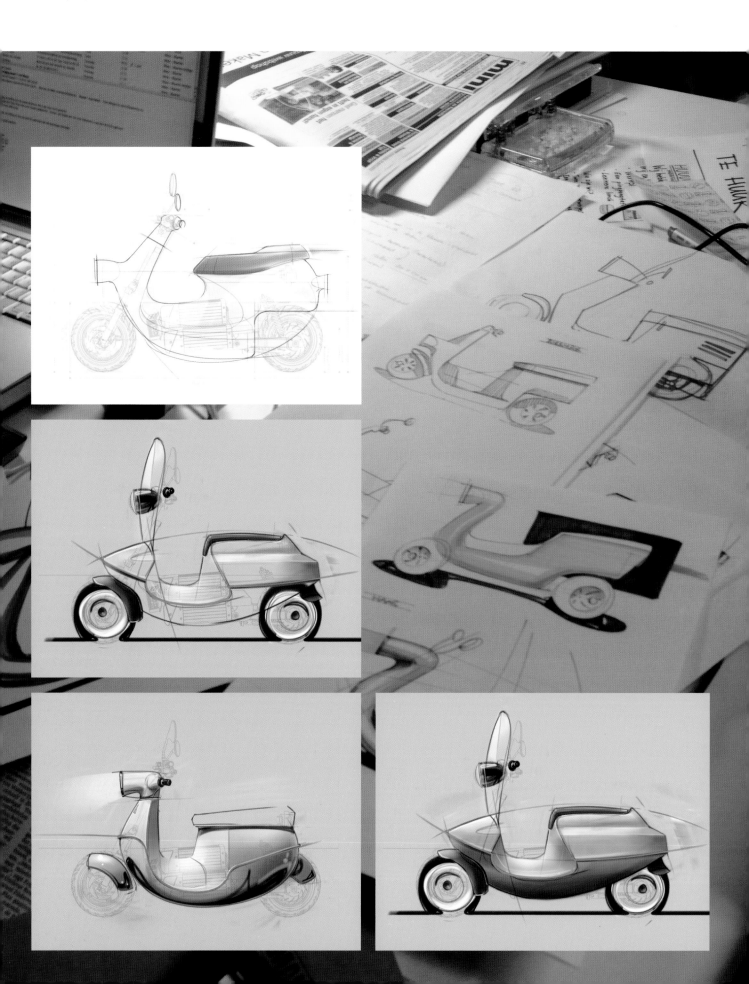

After initial exploratory sketches, we made digital sketches of various concepts, using a technical drawing as an underlay. This way, the viewpoint, size and level of detailing for the various sketches could easily be kept similar.

In our first presentation, the concept presentation, we had to convince the team of our more thorough design approach.
We showed 4 concepts: the Sandwich, our favourite and most extreme in its shape, communicating the innovative material used for the monocoque frame; the Torpedo, which has a more exciting and defined shape; and two 'safe' options: the Panda X and the Barbapapa, both quite close to the original starting point, but highly adaptable to changes.

We received an OK on the Sandwich and the Torpedo, and after a follow-up feasibility study, we chose to further develop the Torpedo design.

NOTE: In the concept presentation initial sketches were shown, as well as reference images concerning style and production methods.

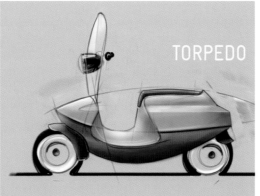

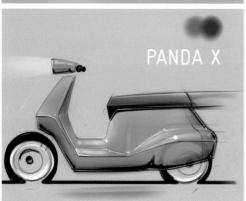

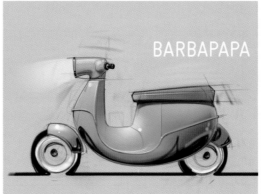

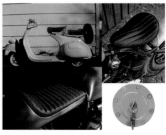

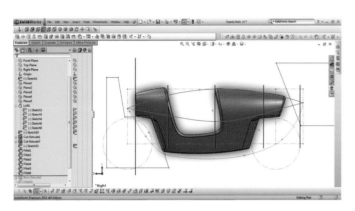

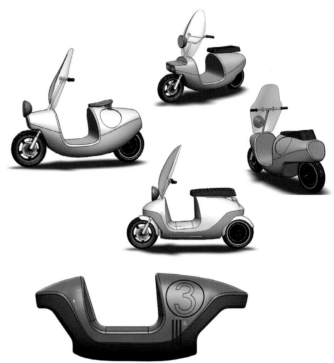

After the concept selection, we were given carte blanche. This being a non-commercial project, we were completely free in our design and styling from this point on. There was, however, limited time and there were no group presentations during the technical evolution and styling of the frame. The images above and to the right were solely used for internal communication, to keep track of our progress and to discuss design issues.

During the process, two things increased in importance to us. First, the need to express the innovative material of the frame as being a biocomposite. Second, we had the impression that the innovative frame would be more easily accepted by future users as a fully mature scooter if the add-ons – such as the saddle, steer, lights, etc. – would have a conventionally luxurious feel to them. We opted for a good combination of conventional and innovative. Renderings such as seen below and on the opposite page were made from CAD drawings to communicate such details to the team, and to convince them of this necessity.

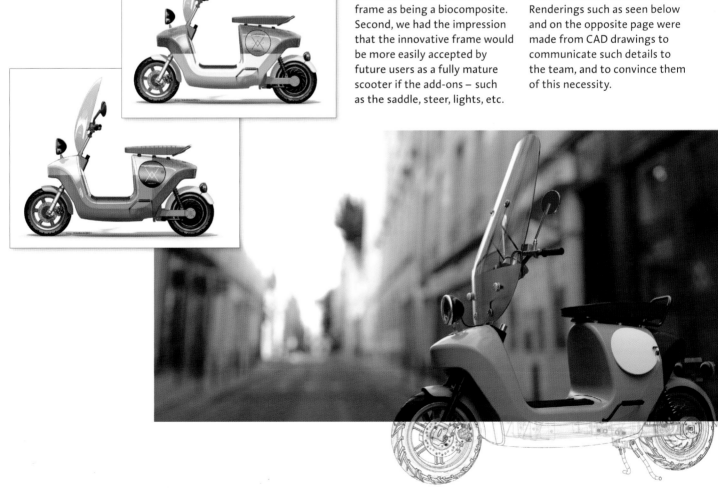

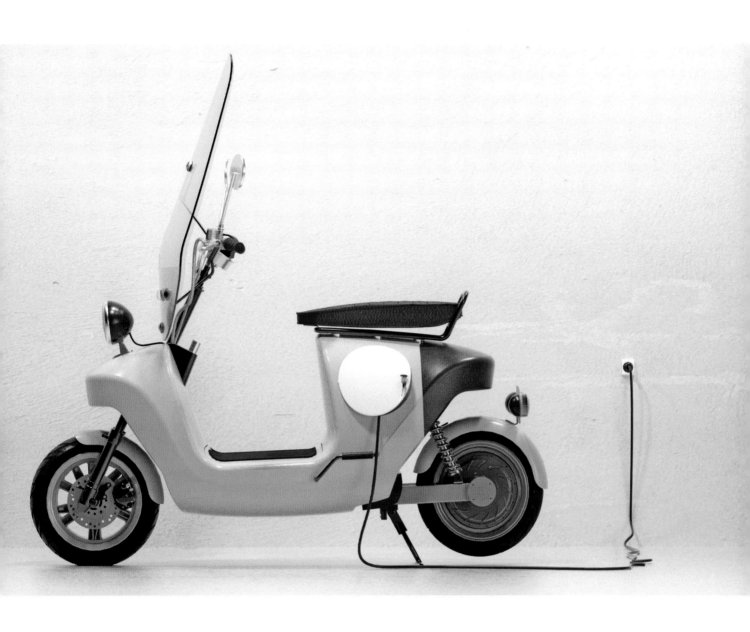

NOTE: At the time of these images, the design existed as a CAD rendering. By placing a design in a photographic context and spending time on creating suitable reflections and shading in combination with this realistic background image, the design will be perceived as part of our real-life world, instead of being a not-yet-existing idea. Adding realistic background images can create a mood. The line drawing added below the rendering on the opposite page serves to give it yet another spin; it makes the image stand for the transition of the idea to reality as well.

WAACS Design, the Netherlands

My Grip
for Bruynzeel

The My Grip school pen is created not only for, but also with children. It combines the best of both worlds: both the ideal ergonomic grip (developed with writing experts), and a design that invites the children to share and self-express.

When using context mapping as a design tool, it is important to recognize the quality of the individual assessments and proposed ideas. Therefore, a selection of questionnaires was shown to the client during the analysis phase, in order to communicate the insights found.

During a context mapping-based analysis, young children were first asked to assess their own school pen and then to 'design' their own ideal pen. WAACS Design created a survey sheet on which the children could write and sketch their ideas. Several general aspects were distilled from this survey and served as a design brief for the project. The design team then started sketching together, making preliminary translations of the children's sketches and finding insights into pen design. These sketches were used for internal communication only, to explore and discuss several possibilities.

To highlight certain special features for each sketch proposal, text was added to the drawings. The main focus point was to quickly explain the story without spending too much time on details and create a broad range of ideas.

NOTE: The 'tails' on the sketches of the pens display familiar characteristics or associations with animal-like shapes. This is a very direct (iconic) way to semantically represent 'animals'. Children are much more sensitive to semantics at a direct, iconic level, than they are to indexical or symbolic connections in semantics.

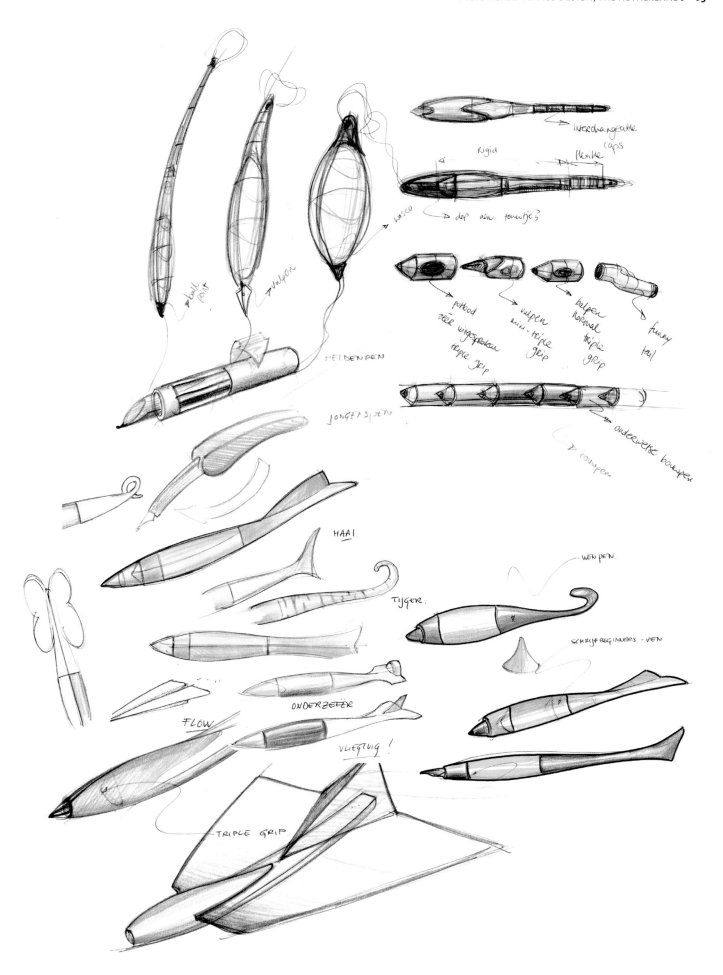

Concept sketches

Six concepts were derived from the sketch phase (of which several are depicted in this case). These were presented to a group of representatives of the client, who were mostly marketeers. The main focus was on concepts that sell.

NOTE: how consistent the several concepts are in the detailing and layout of each concept slide. The concept sketches are more realistic than those for the previous phase, suggesting the next step in the design process. At the same time, the photos and other images combined with these sketches vary. They serve to highlight the unique and strong aspects of each individual design.

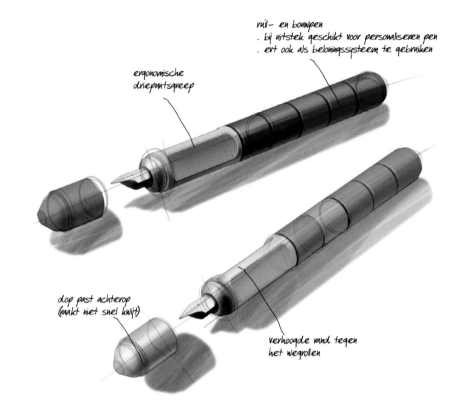

ruil- en bonuspen
. bij uitstek geschikt voor personaliseren pen
. evt ook als beloningssysteem te gebruiken

ergonomische
driepuntsgreep

dop past achterop
(raakt niet snel kwijt)

verhoogde rand tegen
het wegrollen

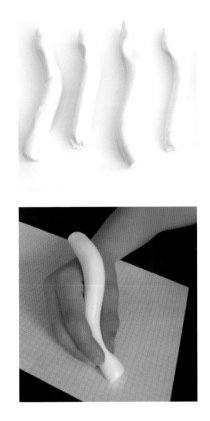

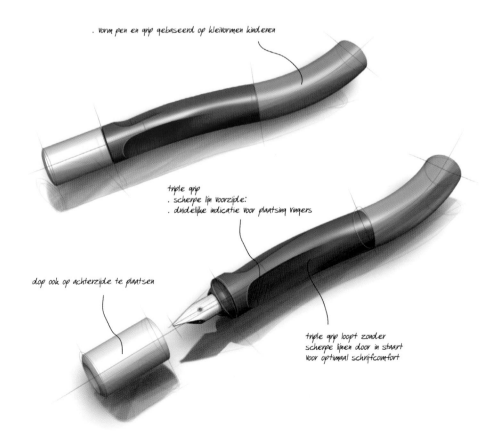

. vorm pen en grip gebaseerd op kleivormen kinderen

triple grip
. scherpe lijn voorzijde:
. duidelijke indicatie voor plaatsing vingers

dop ook op achterzijde te plaatsen

triple grip loopt zonder
scherpe lijnen door in staart
voor optimaal schrijfcomfort

By using a neutral layout and concise texts, the self-explanatory sketches pop out. They served as a means for starting a dialogue between the client and the design team, and together deciding on a direction for the next steps. In this case, this led to a concept direction that combined the best aspects of three concept proposals. The main shape was based on clay studies with children; the product parts were based on collectible elements, which also serve as building blocks and caps.

NOTE: Each of the concepts was presented separately in a similar manner. The layout was kept clean and well-organized, using a bold printed title at the top and clear typed texts near the sketches. Combining perspective and side views of the designs results in a rich viewing experience; the perspective sketches generate appeal with their viewpoint, colour and contrast with the shadow cast, and therefore serve as a focus point; the side view sketches fulfil a supporting role.

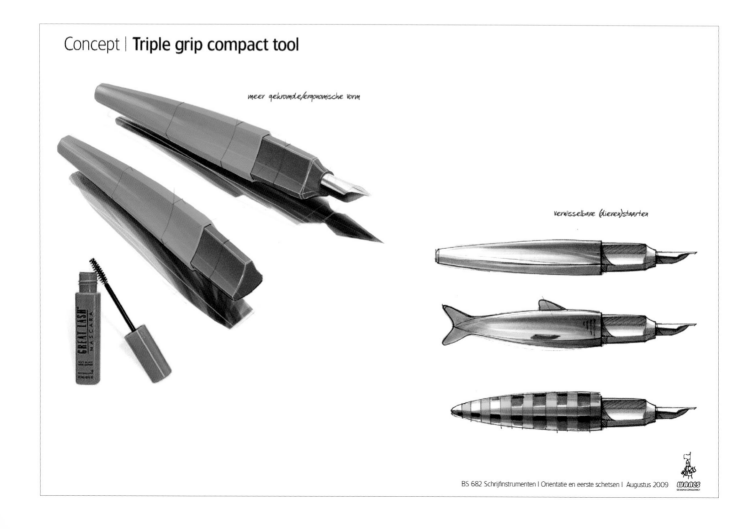

Concept | **Triple grip compact tool**

Concept | **Triple grip compact tool**

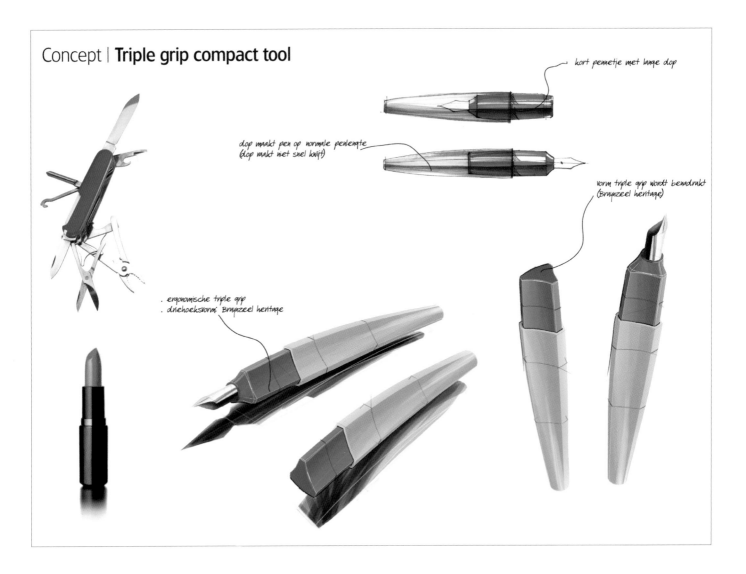

kort pennetje met lange dop

dop maakt pen op normale penlengte
(dop maakt niet snel kwijt)

vorm triple grip wordt benadrukt
(Bruynzeel heritage)

. ergonomische triple grip
. driehoeksvorm Bruynzeel heritage

This image was used during the concept design phase to illustrate that the chosen proposal is technologically feasible and in compliance with safety regulations. These matters are often tested in CAD and therefore presented in a clean and explanatory no-frills rendering to the client.

NOTE: an example of applying the logos approach from visual rhetoric, which is discussed in chapter 4.

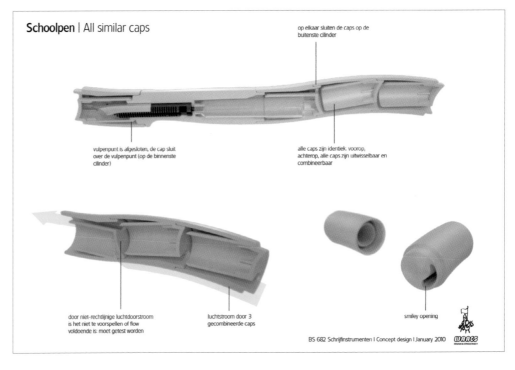

Schoolpen | All similar caps

op elkaar sluiten de caps op de
buitenste cilinder

vulpenpunt is afgesloten, de cap sluit
over de vulpenpunt (op de binnenste
cilinder)

alle caps zijn identiek. voorop,
achterop, alle caps zijn uitwisselbaar en
combineerbaar

door niet-rechtlijnige luchtdoorstroom
is het niet te voorspellen of flow
voldoende is: moet getest worden

luchtstroom door 3
gecombineerde caps

smiley opening

BS 682 Schrijfinstrumenten I Concept design I January 2010

A combination of rendering and digital sketching was used for presenting a retail display for the My Grip pens. Utilizing the existing CAD model for the new school pen ensures realistic dimensions for the display. Since the illustration is used for presenting a retail concept, the choice was made not to render the display itself but present it as a sketch.

A neon colour range was presented to marketeers at Bruynzeel as a potentially interesting colour concept that responds to the latest kids' fashion trends. In addition, a packaging was designed and illustrated, referring to the twisted and dynamic shape of the My Grip pen. A high-quality photo-realistic product rendering was used as the icing on the cake.

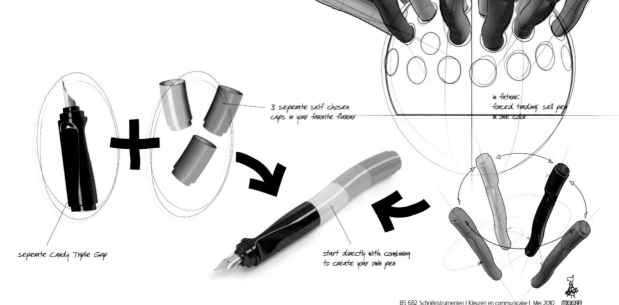

NOTE: The fluorescent choice of colour with a limited palette suits the young user public of the pens well. The colour palette reflects the teenage culture context and has the advantage of being particularly eye-catching in a shop.

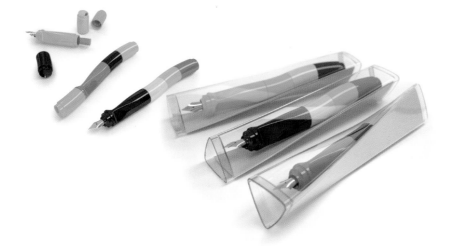

CHAPTER THREE
Visual Semantics

"To visualize is to make certain phenomena and portions of reality visible and understandable; many of these phenomena are not naturally accessible to the bare eye, and many of them are not even of visual nature" – Joan Costa [3.1]

All visual information appears to refer to one meaning or another. This meaning will not be the same for everyone, as it depends on factors such as age, profession or cultural differences. Especially in this era of global entrepreneurs, it is important for a designer to be aware of this. Visual Semantics is a field of study that investigates the connection between visual signs and the things to which they refer, i.e. their meaning. This chapter will clarify terms such as icon, symbol, archetype and metaphor, as well as discuss the approach of two of the founders of Semantics: the American philosopher Charles Sanders Peirce and the French philosopher Roland Barthes.

3.1 **Introduction**

People get familiarized with visual signs such as traffic signs, icons, pictograms, etc. throughout their lives and learn to use and identify them. In general semantics, elements that carry or represent meaning are called signs, or signals. This can be a word, a sound or an image. For our purposes, we will consider visual semantics only. For example, the signal is an abstract image of a petrol station, the referent is the actual petrol station.

The meaning we attach to a sign may not be evident to everyone; it is one that 'we' have agreed upon. 'We' can stand for 'people', 'young adults', 'marketers', 'vegetarians', 'Chinese', 'obese children', 'war victims', and so on. Obviously, a certain visual sign will not evoke the same meaning for all these different groups of people. Thus, to understand semantic meaning you have to be aware of a certain set of conventions and codes. Some cultures have different conventions than others, and some people are better at them than others. Additionally, in time, a certain meaning can shift.

3.2 **Some terms in semantics**

Semantics involves terms such as metaphor, symbol, sign, icon and index. To get started, we need some of these explained so we can be sure we are referring to the same thing.

Archetype

Some signs are applied globally, such as traffic signs. Visual signs can be very helpful, as they can be understood independently of language and can be used to transcend cultural codes. A specific category of signs is broadly used for this, namely archetypical signs.

We call something an archetype, if it embodies the fundamental characteristics of something. It is like a prototype of something, a 'standard example' or 'basic example', from which others are copied. It is an image that is universally present in individuals.

A sign, or 'signal', and its referent

Old and new archetypical abstractions of vehicles

Archetypes are meant to be universally clear and easily understood. In traffic signs you will find various archetypical representations. If you travel around the globe, you may find yourself slightly off balance by the differences in traffic signs, as each culture may use another representation of 'vehicle', but they will generally be understandable. These archetypical images will slowly change over time, for instance, as its referent evolves due to innovation.

Another area in which images are used to transcend cultural differences is that of Internet icons; universally understood and independent of language.

As times change, new archetypes are formed. For instance, they may come into existence at the Olympic Games in Rio de Janeiro, as it will be the first time that all Paralympic sports are captured in pictograms.

Paralympic sports pictograms of the Olympic games 2014 in Rio de Janeiro, Brazil

Various archetypical images and their referent

(Arche)typical sketches

Much can be read from a drawing. For instance, a product designer makes different kinds of sketches than an architect or an artist. Sketching is regarded a part of product design and can carry meaning as such. Sketches made at different stages of the design process can be distinguished fairly easily, just like archetypical sketches.

Sketches in a portfolio can be read as signs referring to specific phases in the design process, or in general to the field of product design.

Car design sketches usually are very recognizable as such. Not just because of the subject, but also in terms of look and feel; for their strong emotional appeal. Words such as beautiful, suggestive, dreamy, futuristic are often used by people to describe them.

Many car design sketches need to allure more than that they have to convince their audience on a functional level. They may express more of a feel than a look. They may carry you into an imaginative future. Might they look more futuristic because of the fact that – in comparison to other industries – there is generally a longer time period involved in the automotive sector before the car design goes into production?

Typical brainstorm sketches

p. 168

p. 129

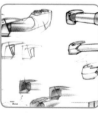
p.122

p. 25

Typical concept sketches

p. 185

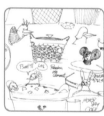
p. 163

p. 110

p. 85

p. 157

Typical in-house discussions

p. 160

p.188

p. 163

Brainstorm sketches

Some characteristics of these sketches are: a high level of diversity, little detail, hardly or no colour, scribbly, associative and intuitive.

Concept sketches

These sketches usually have more colour than brainstorm sketches, are less divers and stay within a certain (product) direction. They are exploratory and problem-solving in nature, analysing aspects such as usage, production or material, for example, whereas some other aspects of the subjects may already have been determined.

(In-house) discussions

This refers to sketches used when designers/team members discuss ideas together. An (informal) combination of sketches and text (scribbled thoughts or remarks) can be seen posted on a wall, for example. This kind of discussion often takes place in-house, or with a client with whom there is an established relationship.

Concept presentation

These sketches usually express or demonstrate feasibility, for instance in terms of production, material or usage. Several options are visualized in a similar manner, enabling an objective comparison and selection.

Further development

Similar to concept sketches in exploration and problem-solving, these sketches show more refined detail, exploring smaller variations than before, within a smaller range. This stage generally applies more realism and detailing.

Presentation sketches

These also communicate the design, expressing the look and the feel in a more elaborate or realistic manner than before. More detail and colour is added, and possibly a context as well. Presentation sketches are often created to convince, involve or allure the viewer, who may be from outside the field of design.

Typical concept presentation sketches

p. 123 p. 87 p. 110 p. 169 p. 191

Typical further development sketches

 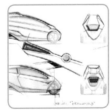

p. 172 p. 112 p. 158 p. 186

Typical presentation sketches

p. 173 p. 13 p. 126 p.24 p. 83 p. 155

External hard drives for Freecom and Vitality cookware range for Tefal by FLEX/theINNOVATIONLAB®

p. 167

In sketching, we can make use of archetypes as a reference to something that needs to be clearly or easily understood. Because of their generalising character, archetypes are highly suitable for referring to a context in an 'objective' manner (see Barthes, later on in this chapter).

Much-used examples can be found in product size references or underlying user contexts.

Archetypical products

If an innovative idea is not immediately understood due to its unfamiliar character, extra focus on these contextual aspects is required and we can use visual archetypes to do so.

If a product itself is not archetypical in shape, its communication may need to focus more on the explanation of very basic information, such as usage and size, than when it is a recognizable product.

However, if a product is archetypical in shape, this leaves room for other aspects to be communicated, without this leading to any confusion.

Non-archetypical products

p. 156

p. 189

Archetypes in products

p. 76

p. 132

Visual analogy

p. 82

A visual analogy is an image that shows similarity in some respect between subjects that are otherwise dissimilar. The operation of a computer presents an interesting analogy to the functioning of the brain, for example. [3.3]

A visual metaphor is a figure of speech that describes a subject by asserting that it is, at some point of comparison, the same as another otherwise unrelated object. A metaphor is a type of analogy and is closely related to other rhetorical figures of speech that achieve effect through association, comparison or resemblance.

The lion is a common charge used in heraldry. It customarily symbolizes bravery, valour, strength and royalty, since traditionally it is regarded as the king of the animal realm. You will find many examples of the lion metaphor in Western European countries. An example of this symbolism can be found in the coat of arms of Gelre by the 15th-century Huldenberg Armoury. What a difference it would make if you replaced them with four mice.

Visual metaphor

Gelre's coat of arms by the 15th-century Huldenberg Armoury

Coat of arms with 'cuter' animals

Car manufacturer Peugeot uses a lion in its logo for its brand identity

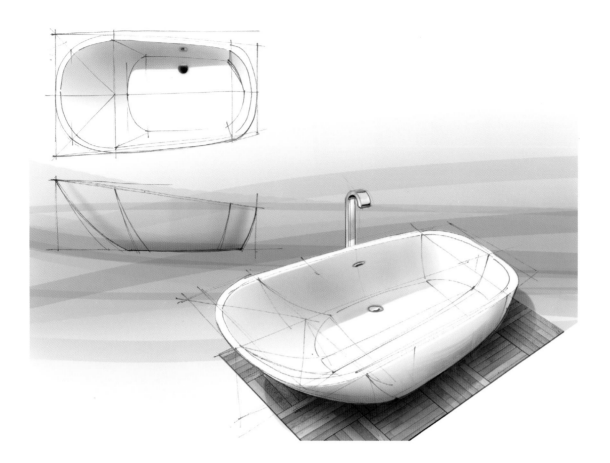

3.3 **Abstraction**

Somehow, our brain is able to understand
abstract images. The human race is one of
the rare species on earth that can do so.
This feature of our brain is greatly useful, as
we can present simplified visual information
to it and have it be understood.
In perception, the brain deciphers what
is sees and then compares this to what it
knows. We can actually save the brain some
work by simplifying visual data. Abstraction
is one of the means of doing so.

Abstraction in sketching
In the sketch of the bathtub above, the blue
coloured stripes hint at water, showing
abstracted characteristics of water. In
combination with the sketch of the bathtub,
our association is confirmed and we can be
sure that 'water' is referred to.

An image of a hand displays much more
information than a line drawing of a
hand. Even after having cut the hand free
from its surrounding, there is still much
to see in addition to the action the hand
is performing. We can see gender, race,
birthmarks, nail care, age, and various

Image of the Imagine Campaign for LEGO by Jung von Matt

aspects of the person whose hand is displayed. A line drawing of a hand can leave many of those aspects out, which focuses the attention more on the action the hand is performing.

It is exactly this advantage of a line drawing that makes it highly suitable for e.g. an instruction manual. In such a situation, the image aims to have the reader understand the action that is displayed; unnecessary information ('visual noise') in the image will only distract from this objective.

When you have to make a choice between a picture or a line drawing, you need to ask yourself: do I need to show what it looks like, or how it works? Do I need to visualize a form or a mechanism? In the latter cases, abstraction will be more effective.

p. 120

p. 113

p. 188

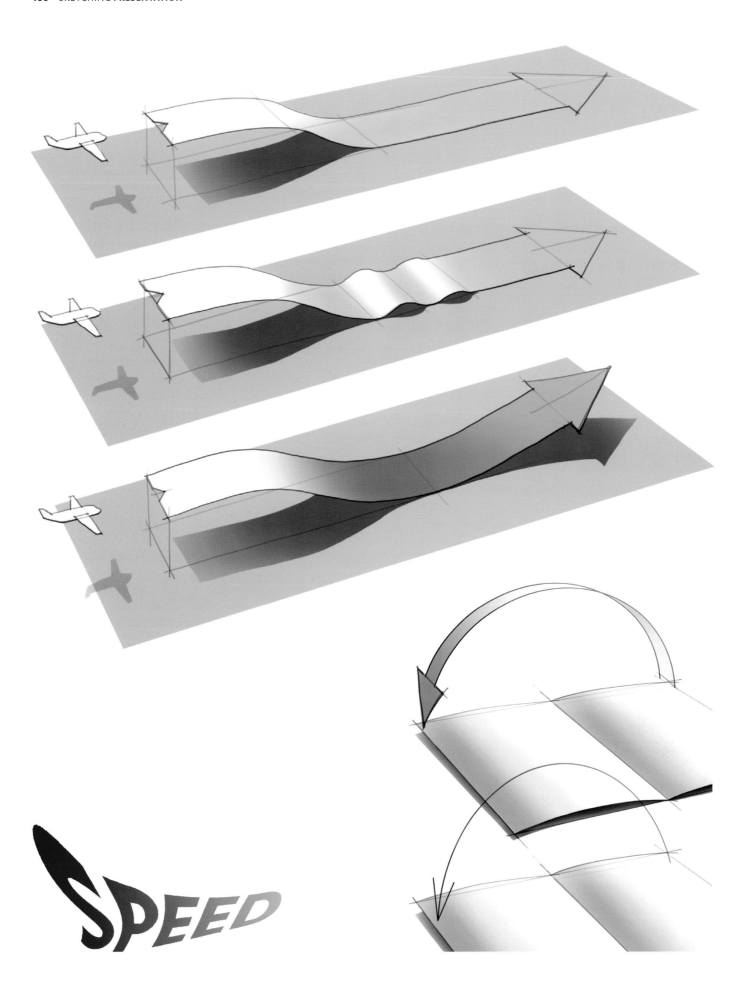

3.4 **Expressing motion**

Although a sketch in itself is static, we often do strive to depict motion or action. There are several ways to express motion, using arrows being a widely applied example. Arrows added to perspective sketches can also be sketched in perspective. This greatly enhances the sense of depth of that image.

Another method for depicting motion is the use of sequential steps, similar to those used in comic. The mind automatically fills in the gaps between the steps (Gestalt: continuity) and transforms the image into fluent movement, similar to a movie. Usually instruction guides and manuals are organized in this manner. Derived from this method, is an approach for which so-called 'afterimages' are sketched such as seen in the image on the left. Here, motion is suggested in one still. Yet another, slightly similar, method derived from this is sketching a 'motion blur' such as depicted below. Notice, however, that in both images the subject itself also expresses this motion; the skater by means of his posture and the object below by means of its form language, which suggests speed.

p. 113

p. 188

p. 152

3.5 **Charles Sanders Peirce**

There are two well-known approaches to semantics. One is that of Charles Sanders Peirce, an American philosopher who in the 1860s created a widely used classification system of how signs and their referents are related. He indicated that there are 3 manners in which signs stand for their referents: iconic, indexical and symbolic.

1 **Iconic relation**
In this case, the sign resembles what it actually stands for. It is a figurative relation; you can recognize the shape of the subject. This relation seen, for instance, in road maps (being a scaled version of a geographical area) or in instruction manuals using abstracted visuals of how to use or assemble a product.

In addition, pictograms such as those used for the Olympic Games fall into this category. In general, pictograms are an abstraction of reality used to convey a message in a simple and clear manner without language barriers. Pictogram has the Latin words image (picto) and language (gramma) in it.

Advertisement image of the Big movies, mobile size campaign for Vodafone by Scholz and Friends

p. 123 p. 24

p. 85 p. 115

Signs with an iconic relation to their referent

p. 117

p. 130

2 Indexical relation

In this case, the sign refers to something in an indirect manner, for example by association. A crystal refers to snow and a thermometer to temperature. But also many Internet pictograms, such as the envelop which stands for email, but visually refers to regular mail as we know it.

p. 116

3 Symbolic relation

These types of signs have a non-figurative relation to their referent; the visualization does not mimic reality. Instead, they are based upon agreement or habit; based on conventions.

Signs with an indexical relation to their referent

Signs with a symbolic relation to their referent

Semiotic moments

Peirce also spoke of 'semiotic moments', stressing the fact that there is a 3-fold relation to be identified among the sign, its referent and the interpretant (he/she who interprets). He thus pointed out that the context in which we perceive a sign is also very relevant. We are faced with traffic signs in traffic, for example, where they have a clear and understood meaning. Some relations work better in certain contextual situations. Of course, an iconic relation can only be made when the viewer is acquainted with the referent it stands for. However, usually – especially in communicating with people of one's own (sub)culture – iconic signs are the easiest to understand. This is why so many of them are used on the Internet. Symbolic signs require the most (insider) knowledge to be understood. When using images that represent meaning in a presentation, be aware of the levels of semantics indicated by Peirce. When using indexically or even symbolically related signs, be sure that your target audience shares the same conventions regarding the meaning of these signs.

3.6 **Roland Barthes**

In the mid-1900s, the French philosopher Roland Barthes approached Semantics from another point of view. He looked at the kind of meaning a sign can have for the viewer. He identified several layers of meaning. First off, he distinguished 2 different kinds of meaning: denotation, which is the explicit or literal meaning, and connotation, which is a commonly understood cultural or emotional meaning. One could say that denotation is objective and connotation is more subjective. These two types of meaning can then be further classified into a primary and secondary level.

Denotation
If we regard the image of the cyclist, we can apply these layers of meaning as follows:
1-primary denotation: "This is a Caucasian male cycling with trees in the background". This is a fact and a commonly shared knowledge.
2-secondary denotation: "He is cycling on a '90s Cannondale bike, which is quite an expensive bicycle". This is still an objective fact, but not everyone will know this.

Connotation
Here, again, we can distinguish two levels; primary and secondary. Connotations are subjective, different for everybody, and usually classified as either positive or negative.
3-primary connotation: A negative version could be: "He is showing off; it is not necessary to ride such an expensive off-road bicycle on the road". A positive version could be noticing the urban environment in the background: "He is using a sportive and environmentally friendly method of transportation in the city".
4-secondary connotation: "He looks like a colleague of mine".

As the levels of meaning get richer and move more towards the levels of connotation, the outcome or effect of the image becomes less predictable. The most important thing to realize here is that, in order to transmit the intended information, both the addresser and the addressee must apply the same code in a literal sense, but equally importantly regarding denotation and connotation conventions.

For instance, if you place a product in a context image, make sure not to communicate any unwanted extra connotation. This is particularly occurs when one's target group is not well-known, or extremely divers. A safe approach here is to keep the referents as primary as possible, which may mean archetypical.

However, if the viewer does understand the intended message up to level 3 or even 4, it will be a very effective one. An image with layered meaning is a rich image. The viewer may feel that the image is custom-made, or that he or she is particularly appreciated and part of an exclusive group of people. For this reason, large companies apply different marketing styles and commercials in different parts of the globe.

On the website of Flex/the INNOVATIONLAB® (below) we encounter product images, surrounded by line drawings that express the (user) context of the product. This is a functional context, archetypical in nature, which according to the Barthes approach would fit the primary denotation level nicely. It is direct and easy to understand by the target group of the website.

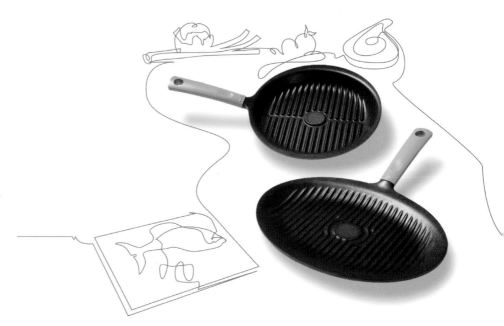

Logo of Apple Inc.

If we view the Apple Inc. logo in light of Barthes' theory, it is at both the denotation and the connotation level that we associate this image with some deeply rooted values in our (western) society. [3.15]

The apple itself stands for a widely known and available fruit, tasty and nourishing. Apple trees grow on fertile soil and provide nourishment. We all know what taking a juicy bite from an apple feels and tastes like, which brings back positive memories and may even be associated with a new and fresh start. That would be the denotation level.

Stepping into the connotation level, the apple has a special role in the biblical story of Adam and Eve. A bite from the apple led to the fall of mankind. Although this may sound quite negative, to some it also represents an admirable (positive) act of rebellion. In reality, the small Apple Mackintosh company found itself competing with the established IBM computers at its start and featured as somewhat of a rebel itself with its nonconformist approach to computer interfacing and architecture. Furthermore, the concept of eating an apple from the Biblical tree of knowledge combined with the product of a computer (and internet) actually makes this into a symbol representing a device that provides access to knowledge.
All in all, a very positive logo with quite some powerful associations.

p. 128

p. 122

p. 162

3.7 Colour and semantics

People react to colour on a visceral level; from their gut feeling [3.4]. Whether you embed your presentation in a colour scheme or use colour in a product, your viewer's first reaction will largely be subconscious, but will set the mood or emotion with which they receive the visual info. This also happens because colours may represent certain meanings. You need to make sure this associated meaning or emotion is an appropriate one. To be able to select a suitable colour scheme, it is important that you know your audience well.

For example: gold is understood to signify wealth virtually on a global level. White, however, could stand for purity, but also for death. Happiness could be signalled by white, but also by green yellow or red! [3.5] Ask yourself: Is your audience generally global, Chinese, Muslim, young, old, male, female, part of a subculture?

Do they share a certain field of expertise? Etcetera.
Before diving into colour as a representative of meaning, there is something else to be aware of. One cannot blindly state the meaning of a colour in a certain (sub)culture. The context in which the colour is displayed is also important. Orange in fashion may have a different meaning than orange in traffic or religion.
A colour can also be perceived differently due to the colour(s) it is surrounded with. Red stands out among shades of grey (and will attract extra attention), but to a lesser extent among other warm and saturated colours.
Colour combinations can have an even stronger association than separate colours. For instance, green and red representing Christmas, or black and orange for Halloween.

p. 157

p. 123

p. 116

p. 125

p. 89

p. 114

Other aspects that can change the meaning of a colour are, for example, class differences, climate, landscape, religion, aesthetic traditions or contemporary culture and trends, to name a few. Young children favour bright, more primary colours, whereas adults prefer subdued, less saturated colours. Each season also has its own colours. Each separate country may also have its own colour symbolism, such as green being a symbol of (Catholic) Ireland or orange being a positive colour in the Netherlands, referring to the Royal Family. The meaning of colour can also vary between subgroups: red is extremely negative in the finance sector, referring to so-called red figures, for example. [3.5] 'British Racing Car Green' is a dark green that stands for high-speed and high-performance cars. [3.14]

Yellow is the most visible colour of the spectrum, as the human eye processes the luminous colour of yellow first. Yellow is the colour of traffic signs and of caution all over the world.
Blue is the colour most favoured among western people. In addition, blue is quite probably the colour we have seen most often, as it is commonly associated with the sea, the sky, eyes and cold temperature.

Red is a colour of extremes. It captures attention and is among the most favoured colours of people globally. The Russian word for red is 'beautiful'.
The most common form of colour blindness makes it hard for people to distinguish between reds and greens, colours that are often used in western society to represent Dos and Don'ts (!). If you use these colours for colour coding, make sure you also use something else to distinguish between them, such as position, line thickness, shape, etc. [3.16]

The most well-known symbolic colour differences are those between different cultures. Let's consider western (Christian) (1), Chinese (2), Hindu (3) and Muslim (4) culture, representing four major religions on the globe, and what a colour can mean in each of these cultures. As stated earlier, the meaning a colour represents or is associated with has to be viewed in a more specific context. The image below is not meant to give a complete overview, but illustrates the colour semantics complexity by means of some remarkable global differences and similarities.

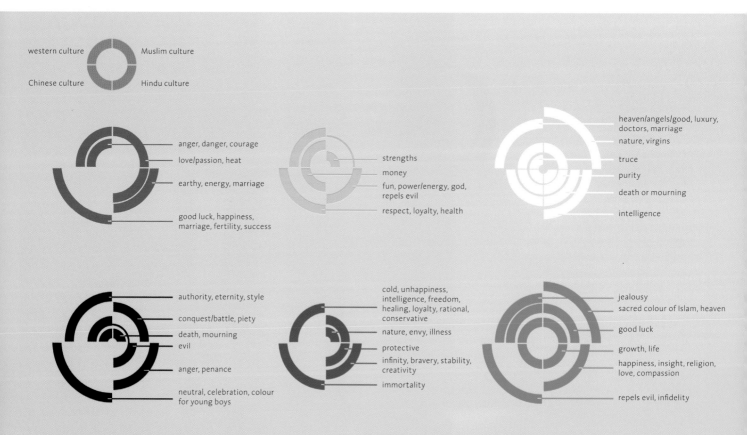

References [3.6] until [3.13]

References

[3.1] Costa, Joan, La esquematica: visualizar la informacion, Barcelona: Editorial Paidos, Colleccion Paidos Estetica 26, 1998

[3.2] Broek, Jos van den, Willem Koetsenruijter, Jaap de Jong en Laetitia Smit, Beeldtaal Persectieven voor makers en gebruikers, Boom uitgevers, Den Haag, The Netherlands, 2010

[3.3] www.graphicdesign.spokanefalls.edu/tutorials/process/visualanalogy/visanalogy.htm

[3.4] www.webdesign.about.com/od/color/a/aa072604.htm

[3.5] Weinschenk, Susan, Ph.D., 100 Things: Every Designer Needs to Know About People, New Riders, 2011

[3.6] www.informationisbeautiful.net/visualizations/colours-in-cultures/

[3.7] www.colormatters.com

[3.8] www.ccsenet.org/journal/index.php/elt/.../8353

[3.9] www.jesus-is-savior.com

[3.10] www.webdesign.about.com/od/color/a/bl_colorculture.htm

[3.11] www.wnd.com/2012/09/black-clouds-and-black-flags-over-obama/

[3.12] www.hinduism.about.com

[3.13] www.colourlovers.com

[3.14] www.colorvoodoo.com/cvoodoo2_gc_lookin.html

[3.15] www.library.iyte.edu.tr/tezler/master/endustriurunleritasarimi/T000560.pdf

[3.16] Cairo, Albert, The functional art, NewRiders, 2013.

Design Case

ArtLebedev Studio, Russia

Istanbul Isiklarius traffic lights for ISBAK

Commissioned by the company ISBAK and the municipality of the city of Istanbul, ArtLebedev studio designed a new traffic light from scratch.

Metaphor

The traffic light is shaped like an exclamation mark – an established sign for calling attention and stressing important points. Yet the object remains instantly recognizable as a traffic signal. Incidentally, Istanbul has tens of thousands of traffic lights today, which made this project all the more exciting.

The Isiklarius is the world's first traffic light to use signal panels based on the PHOLED (phosphorescent organic light-emitting diode) technology. The old Turkish word Isiklar stands for firelights indicating stops on caravan routes, called caravanserais.

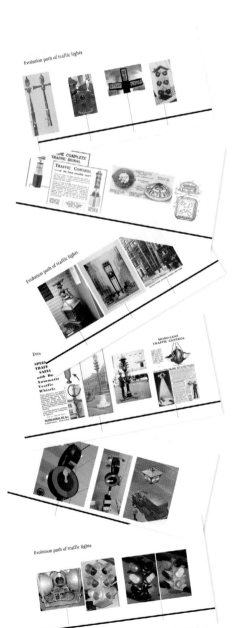

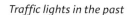

Traffic lights in the past

Possible traffic lights in the future

Traffic lights at present

*Studying GOST standards,
rules, and regulations*

The Isiklarius is equipped with a system developed in our studio that detects visually impaired and physically disabled pedestrians. It uses special icons on the signal panel to warn drivers when such persons approach the crossing. There is an audible signal for visually impaired people that also alerts other pedestrians and drivers. The traffic light has a modular structure, and can be mounted on a base with any profile or diameter. Brackets are secured with off-the-shelf tools and do not require particular precision. The upper component with its two sections is build as a mono-unit. It doubles as a pedestrian light, which saves maintenance costs.

First we investigated what the traffic lights used to look like. What are they like now, and what could they be in future? We made a historical overview of the topic and conducted careful research into the standards and restrictions of the project. These images were grouped and both discussed inside the design team and communicated to the client. This was a great help for the team, in addition to which it provided the client with an idea of what to expect. These days, similar policies and regulations are applied almost everywhere. Although a broad variety of traffic lights already exist, there still is room for improvement on the design in terms of appearance and usability.

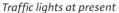

The most promising directions

Bringing it back to earth

Examining the most promising directions

After the initial brainstorming session, the team scratched the ideas that wouldn't fit existing constraints, after which twelve promising design directions remained.

One person in the team was selected to sketch these concepts for the presentation to the client. This way the sketches would have a similar style. This was important, as they served as instruments in the selection phase of the design process, during which the manner of presentation should be kept consistent and unbiased.
Our objective was to present the designs in a simple and clear manner. Sometimes we changed the perspective and view of the traffic light to show the form and construction of our design proposal more clearly.

NOTE: This created a nice side effect; if they had all been sketched in exactly the same manner (same viewpoint, same size), the result would have been less interesting to look at. By creating differences in viewpoint and size, a more dynamic/interesting image emerged, while still maintaining uniformity among the sketches.

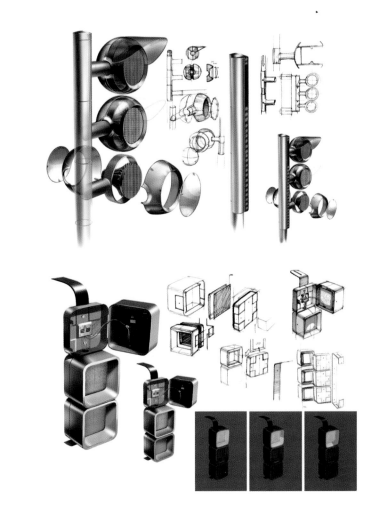

Presenting the three best options

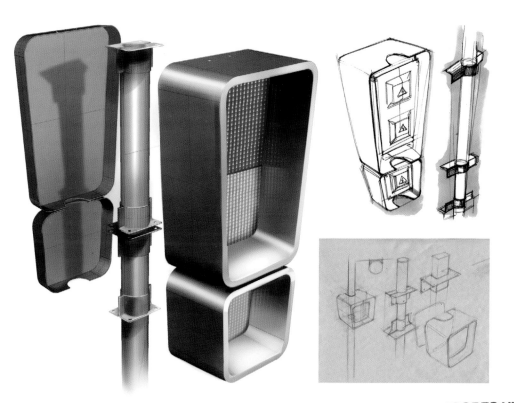

Bringing it back to Earth

The design team then further explored the concepts to demonstrate feasibility.

Analysing

After thorough analysis, only three options were kept. These three versions were further developed, with a focus on their construction. The three options were then compared, and the images you find on this page were presented to ISBAK.
For obvious reasons, the previous presentation met with tons of questions from the engineers.
For that reason, our next report presented the big picture for each design, surrounding it with many small sketches elaborating on parts and explaining details for each direction.

Developing extra features

Next up was picking the one design that would meet all our requirements. Engineering the structure, fixing all the parts, determining the installation process, organizing maintenance and ergonomics.

During the previous presentation, the group of representatives from the client discussed all these matters for each of the three directions with us and then selected the definitive design. The sketches for that design were used internally for further development, ideation and communication at the ArtLebedev Studio. Making sketches serves as a good tool for us at this point in the design process. As soon as we arrived at the optimum solution we turned those sketches into a CAD.

We wanted to optimize the process and start off with selecting the most effective internal layout and principles for opening and mounting the traffic lights.

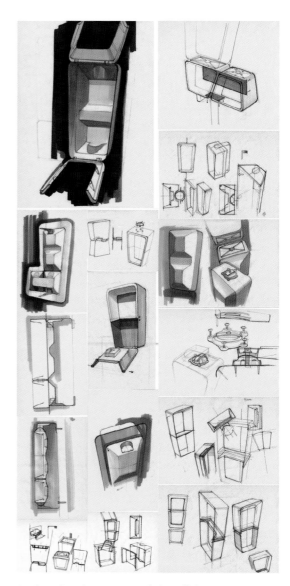

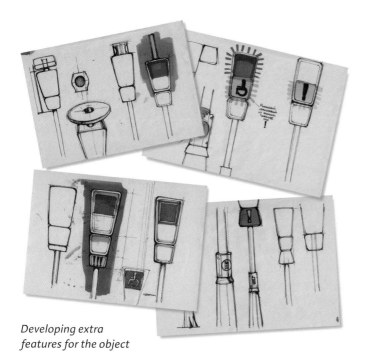

Developing extra features for the object

Engineering the structure, fixing all the parts, determining the installation process, organizing maintenance and ergonomics

Preparing dummies; now regulating the traffic in our industrial design department

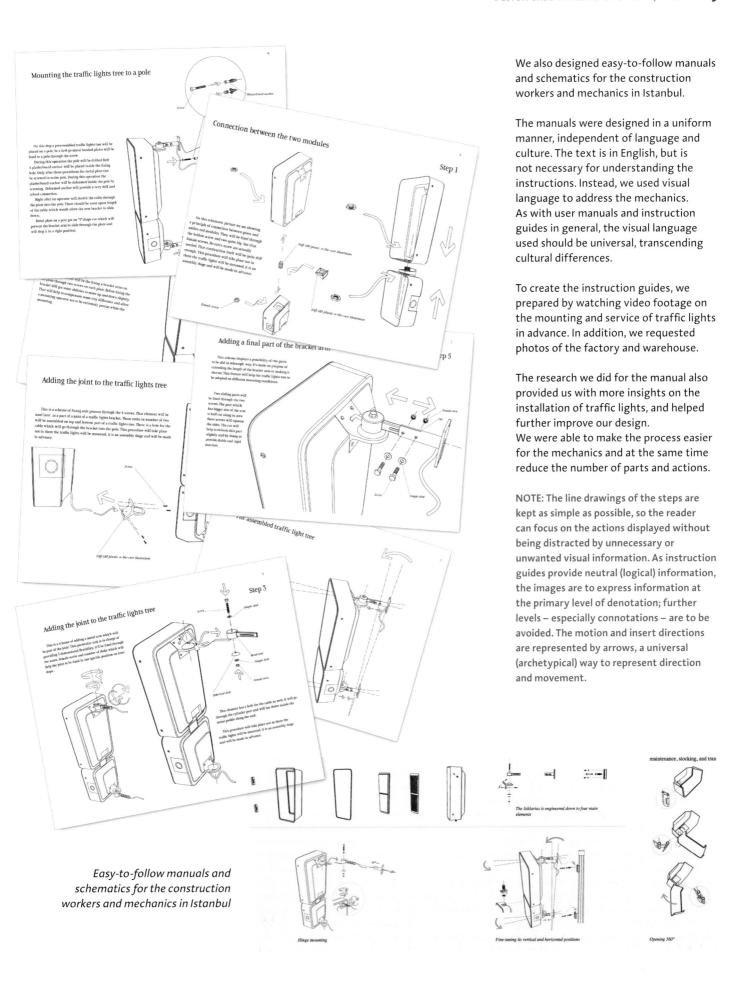

We also designed easy-to-follow manuals and schematics for the construction workers and mechanics in Istanbul.

The manuals were designed in a uniform manner, independent of language and culture. The text is in English, but is not necessary for understanding the instructions. Instead, we used visual language to address the mechanics. As with user manuals and instruction guides in general, the visual language used should be universal, transcending cultural differences.

To create the instruction guides, we prepared by watching video footage on the mounting and service of traffic lights in advance. In addition, we requested photos of the factory and warehouse.

The research we did for the manual also provided us with more insights on the installation of traffic lights, and helped further improve our design. We were able to make the process easier for the mechanics and at the same time reduce the number of parts and actions.

NOTE: The line drawings of the steps are kept as simple as possible, so the reader can focus on the actions displayed without being distracted by unnecessary or unwanted visual information. As instruction guides provide neutral (logical) information, the images are to express information at the primary level of denotation; further levels – especially connotations – are to be avoided. The motion and insert directions are represented by arrows, a universal (archetypical) way to represent direction and movement.

Easy-to-follow manuals and schematics for the construction workers and mechanics in Istanbul

Presenting the end result
Often you need to place the design in a context to demonstrate how it would be implemented in its intended surroundings. This could be a realistic one ("will it effectively fit its surroundings?"), or a more abstract but still related one, to emphasize the atmosphere. In the image to the right (without context) the (shape of the) design is clearly visible, without distractions. The image below shows out-of-focus surroundings, keeping your attention on the one object in focus, the design itself. Nonetheless, the surroundings do give you a feel for the actual environment of the object.

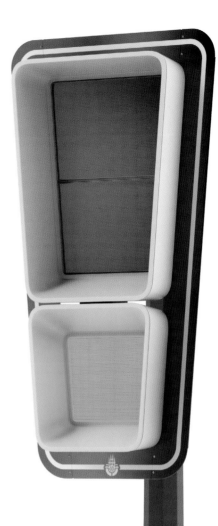

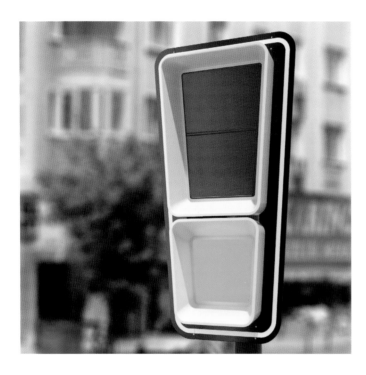

All images on this page were presented to the client, including the bottom left ones. We did our best to accurately place the new design in an original environment of the city with the use of computer graphics. By doing this, we proved that the new design can fit the city quite well and works well with various degrees of visual noise.

Our website displays a great amount of information on each project. It starts with a relatively elaborate overview section of the design. The images you see on the page before you are also displayed in this section of the website. Both images display the design in a user context.

NOTE: The image above explains the principle of interactivity in a far more effective manner than words can (however, explanatory texts are also available on the website, should you have any doubts.

The image below illustrates both the system's modularity and the pattern used for the cover glass. Here, the Istanbul cityscape in the background is displayed more explicitly, as is serves to support the choice of the pattern imprinted on the glass.

In addition to the overview section of each design, one can choose to view the high res imagery or the more elaborate process section. Here numerous sketches, photos, renderings, mock-ups, etc. are displayed, all accompanied with a chronological description of the development of the design.

As soon as a project is completed, we always share the internal process for anyone interested. This serves several purposes: It helps people appreciate the result with a better understanding of what factors led us during the work and why some ideas were eliminated. In addition, it shows our approach and hopefully encourages other designers and companies to use the power of design in their business.

NOTE: The grey background represents the user context of Istanbul. It is recognizable as such, but kept abstract with light grey values to support the design instead of attracting too much attention away from the design. The colours green, orange red are inextricably connected with traffic lights. The exclamation mark is not, as it is a punctuation mark for emphasizing something. An interesting detail is that the mark is most recognizable when the full stop below is lit; the moment of the light turning green is thus marked joyfully!

Fabrique in collaboration with Mecanoo Architects, the Netherlands

Development of Train Station Furnishings and Equipment for ProRail, NS and Bureau Spoorbouwmeester

"The station needs an identity"

What do we want train stations to look like in 2015? How do we provide the traveller with a feeling of being welcome? In a pitch initiated by the government agency ProRail, NS (Dutch Railways) and the advisory body Bureau Spoorbouwmeester, the multidisciplinary design agency Fabrique collaborated with Mecanoo architects to develop an overall vision for Dutch railway stations. Within the changeful context of travel, the changeable needs of travellers and the possibilities of stations nowadays, the two studios, coming from different fields of play, created a joint vision.

In the first pitching round a vision was asked for; It was the explicit wish of the commissioner that the ideas wouldn't be presented as designs but as ideas with accompanying visualizations. This created an open and inspiring situation, in which initially ideas and intentions led the process rather than boundary conditions.

Step 1 Analysis

Step 2 Grouped needs

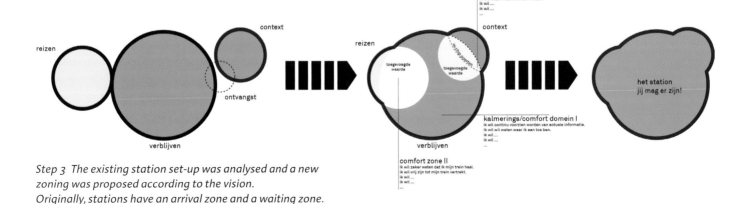

Step 3 The existing station set-up was analysed and a new zoning was proposed according to the vision.
Originally, stations have an arrival zone and a waiting zone.
For new stations a 'hang-out' zone was proposed.

Fabrique en Mecanoo started with analysing the expectations and needs of travellers in a future context. We took 2015 as a starting point and defined what would be relevant in this highly digitized world. It was clear to us that the following themes would feature as important factors: a 'work hard and play hard'-mentality; more elderly travellers; the agony of choice; a greater number of competitors for Dutch Railways.

As a result, 5 key needs were defined: continuity of activities during travel (no wasted time); knowing what to expect; quality (good cappuccino is the standard); the option of waiting in different manners; and, of course, shopping.

This lead to an overall concept, which in Dutch was named: "je mag er zijn". This phrase combines connotations of "you're more than welcome to be here" and "you're worth it". As an elaboration on this concept, Fabrique and Mecanoo arrived at the conclusion that the railway station needed a stronger identity. In the Netherlands, the railway stations are identified with the logo of NS (Dutch Railways) combined with the location, for instance [logo] Amsterdam Central. The designers proposed renaming the stations and simply calling them 'het Station' ('the Station').

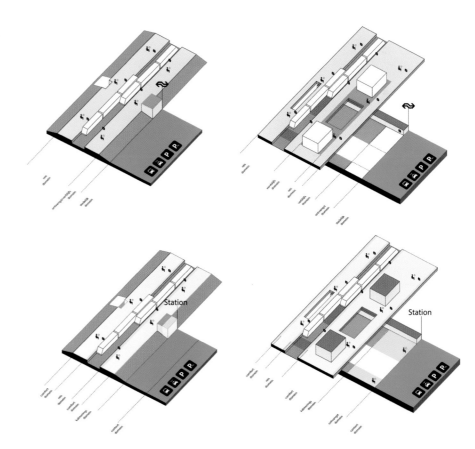

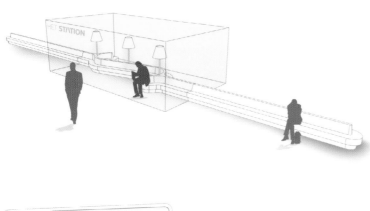

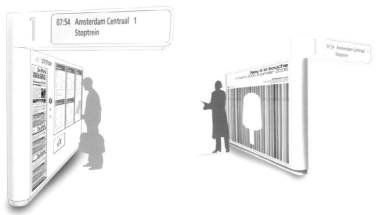

Visualization

In this first phase, the challenge at hand was to envision the future. This would serve to substantiate design decisions to be made at a later stage. Many of graphs and schemes were made not only to express the idea, but also to communicate matters such as the effects of this vision on zoning for the different types of stations.

Phase I was communicated by means of a presentation, in addition to which a booklet was handed out. This is a common modus operandi in architecture. In product design, sending out .ppt files is a more common practice.

NOTE: The blue in the image to the left stands for 'glass', the lamp refers to 'homely'. Because of the abstract nature of the image, the viewer will of course understand that this is not supposed to represent a realistic image of the idea.

The shapes and colours at the bottom of the left page represent meaning through a conventional relation, i.e. what they stand for is based upon conventions. These conventions are not universal, but exist within the setting of this design project and are 'learned' by the viewer, for instance by means of visual connections with the images of the plan views.

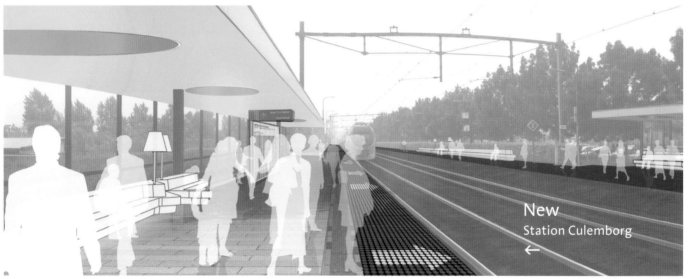

In the second phase of the design process, several ideas were applied in a test situation. 4 existing railway stations were selected and transformed according to the vision.
In the drawings shown here, all ideas concerning furniture, shelters and lighting are combined into one picture. The photos at the top depict the existing situations. These ideas were presented by means of a live presentation. In this example, the drawing was gradually built up from the existing situation to the desired situation, but still on an abstract level. No details, no explicit materialisation; the desired experience of the travellers was the most important theme.

The existing situation was used as an underlay and kept visible for (scale) reference. This was done in a manner that did not attract too much attention to the underlay, and kept focus on our proposed designs.

The drawing below shows three different versions of canopies. They're simply visualized as cross sections – for small, mid-sized and big stations. Although they differ, they clearly are related.

Nieuwe overkapping
bij enkelzijdig perron
bv. Duiven, Culemburg

Nieuwe overkapping
bij dubbel perron
bv. Delft - huidige situatie

Nieuwe overkapping
voor het hele perron
bv. Leiden

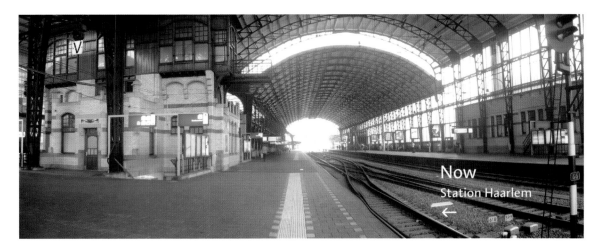

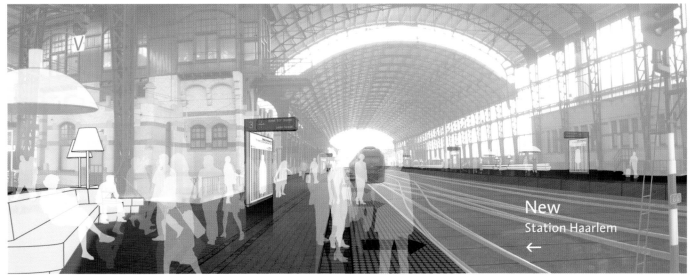

The collaboration between the design studio and the architecture agency had an interesting effect on both parties. Designers, especially industrial designers, are often used to designing products separately from their environment. Products are often presented against a variety of backgrounds, ranging from plain white ones to ones filled with colourful marker lines. Architects, by contrast, often start from a real-world perspective and try to blend their design into the existing space. This can be seen in the visualizations of the stations: the old stations are transformed into new environments.

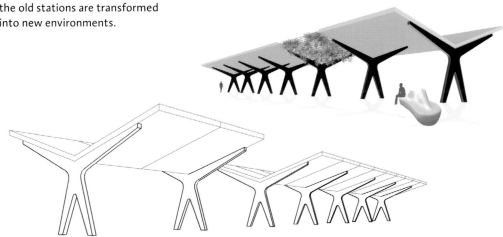

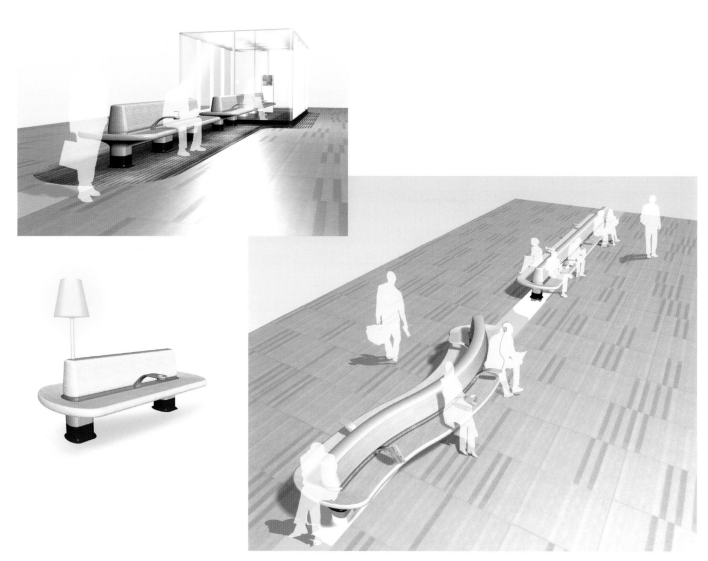

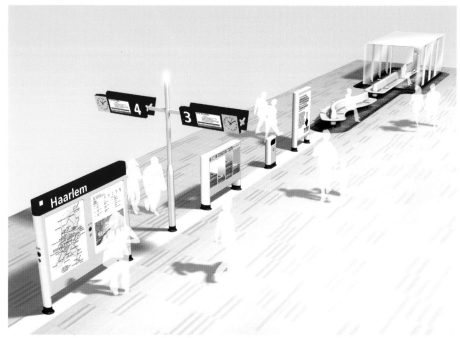

NOTE: Gradually, throughout the design process, the visualizations communicated to the commissioner become more realistic.
On this page, you can see furniture designs placed in a context. This context, however, is still abstract, but refers to the context of NS stations. The surroundings of the designs are abstract in order to keep the focus of the image on human interaction without disturbance from (unnecessary) background/visual noise.

Final renderings in realistic surroundings

The images in bird's-eye view show an overview of the effect of our designed interactions. It enables us to visualize several possible variations/objects in one sketch.

A nice side effect to these images was that an evaluation of the proposals was much easier with such sketches, as discussion topics could be easily pinpointed in it.

Of course, we also needed to evaluate the effect of our design proposals in relation to their realistic surroundings. This was best achieved with a more realistic/natural viewpoint such as one at eye-level.

Examples of some of the executed ideas; the private area and furniture. The final designs as shown here were made by Fabrique and manufactured by OFN-Epsilon on the basis of ideas from Blom&Moors.

VanBerlo,
the Netherlands
Embrace
for Durex

Embrace™ Pleasure Gels

Durex Embrace™ brings a new dimension to sex with 2 sensual pleasure gels, subtly crafted with couples in mind.

The design brief was to design primary and (if necessary) secondary packaging for a new set of his and hers pleasure gels. This needed to be built upon the newly defined Durex brand language, clearly differentiate itself from on-shelf competition, and provide a special user experience. Technical aspects such as material and size were fixed from the outset.

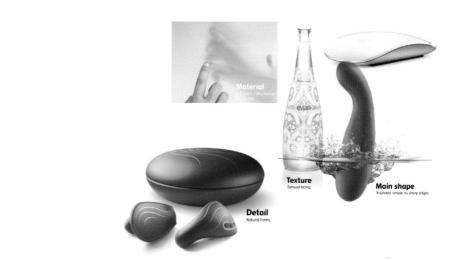

Material
Soft touch / silky feeling

Texture
Sensual lacing

Detail
Natural forms

Main shape
Rounded, simple no sharp edges

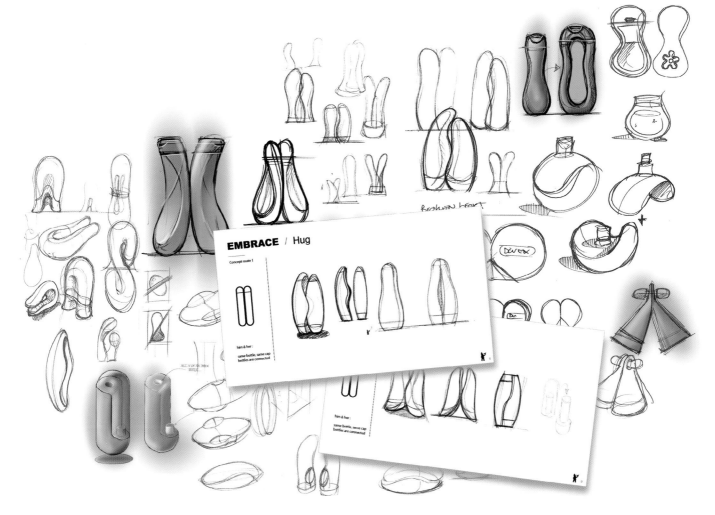

EMBRACE / Hug

Concept route 1

him & her :
same bottle, same cap
bottles are connected

Idea generation

After determining the so-called 'design DNA' through images and words, the idea generation phase started. At the start, we created a high number of sketches, which we then proceeded to cluster into different concept routes. The created sketches were evaluated internally and the best ones were selected to be included in the presentation for the client.

In the first round of sketches, our designer team explored different ways of combining two shapes into one. Several ideas were highlighted in colour, representing different possible directions. The ideas were each presented to the client on a separate page.

Concept design

In the concept design phase, the chosen directions from the idea generation phase were evolved into a higher level of detail and visualization, presented to the client in images from different angles. We sketched on a scale of 1:1, taking into consideration the shelf footprint provided to us in the client brief. Printouts of the sketches were made in order to evaluate them off-screen. One of the earlier sketches, referred to as the Huggalicious, demonstrated a concept of two differently shaped bottles perfectly fitting together, 'hugging' each other so to speak. The challenge that emerged from the concept design phase was to evoke a similar 'huggalicious' effect, while using the same bottle shape for both the his and the hers bottle, simplifying the production process. This led to another round of sketching, in which we took the chosen design direction to the next level. The correct logo size and the required regulatory text were included in the sketches to create a more realistic image of the final product.

NOTE: The colours blue and pink represented male and female. The quest of that phase was to explore and focus on the shapes of the primary package. Colour served as a functional tool, just to indicate gender. By means of their shape and position only, the packages subtly and discreetly refer to the user context of the pleasure gel they contain.

In order to explore and evaluate the shapes in the most effective manner, most of the sketching was done in plan view.

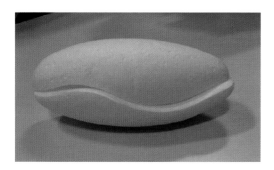

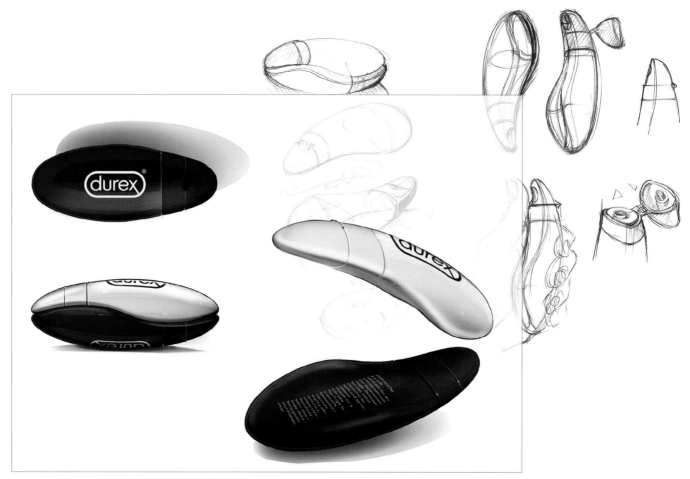

The chosen concept was then digitized and rendered. This took the project to a level with more realism, and provided the base for our colour study.

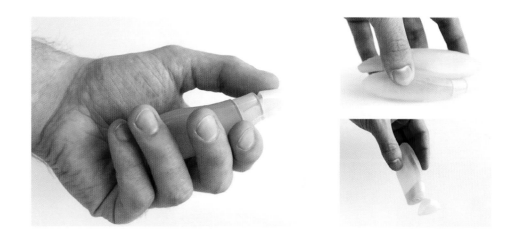

Seductive

Emotion

Intimacy

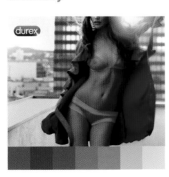

Purple flow

The moment

Silky red

Colour study on pleasure gels
As the design needed to communicate to a male and female consumer by means of a colour code, a number of mood boards were made. We explored several directions and presented them to the client. The colours were tested in a qualitative consumer test.

NOTE: VanBerlo paid great attention to the meaning of colour and its relation to emotion. A colour study was performed in order to arrive at the most appropriate colour combination. Mood boards are a highly effective way to pinpoint emotions. Colours can be selected from images to create a colour harmony.

The colour schemes reflect a mood through associations with the colours themselves, but also through what is seen in the images. The referents were chosen with quite subtle differences and are therefore far from universal. Finally, a test with potential users can narrow down the colour choices.

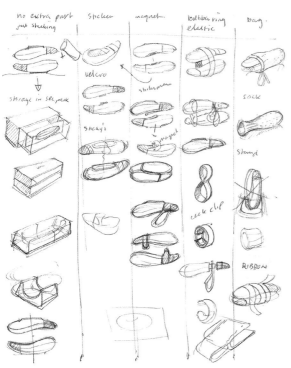

Connection options

During the concept testing phase, the client team asked us to look into different ways of connecting the two bottles after they have been taken out of the secondary packaging.

At this point in the process, our design team sketched over preliminary 3D CAD models they built. A 'master sketch' was made, which was then modified to represent different concepts. We prefer sketching over 3D modelling because it offers a greater deal of flexibility and speed in creating a great number of different options. Connecting mechanisms explored included magnets, stickers, bags, ribbons, clips, and bands...

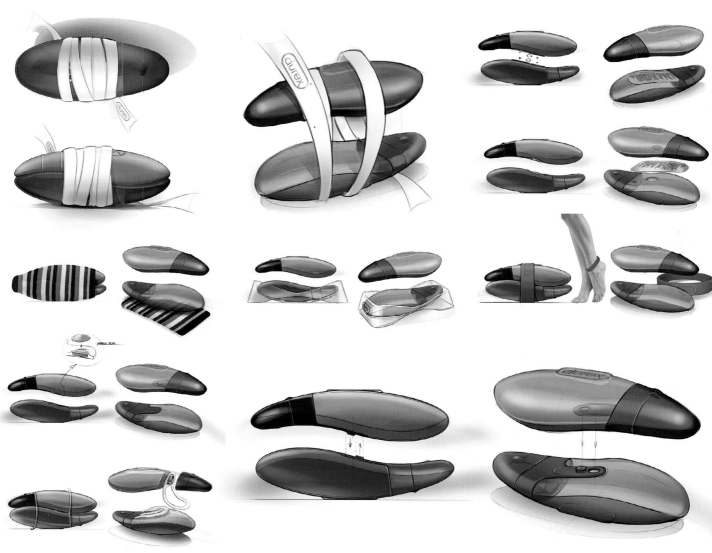

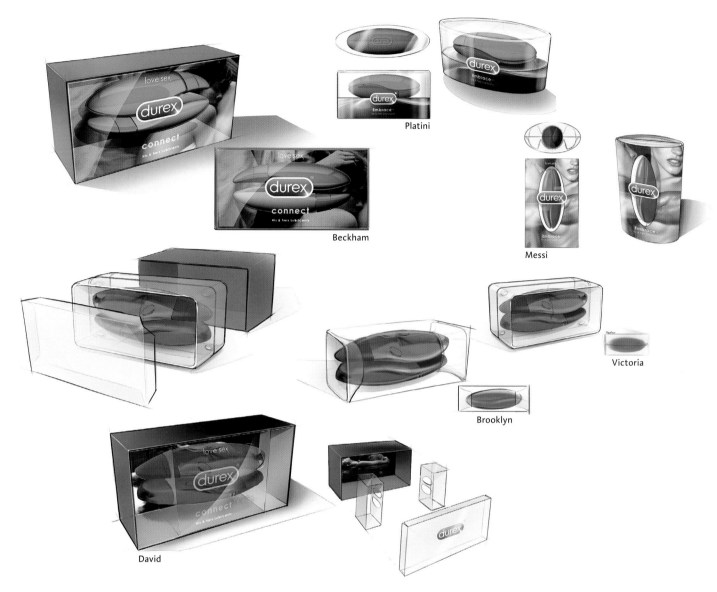

Platini

Beckham

Messi

Victoria

Brooklyn

David

Secondary packaging

With the secondary packaging we explored several options; first in handmade sketches and then through several concept directions that were presented to the client in both 2D and 3D digital sketches.

This was done to give a good impression of what the packaging would look like, and to show what the effect would be on the shelf. We looked at both vertical and horizontal methods of presentation, and played around with the concept of letting the bottles float inside the packaging.

As soon as a leading direction was chosen, several options for creating the desired floating effect of the bottles inside

the secondary packaging were investigated. The names given to the concepts all came from world-class football players. In projects for this particular client, we often use these kinds of monikers in order to make referring to the different options easier. It also adds a touch of lightness and fun to the project. When the Beckham concept was chosen as the leading direction, iterations were named after his family members.

Final product

In the final execution of the product you can still find the original design intent: unique shapes on their own and still in harmony when connected to each other.

Marcel Wanders, the Netherlands

Dressed Tableware for Alessi Italy

"Welcome to my kitchen!
Let me be your servant and chef.
In this magic universe where peas
kiss carrots, where cauliflowers
flowerlessly bloom, where parmesan
makes love with penne and balsamico
is fiercely wrestling oil.
Where knives are chopping things
together and spoons divide and
collect at once.
In this world where books of rules
are left to bookshelves and the eye
and nose surprise each other, in this
universe I cook for pleasure.
But today is a special day;
Today my guests have buttons in their
belly and a thousand words to share.
They wear flowers in their hair, and
butterflies rest on their shirts.
Today I have a helping hand, I'm
helped by knights in shiny armor,
A team of cool hot beauties, I call
them friends.
Polished, black, Shiny and matt;
Perfectly handy and charmingly
beautiful they cook, they bake, they
collect my shear inspired culinary
genius.
These friends and servants conquered
not only my kitchen but conquer my
table as she sautés, stirs and bubbles
in jewels.
Today we don't cook, we create.
Today we don't hand out, we serve,
Today we don't eat, we taste.
Today we don't talk, we are one,
Today we don't live, we celebrate life.
Today we are at the chefs table and
we are still, like every day, dressed for
the occasion.
Surprise your heart with your eyes and
see that tomorrow will be another
very special day..."

– Marcel Wanders

In 2012, the Dutch designer Marcel Wanders was commissioned to design a series of aluminium Cookware for the Italian tableware firm Alessi.

Pots and Pans join the table as a new addition to the Alessi Dressed family. To accompany the place settings, glasses and cutlery of 2012, a complete range of saucepans and frying pans topped with patterned sparkling silver lids were designed, dressed to cook and dressed to serve. Jewels in the kitchen become jewels on the table.

Time to get dressed for the occasion.

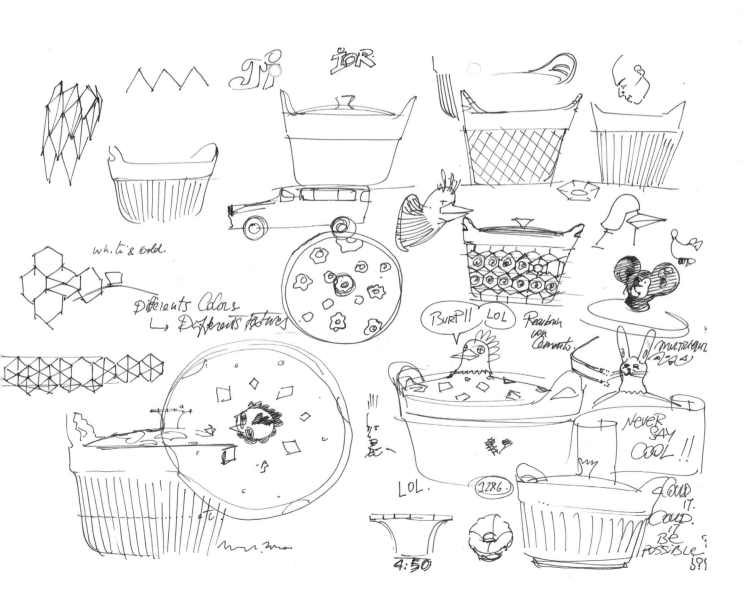

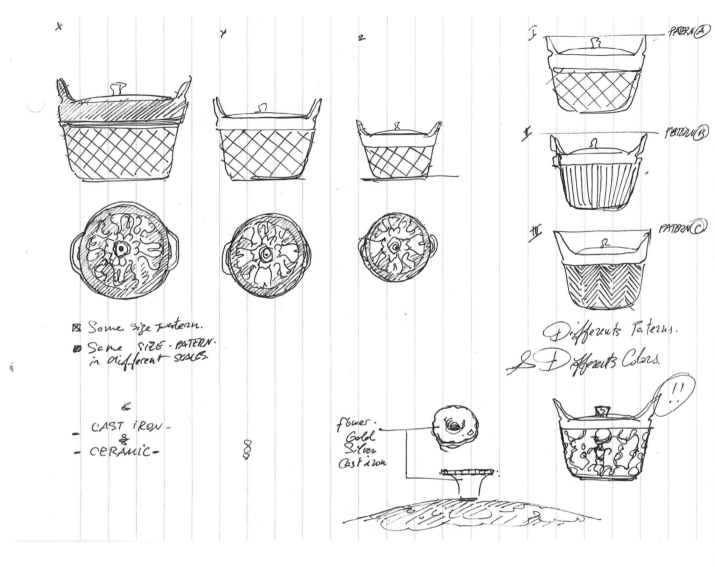

Same size pattern.
Same SIZE · PATERN. in different scales.

&

- CAST IRON -
&
- CERAMIC -

Differents Paterns.
& Differents Colors.

PATERN (A)
PATERN (B)
PATERN (C)

flower.
Gold
Silver
Cast iron

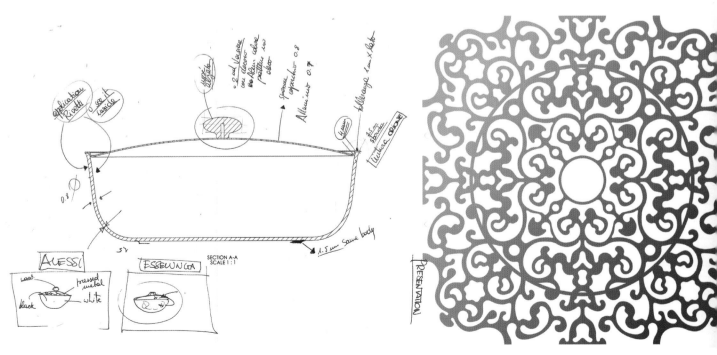

ALESSI

ESSELUNGA

SECTION A-A
SCALE 1 : 1

PRESENTATION

In terms of appearance, these pans distinguish themselves from existing pans at first glance by the ornamental pattern embossed at their centre and on the lids. This is a typical and recognizable feature from the designer, as elaborate ornaments commonly appear in designs by Marcel Wanders.

On Marcel Wanders's website, the pans are displayed in a black setting surrounded by this ornament.

This draws extra attention to the ornament and its application on the pans.

The dark background in combination with the white poem text and imagery supports the feel of fairy-tale magic and luxury, as also features more often in designs by Marcel Wanders. Browsing through Marcel Wanders's website, you will notice how well this design fits in with the rest of his collection.

NOTE: The pattern as seen on the left suggests richness and wealth, but also decadence and kitsch. The semantic relation of this pattern to what it stands for is indexical and its connotations vary according to the different interpretations people can have.

What will strike you in looking at these product images may not even be the pans, but the animals next to them. The animals, possibly the content of the dinner, are dressed up as though they are having the festive dinner themselves. Is it 'Dressed tableware, dressed dinner'?

The first animal we saw in this case, is the perfectly white rabbit with its red bow tie, sitting in a black pan. It is actually the only animal in a pan; all the other animals are displayed next to the pans. This adds an extra layer to an already extraordinary situation, as this is suggestive of a magician's black hat, from which the rabbit just emerged. It could also refer to the white rabbit in Alice in Wonderland.

All the pans are accompanied with the animal they are meant to fry or cook. The image of the magician may not be referred to in all cases, but the animals being consistently fancy and well-dressed refers to both luxurious dinners and to fairy tales and fables, which are (western society?) denotations.

Closely following this association, one might also detect a gruesome connotation: the fact that it is extra cruel to start cooking an animal that has just been given a personality.

NOTE: From a Barthes point of view, the primary denotation is "pan and rabbit" or "pan and chicken", secondary denotation: luxury pans, high-class, immaculately white rabbit, dressed well. The primary connotation would be the associations with fables. The secondary connotation, especially for a vegetarian, could be that animal cruelty is horribly displayed in this indirect manner.

NOTE: An image using semiotics only referring to primary denotation is safe, clear and not offensive. Using multiple layers of meaning, as is done here, may be tricky but greatly enhances the visual experience of the viewer.

Both Marcel Wanders and the company Alessi communicate images of the 'Dressed' designs for promotional purposes. The imagery can be found on the website of Marcel Wanders's, in the Alessi brochure Fall-Winter 2012 (displayed on this page), in a promotional video on Youtube and in the Alessi web-shop (the latter two displayed on the opposite page). For each of these situations, the images may serve a different purpose.

The Alessi brochure is the main platform for displaying the designs in their most glorious and seductive manner. The audience mainly consists of (potential) customers/users and retail buyers.

The animals only partially serve as a reference to the use of the pans, but mainly – on the denotation level – as a reference to fairy tales, luxury and uniqueness.

The layout of the pages allows the imagery to be admired to its full extent, and for the animals to play a prominent visual role. Both by means of colour and detail they attract visual attention. And, of course, by being extraordinary.

Alessi has posted a promotional video on their website (and Youtube), presenting the complete Fall-Winter 2012 Alessi collection. Target audience: potential customers and retail sellers. The Dressed pans are now seen as part of the collection.

Here on the left, some stills of that fragment are displayed. The ornaments and the shape of the pan are clearly visible at the start and end of the video. The animals, as seen in the brochure, have been left out and a cartoon-style piece of meat, suiting the style of the animation, is put in the pan to fry.

Seeing these video stills might make you realize the impact of the animal images, which are both visually and semantically dominant. In this case, the pans are seen in a completely different style. Not such a wise decision, one might think at first glance. But considering that the animation shows the use of the pans, it might not have been such a bad idea after all.

The pans are now shown in a more neutral manner, as they are. And more importantly, the animation was made to present the complete Fall-Winter 2012 Alessi collection and not just the Dressed pans. By choosing an animation style and keeping it consistent throughout different designs, a coherent collection is communicated to the viewer.

In the video and the web-shop, the animals are left out. The video shows the designs 'objectively' in the context of the complete Alessi product range.

NOTE: In the section of the Allessi web-shop where customers select the products they wish to buy, the products are displayed in yet another manner. No animals are seen in this section either, nor any ornaments. No seducing the customer here; just plain (side) views and product information. There are reasons for this. First, displaying the items in side view is consistent with the rest of the web-shop, thus communication uniformity again. Second, this viewpoint has the big advantage of visually distinguishing the pans from each other in the best possible manner, so that the customer can best find the selected item.

The audience of the web-shop mainly consists of consumers who are presumed to already be aware of the design and to be on the page to click and buy. The products are shown almost in thumbnail size, but effectively recognizable.

CHAPTER FOUR
Visual rhetoric in design communication

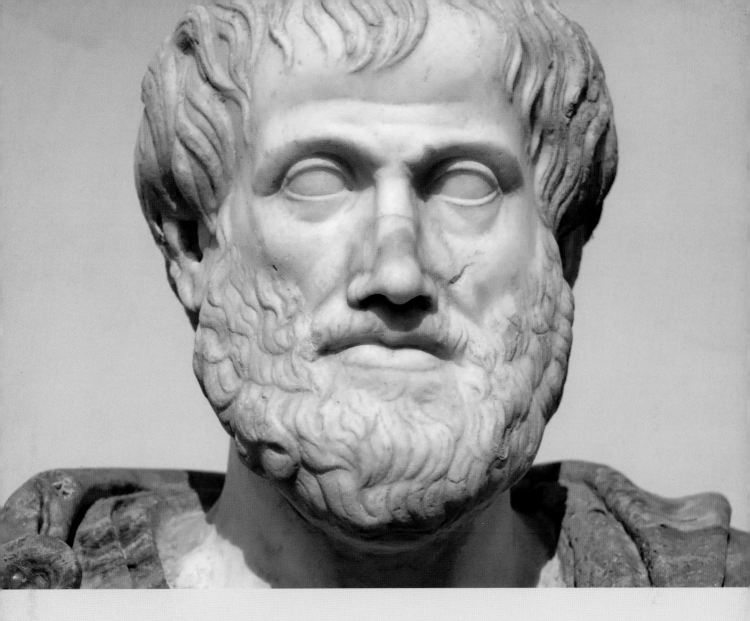

A designer communicates a variety of content. In some cases, his/her presentation is informative, communicating form, usage, progress or technical assembly, for instance, and in other situations the presentation requires a more convincing or persuasive character. This is where Visual Rhetoric plays an important role. Rhetoric is the art of persuasion. To whom you communicate influences the manner in which the message is told. The context of a sketch or image can influence how it is perceived.

Rhetoric originally comes from ancient Greece and was exercised verbally: argumentative and legal communication. The theory, however (Aristotle, 330 BC, image above), is still very useful in both verbal and visual rhetoric. Nowadays, images (photos, renderings, sketches, info graphics, PowerPoint presentations, etc.) are common means of communication. The emergence of marketing, together with the easy accessibility of imagery through the web, has stimulated this. Rhetoric can function as an important visual analysis tool.

4.1 **Context and framing**

An object that is visualized without surroundings or context may not be understood. Often a context is needed to provide meaning, or simply to indicate what a visual is about. Especially with innovative or rare products, the audience may need a context to understand what they are.

Not using a context can cause confusion, but it could also evoke curiosity, which would turn the image into a teaser.

Tarta ergonomic backrest; teaser image and context image

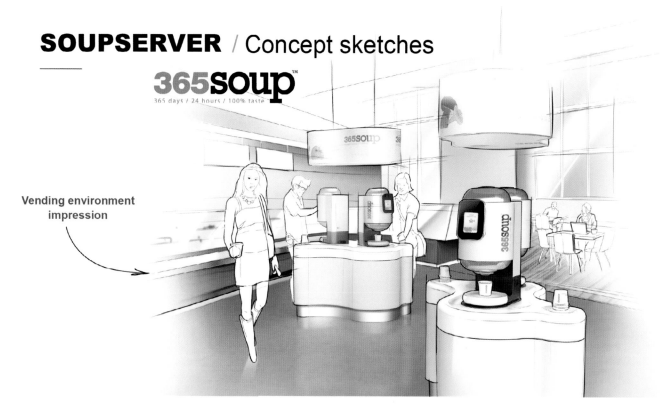

VanBerlo's Vendinova SOUPSERVER; product renderings put in a user context through sketching to give an impression of a branded retail environment

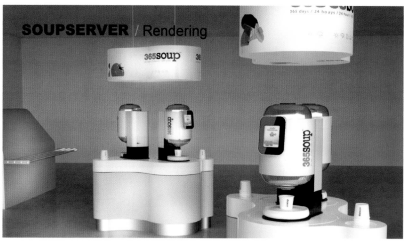

Home pages of websites often use small (cropped) product images without context. If these were part of a presentation it would be overwhelming and confusing, but reading them as thumbnails ensures that the missing context makes them function as teasers.

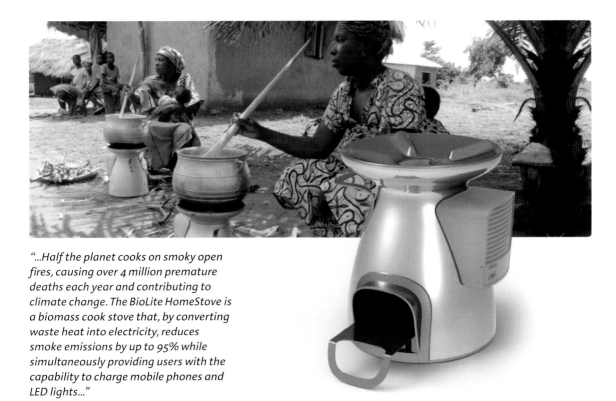

"...Half the planet cooks on smoky open fires, causing over 4 million premature deaths each year and contributing to climate change. The BioLite HomeStove is a biomass cook stove that, by converting waste heat into electricity, reduces smoke emissions by up to 95% while simultaneously providing users with the capability to charge mobile phones and LED lights..."

Images of the BioLite HomeStove (above), and the BioLite CampStove (below)

A context can be informative, explaining usage, size or other denotations, or a context can evoke a certain emotion or association. Furthermore, contexts can be used to emphasize the look and feel of the subject, or to associate it with the desired user group or design language.

On the BioLite website two basic product groups are promoted. The BioLite HomeStove and the BioLite CampStove make use of the same technology, but aim at two entirely different user groups. This is made instantly clear by the background images chosen for each. The usage of the CampStove is then visually hinted at by means of the added iPhone and branches.

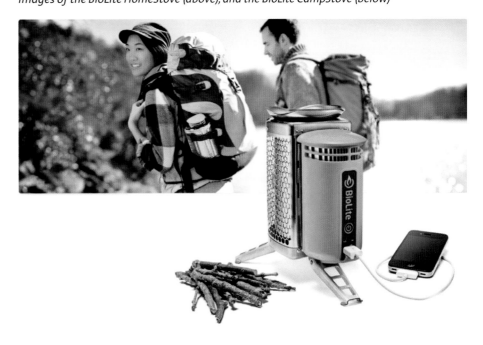

In highly innovative designs, which are thus unrecognizable by the mainstream public, a context image is needed for communicating the design, as is the case with e.g. the LUNAR case or the Spark case. The latter makes use of associations with the airport to emphasize flying. In the WAACS Design case, the usage and user group are solely communicated through the design, and no framing or context images were needed to communicate the design intentions.

p. 189 p. 156 p. 84

If you pay attention to context, you can encourage the viewer to think in a certain direction. This is what we call 'framing': literally placing a setting inside a (picture) frame. The aspects we see grouped together inside this frame are automatically connected (Gestalt), usually by association. However, much like an image in a frame, it displays only that part of the world it focuses on. When framing an image, part of the surroundings are left out and the displayed context becomes the focal point.

Framing as a technique has gained a bad reputation, for instance in deceptive marketing of consumer products that makes us feel that we are being misled. It is, however, important to realize that there is no such thing as purely objective communication, as any message will make use of some sort of framing and assumptions. Additionally, framing can also be used for a 'good' cause.
By means of framing, decision-making and judgment is influenced due to manipulation of the way in which information is presented. [4.1] It can therefore also function as a means of persuasion and communicate certain opinions by means of explicitly leaving out or adding images or text [4.2]. Framing is most effective when the aspects selected to be included in the image are the ones the viewer will be most susceptible to.

A special kind of framing is known as 'greenwashing', in which case framing is (deceptively) used to promote the perception that an organization's products, aims and/or policies are environmentally friendly.

To apply framing, follow three steps:
***select:** what aspects are present; which are shown; which are left out?
***salience:** what aspect(s) is/are to be emphasized?
***spin:** add an extra twist (optional). This can be a text caption, similar to catchy headlines in a newspaper, or a choice of colour, contrast, viewpoint, etcetera.

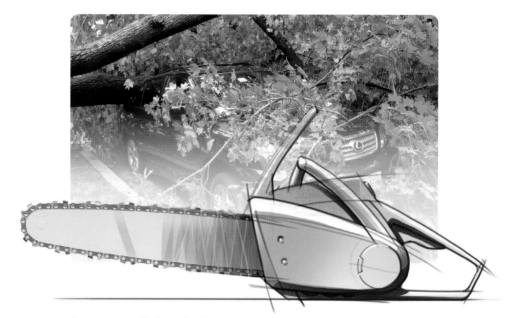

As a rescue tool after a hurricane

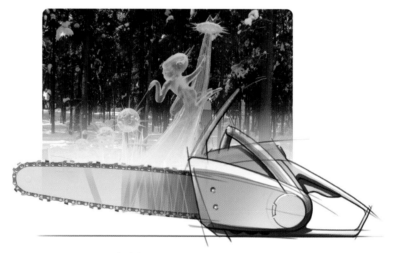

As an ice-artist's delicate sculpture tool (positive)

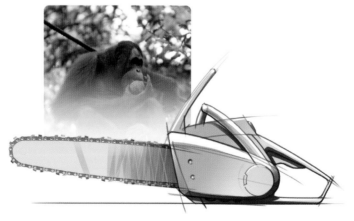

As a tool demolishing rainforests and natural habitats (negative)

Website image for Icelandic

Website images of the Nike Epic Sportpack on Phil Frank's website (the designer)

p. 167

p. 115

p. 152

p. 120

p. 125

p. 82

The image of the backpack without context serves mainly to express form. The image of the person wearing it, not only communicates usage and size, but adds a twist (spin) due to the way the person has placed his hands. The dark background directs the attention to the unusual posture of the arms, which visually stands out. The posture demonstrates a tight grip (associated with the wear-resistance of the backpack), but also healthy and trained arms to refer to adventure and leisure.

For example, in the npk design case a neutral context image was used to express size and connect the design to the bicycle. The ArtLebedev website displays an abstracted image of the city of Istanbul in the background, emphasizing its cultural context. For the pitch sketches in the Van der Veer Designers case, text was used to emphasize certain design characteristics. In the visualizations by Fabrique, context is necessary for understanding the impact of the designs on human travel behaviour. Of course, only neutral or positive situations are displayed here. In the VanBerlo case, the images used for colour inspiration also emphasized mood. In the Waarmakers image of the scooter, the realistic city background creates a mood and also simulates the physical existence of the design (which was at that time still just a CAD rendering).

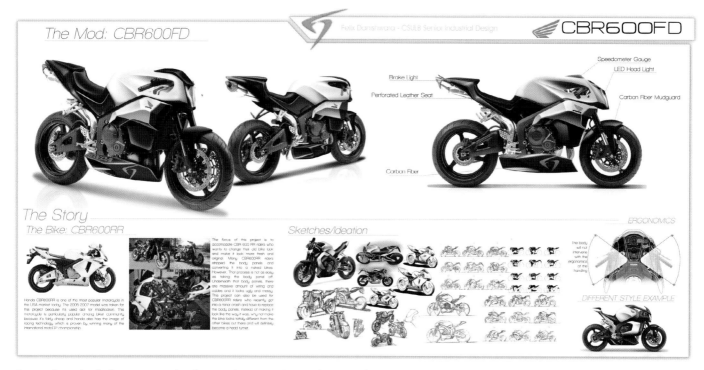

*Screenshot of a design presentation for a Body Conversion Kit for a Honda CBR
on the online portfolio of student-designer Felix Danishwara*

4.2 **Rhetor and audience**

In classic rhetoric, the person who speaks is called the rhetor; the ones who listen are the audience. The audience of an image is the viewer. Pointing out the visual rhetor, however, is not always that easy. Is it the person who made the sketch or image? Not always. For instance, on a website of an independent photographer, the rhetor will most likely be the photographer him- or herself. However, when a photo is made for a client, this will not be the case. The rhetor may no longer be the photographer of the image, or even the image rights holder, but rather the commissioner (person or company) that will use the image in his or her communication. For instance, product images on the website of a manufacturer (rhetor) are usually aimed at potential buyers (audience).

When an independent designer meets a client, the designer is the rhetor. However, when the designer works for a design studio, he/she represents the design studio, in which case the design studio is the rhetor.

On a design studio website, the studio presents itself. The rhetor of the posted design sketches and images once again is not the designer, but the design studio. The general audience of a design studio website will consist of potential (business) clients. The side effect to having an online portfolio is that everyone has access to this information, including people interested in design and competition.

An online portfolio of a design student has a clear rhetor: the student. The audience, however, will be quite divers, consisting of fellow design students and designers checking out the competition or looking for inspiration, but also headhunting design studios and potential clients looking for a designer to commission.

Rhetorically different situations require a different rhetorical approach; different ways in which information is communicated. On the manufacturer's website the product quality will be emphasized. On the design studio's website the quality of the process that led to the product is represented as equally or even more important.

Because of the differences in rhetor and audience, the same image can have a different message in each rhetorical situation. The image of the Grolsch beer bottle, for example, as seen on the website of the beer producer's, may indicate the lifestyle the drink wants to be associated with. The very same image placed on the website of the bottle's designer, however, may serve to communicate "we also took the image of the beer brand into consideration for our bottle design".

4.2.1 **Some specific audiences**

Crowdfunding

The field of design has become part of the public realm to an increasing extent, partly due to crowdfunding. This means communicating ideas that are not yet finished (concept-style) out in the open, after which they are then assessed by people who may have little knowledge of the field of design and are not likely to have much experience in making decisions based on visual material. Where a professional in the field of design is able to look 'beyond the visual' to the idea itself, a 'design illiterate' is quite probably not able to do so. A person untrained in reading visuals will be guided by the manner in which you present something more than the design concept itself. Presentation, or the manner in which you present (or communicate) something, is therefore becoming too important. There is a great chance that design visualization illiterates will perceive concepts presented in the form of a computer rendering as 'well-thought-out' and 'ready', whereas a handmade sketch will be interpreted as just an idea. In reality, this may well be the other way around.

In design competitions or crowdfunding, for example, this may present a real problem. Elaborate CAD renderings can easily deceive a visually illiterate audience. Kickstarter indicated this problem and banned renderings, allowing only photos of working prototypes. Kickstarter announced its prohibiting product renderings in the Hardware and Product Design categories: "To clarify, we mean photorealistic renderings of a product concept. Technical drawings, CAD designs, sketches, and other parts of the design process will continue to be allowed. Seeing the guts of the creative process is important. We love that stuff. However, renderings that could be mistaken for finished products are prohibited".

So there is a contradiction present in the visualizations for crowdfunding projects in the field of design. On the one hand, in order to attract sufficient funds for creating a product, the concept needs to be easily understood by non-designers (so you would expect teasers and visually dazzling drawings) but, on the other hand, crowdfunders should not be the victims of deceptive dream material. Creative power needs expression. Sketches and concept drawings are an essential part of communication in designing.

Company size

In small companies, activities are intertwined and distributed among few people. In this case, the spokesperson (to whom the presentation will be given) will probably have some general and technical knowledge of the product. If the spokesman is the owner of the company, decisions will also affect his or her personal life. If the company turns a high profit, he/she will directly benefit, but when there is a loss, the implications will be felt personally by the spokesperson as well. In small companies, decisions are usually debated elaborately and the focus is more likely to be long-term.

Large companies can have a board, members of which are often senior and might be more conservative than, for example, a marketing director.
In a big company, the self-interest of representatives can differ and may even be independent of design decisions. The implications of right/wrong decisions are felt differently. The self-interest of a manager could be more career-related, in which case shorter-term decisions will be considered favourable (although, less so for the company). In a large company, the spokesperson can be a marketing director, or a communications representative. This person may have little technical knowledge of the design or the process involved. When you discuss design with them, beware of the possible effects of their visual illiteracy.

Design competitions

The audience of visual presentations submitted to a design competition will be the jury. It is important to know whether the jury has specific expertise, is visually trained, culturally different, etc. Particularly in online competitions, the jury can be overwhelmed by the number of entries due to the easy access to these contests. The jury may be faced with limited time to asses all entries. In this case, it will not have the time to thoroughly assess the design concepts, and is more likely to react to presentations on a visceral level.

Education

In training students in design schools, semester presentations are highly important learning tools for communication skills and to experience the differences in the opinions of various teachers. This adequately prepares students for the real design world, in which they will also have to cope with a number of different reactions throughout the design process.

Grolsch beer bottle

MASSAUD

Contact us

Discover ME.WE Click to learn more

Website image from Studio Massaud, evoking beauty, subtlety and tranquility

4.3 The art of persuasion

According to the classic rhetorical approach, there are three methods for addressing the viewer in order to convince: ethos, pathos and logos. Those refer to credibility, emotion and logic respectively. In general, all three aspects simultaneously feature in any presentation. This chapter highlights examples in which one of the three aspects is used to a greater extent than the other two.

4.3.1 Pathos

In this approach, the message plays upon the emotions of the viewer. Usually, a message aims at evoking positive feelings, such as happiness or the experience of beauty.
The agricultural vehicle on this page is displayed as a strong and superior machine. Its low viewpoint makes it tower above the grass as though invincible and ready to cut the grass on this perfectly sunny day.

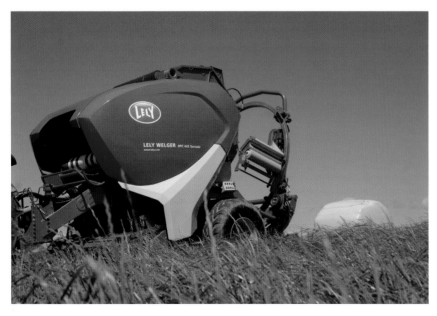

Lely baler machine, designed by FLEX/the INNOVATIONLAB®, evoking positive strength

p. 187

p. 8

p. 83

p. 162

The first image in the nkp case displays a tough and powerful user personality, again easily transferrable to the design of the mudguard itself.

In the Waarmakers case, aesthetics play a significant role in the rendering with the power cord. Therefore, the design itself is also likely to be aesthetically pleasing. The product images for the LUNAR case, displaying details of the design, mainly focus on aesthetics and to a lesser degree on usage. The experience of beauty evokes positive feelings for the viewer; feelings which are then transferred onto the judgment of the design itself.

4.3.2 Ethos

The credibility of the message (visual information) is connected to the credibility of the rhetor. A design studio may choose to convey part of their design process on their website, or display typical designer sketches to convince the audience that they are dealing with professional designers.

The sketches by Carl Liu, presented here on the right, refer not only to his creativity, but also to design as an ongoing process. You might have seen sketches arranged in a similar manner in a presentation before, for instance in the background. Usually, it is not about the content of the separate sketches, but about telling a story of continuity.

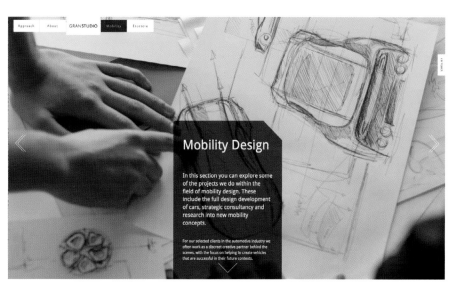

Website image from Granstudio.com: design progress

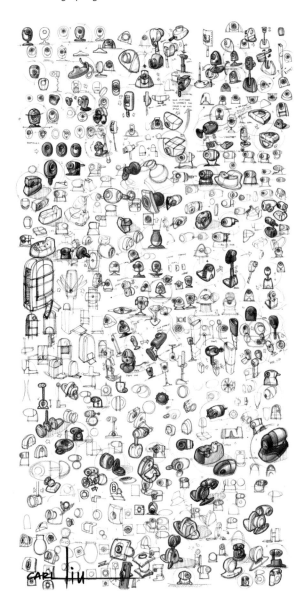

Website image from design firm MINIMAL, revealing studio workspace and various design aspects

Brainstorm sketches by designer Carl Liu

Showing thumbnails on a website not only serves as visual navigation, but can also impress the viewer with diversity and experience, thus promoting the credibility of the design studio. The sketchbooks displayed in the Pelliano case also serve to enhance credibility, being a typical designer tool for underlining the fact that you are looking at the work of a designer (and not a marketeer). The sketches being of good quality suggest that the quality standard of the design(er) is equally high. In general, being able to sketch is an archetypical perception people have of product designers.

In the ArtLebedev case study, the sketches revealed in the thumbnail also display the diversity and creativity in the approach of the studio.

In the npk design case study, the sketches depicted in the thumbnail display the precise and thorough approach of the company.

Browsing the web, you will see that certain designers only display finished products on their site, while others choose to reveal more process images. Providing insight into the working method of a company can offer prospective clients a hint as to what they can expect during a design process, to avoid any 'surprises'.
Additionally, these images can also convince the website visitor of the unique, thorough or creative approach of the studio, and they may serve to communicate that: "we take the client's opinion into careful consideration", etcetera.

Website image from 5.5 designstudio, "We are divers and we have a lot of experience"

p. 25 p. 110 p. 166

p. 195 p. 86

p. 153

4.3.3 **Logos**

In this approach the imagery is focused on convincing the viewer by means of rational argumentation. Design awards are highly convincing proof of the quality of a design. In the image of the drink bottle another piece of 'evidence' is used, namely the fact that the product has been engineered. Displaying a typical engineering drawing next to the image of the product 'proves' this. A more elaborate version of this kind of proof is demonstrated in the upper right image, where we see 'proof' of the fact that the design process was thoroughly executed, including various models, engineering phases, etc.

In the WAACS Design case, the hand holding a foam model of the concept 'proves' that ergonomics were taken into account properly. Towards the end of the process in the Tminus case, renderings take the place of sketches in communicating to the client. A CAD rendering is associated with engineering and may thus suggest technical matters have been solved. Of course, in this example that is actually true, but do consider the fact this is not always the case...
The tape drawing on the real bus in the Van der Veer case also offers 'proof' of reality: "Look, it's possible and it 'fits' the proportions".

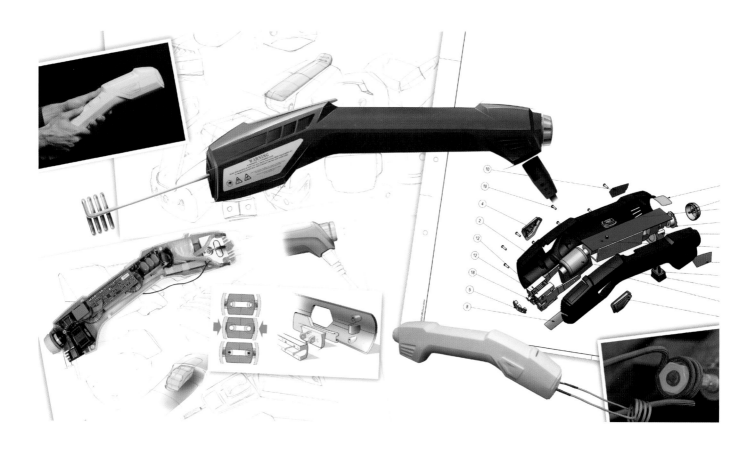

reddot design award

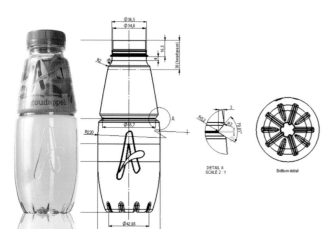

Website images from FLEX/ the INNOVATIONLAB®; iDuctor precision heater tool for iDtools (above), spices packaging for Verstegen (middle) and drinking bottle design for HERO (below)

4.4 **Rhetoric in design visualization**

A certain amount of framing is needed to communicate an innovative product that would otherwise not be understood by the viewer. Beware of the fact that too much framing causes the public to become immune to the message and, in the worst-case scenario, the imagery (and, with it, the rhetor) will lose its credibility. Just like framing, visual rhetoric itself has positive and negative sides. The latter may be the result of inappropriate or excessive use in government propaganda, advertisements, lawsuits, and media journalism. In the Oxford Dictionary, rhetoric is even described as: "language designed to have a persuasive or impressive effect but which is often regarded as lacking in sincerity or meaningful content".
Whenever images are used to convince people of design ideas, however, visual rhetoric can provide valuable tools for doing so. Even when imagery is used to objectively inform people, a rhetorical aspect, whether applied consciously or unconsciously, is almost inevitable. Internet images are frequently removed from their original context and placed into another. This could radically change the impact of an image. Be aware of what your image will look like outside its present context.
Rhetoric is all about persuasion. Sometimes an image is convincing or impressive in itself, but may be unclear as to what it tries to convey exactly. Let us assume that, in product design, there is usually a clear general message that needs to be communicated. Knowledge of visual language and rhetoric can then help make efficient choices.

Let us consider some of the cases in this book and investigate their rhetorical arrangement. Both the npk design case and VanBerlo case represent often-occurring situations. In these cases, the clients are the audience of the communication and are well aware of their product's specifics. The clients are involved in design process decisions and there is a relationship of trust between the designers and the clients.

In the Fabrique case, the client is a large company, the financial stakes are high and there are many stakeholders. The presentations were held before spokespersons, but not everyone involved was present each time. Such a situation calls for thorough documentation of both the process and the decisions, as these have to be communicated independently to all stakeholders, hence the booklets made. A similar reason for making booklets, in this case so-called 'sales leaflets', is demonstrated in the Pelliano case.

The Waarmakers case was a subsidized process with a diverse range of parties involved (the audience of the presentations). The end result was a prototype and the final renderings were made elaborately (photo-)realistic, so that they could conclude the prototype phase and be used for fundraising; seeking production investments.

The LUNAR case consists of an internally initiated project, which means that communications during the design process were strictly internal. Later on, the project was publicized on the Internet, mainly for raising funds, and new visual material was made especially for that purpose.

In the world of car design, as demonstrated in the Audi Design China case, communications are often secretive because the design ideas contain highly sensitive information. The inside audience is highly trained at 'reading' concept sketches and basing decisions upon them.

In the vdVeer case, the client (audience) is a relatively small family business and the project involves a high financial risk. Therefore, there was much communication with and involvement of the client during the project.

The Marcel Wanders case stands out with its provocative product images, initiated by the design studio. By also using these images on the Alessi website, the signature of the designer is still highly present, whereas it is Alessi who is the rhetor on their own website.

p. 162

p. 122

p. 116

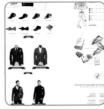
p. 27

p. 83

p. 189

p. 11

p. 152

p. 132

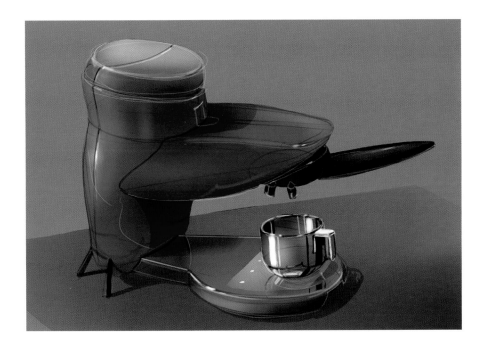

Design sketches in their context

It is difficult to evaluate a sketch, if the context in which it was made is unknown. Is it a brainstorm sketch? And, if so, then surely other aspects of evaluation apply than if it were a sketch for presentation. A handmade sketch is quite appropriate for communication at the start of a design process, or to encourage a client to participate. A sketch still looks like it is open to adaptation, in which the client can play a role. An elaborate rendering, handmade or CAD, does not invite such an interactive involvement, as it looks more definitive and finished. The context in which or from which a sketch is made needs to be taken into account when evaluating the sketch. The context is necessary for framing the work.

Chapter 3 lists various typical designer sketches. They are recognizable as such, as they are related to the design process; they have a certain sketching style, convincingly express the choices made, the creativity, determination, etc. A type of sketch that does not have this typical designer feel to it, is the (too) carefully traced sketch, lacking all spontaneity, and

with it creativity and determination. If the sketches look unconfident, then the designer will be perceived as such as well and the credibility of both the message and the maker will be undermined (ethos).

Visual pitch and persuasion

Compared to other presentations during a design process, the pitch is somewhat different. With a pitch, a design commission can be obtained. In many cases, this takes place in competition with other tenderers, making it even more important that a presentation stands out and is highly convincing or alluring. A pitch needs a highly persuasive character compared to other types of presentation. In addition to arguments that have to do with the content of the presentation ("Is this idea the best solution to the briefing?", etc.), the pitch visuals must present the idea in such a way, that they will persuade and convince the client. A pitch usually contains images of the design in a much more finished state than is it at that moment, expressing a future vision. It is this kind of presentation that benefits most from applying rhetorical theory.

Rhetorical checklist

There are a few questions one can ask to analyse the rhetorical setting of visual information, or to prepare the set-up of a presentation. In addition to clarifying what it is that you wish to communicate, it is extremely important to know the audience of your presentation. Does the audience have knowledge of the product, or the design process, are they visually trained, etc.

- Who is the rhetor? You, or do you represent a studio?
- To whom is the presentation addressed? What do you know about the audience?
- What is the purpose of the presentation, what do you want to communicate or convince the audience of?
- What strategy will you use: ethos, pathos or logos?
- Follow the three steps: selection, salience and spin. What are the grounds for your selection, what do you leave out, what can you best lay emphasis on?
- What are the important visual elements used to do so? For instance: text, combination with an image, chosen viewpoint, lighting choice, etcetera)

References

[4.1] Lidwell, William, Kritina Holden and Jill Butler, Universal Principles of Design, Rockport Publishers, Gloucester, MA, 2003

[4.2] http://nl.wikipedia.org/wiki/Framing

Van der Veer Designers, the Netherlands

Design language and logo for VDL Bus & Coach

Following the acquisitions of several bus & bus component manufacturers, the Van der Leegte Group in Eindhoven initiated a strategic project in order to merge these companies under the umbrella of a new division called VDL Bus & Coach. Together with Van der Veer Designers, a plan was drawn up in order to develop a design language and an appealing brand identity for the new generation of busses and coaches.

Easy visual recognition of brands and products is a key competitive factor in our current economy in general, and in particular in the transportation industry. Easy long-distance recognition was important (i.e. when the bus drives towards you on the motorway) and the logo had to create an impression of high quality when viewed up close.
For a new player like VDL Bus & Coach, it was important to claim a high level of quality from the start: "You never get a second chance to make a first impression".

The ideal ambassador for the new design language is the company's flagship product, the Futura FHD, which was awarded 'Coach of the Year 2012'.

We started with digital sketching, mostly with underlay photos. The upper right sketch here is one of the first sketches ever made for the project. At our studio we selected this theme (along with two other ones) to present to Wim van der Leegte (CEO) and his project team.

1040_New Futura

These sketches (with and without photo underlay) were also presented to the board. Using a photo underlay and keeping it slightly visible was a deliberate choice for the presentation of our design concepts. The reason for this was that the new Futura is based upon the structure of the BOVA Magiq. We deliberately showed the Magiq ghosting in the sketches to 'prove' that the proportions and dimensions were realistic. The conceptual design could now be connected to a known and existing design, and dimensions and proportions could be kept recognisable.

This is extremely important when communicating with people who are not accustomed to make strategic decisions on the basis of sketches.

We are experiencing a growing number of decision-makers who have difficulty in reading drawings and sketches, or anything 2D for that matter. We think this has to do with the development that nowadays Directors and CEOs of companies are no longer 'Product people' but increasingly more often specialists in financial matters.

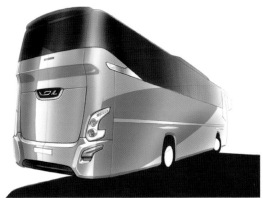

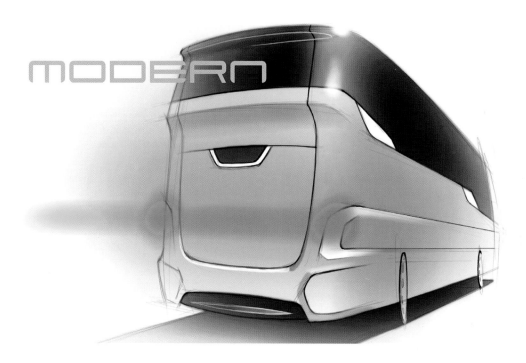

Theme sketches front and rear

The theme sketches were presented during a Marketing and Sales Conference of the International VDL organization, preceding the introduction of the new Futura, with the intention to communicate the fact that a new coach was in development.

Although the sketches were made after the design had been frozen and engineering was well underway, they are intentionally fuzzy as to represent the development stage of the design.

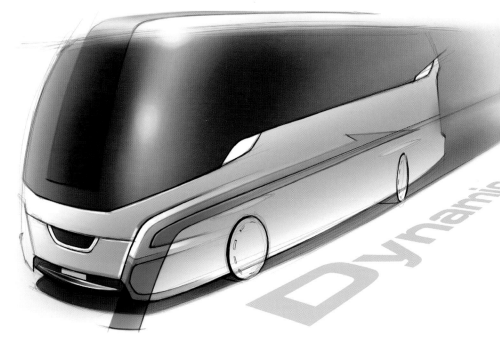

NOTE: The movement of the vehicles is represented by a motion blur of the lights; red being a signal colour, it is very suitable to serve as a visual focus. The added text in perspective also enhances the effect of speed, emphasising the desired characteristics of the vehicle.

Tape drawing

The chosen design direction was translated into so-called tape drawings, which we made directly on a bus we had at our parking lot especially for that purpose. It is important to get a feel for the dimensions of the design in reality. For a coach this is impossible to judge from a computer screen.

The images resulting from these actions were fed back to VDL. Actually, almost all pictures were shared with VDL management, but not always by means of physical presentations. We had a fairly strict regime of sending status reports.

These images were used in the presentations. Tape drawings are an effective way of getting in touch with the true proportions and dimensions of the product. Half a model was taped up to show the design development in comparison to the front of the existing coach. The upper picture shows the main features of the design. One of the key transitions from Futura to Magiq was the need for a less bulky front, and to take out the lower windscreen line typical for BOVA. This had to be done with a masking and painting exercise (including in production) which would add costs to the vehicle. With these pictures we tried to convince management to go along with that, and successfully so. The same goes for the diffusor panel below.

The resulting vector drawings were also used as input for getting our CAD guys started. From these inputs they could easily pick out sections and contours.

NOTE: Adding some detailed and realistic elements to the line drawings is an effective means of increasing realism. The dark shading of the wheel rims and tyres keeps the visual weight of the sketch at the lower half and places the vehicle firmly on the surface.

In this process, VdVD supplied a design skin and maintained responsibility for the engineering. Since we were responsible for the design skin, we were constantly communicating with VDL engineers. Panels moving relative to one another had to be checked for interference; panel interfaces and split lines were defined in a Fit & Finish Book. Here too, the pictures were used extensively in the status reports.

The result was a quality high enough to be of direct use in milling the casting moulds for manufacturing the polyester body panels. Before doing so, a 1:1 scale model was made.

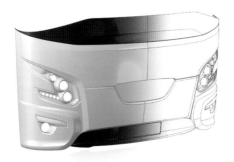

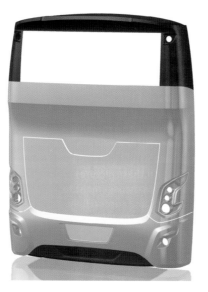

CAD rendering

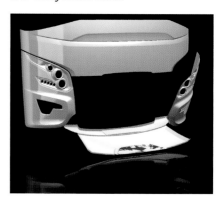

CAD interference check

Full-size model cutting, priming, refining, painting and presentation

The full-size end model was presented to Wim van der Leegte and the board, which led to a GO!

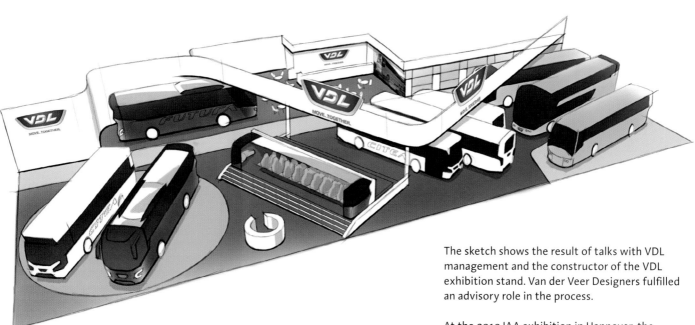

The sketch shows the result of talks with VDL management and the constructor of the VDL exhibition stand. Van der Veer Designers fulfilled an advisory role in the process.

At the 2010 IAA exhibition in Hannover, the new VDL brand was introduced, including 5 new vehicles: the Coach Futura in two variations (FHD 2-axle and 3-axle) and three variations of the public transport bus Citea (LLE, SLE and SLF), all designed by Van der Veer Designers. In 2012, the Futura was awarded Coach of the Year 2012.

Spark design & innovation, the Netherlands

Personal air and land vehicle for PAL-V Europe N.V., prototype

Since time immemorial, mankind has been dreaming of flying cars. This dream is now on the brink of realisation with the PAL-V; an innovative vehicle that drives like a car and flies like a gyrocopter. It can simply and quickly be converted from driving to flying mode. At this time, the first prototype has been developed and extensively tested on the ground and in the air.

Being one of the initiators, Spark collaborated with the PAL-V Company to create a hybrid vehicle that meets both road and aerial certification requirements.

In all phases of the development, presentation of the concept has been extremely important. Initially, for sharing the vision and obtaining funds for feasibility studies, subsequently for feeding the media and attracting investors. Finally, presentation has been important for aligning the development teams that were concurrently working on transforming the idea into a driving and flying prototype.

First idea

To kick off the project, funding was needed. The media picked up the sketches that were made in the feasibility study to visualize our vision and to inspire. The sketches show the basic idea of flying and driving and the relation to human proportion without much detail. They look preliminary and conceptual, so everybody understood that it was a work in progress, an idea.

NOTE: As the idea is non-archetypical and highly innovative, both size and usage need to be explained to the public in order to be understood. The red colour used is known (in traffic) as being a signal colour: it is associated with a 'warning sign', signifying 'danger', and thus is also an effective way to attract attention.

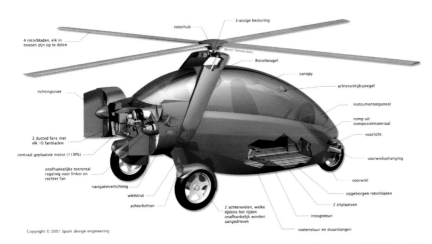

Copyright © 2001 Spark design engineering

Concept overview

We developed a global proof-of-concept design as a first development iteration. A technical illustration-style visual demonstrates the main layout, functionality, systems and key features. Cutaways, text labels, transparencies and an iconic colour help to present the concept in an attractive manner. This presentation was used for demonstrating the idea to investors, as well as for stimulating media coverage.

NOTE: by adding text to a presentation, it becomes more self-explanatory.

Rough or real?

In the early stages of a design project, we usually prefer to present images that are deliberately rough, sketchy and unfinished. This visually helps the client to be aware that the design process has not yet finished, that the current results are preliminary and may change later on. Basically, that there still is work to be done!

In a pitch, however, we may choose to make images that look a lot more like a finished product, showing results that appear more advanced and detailed than the actual phase of the design process at that moment. In these situations, we focus more on presenting what the product could be, rather than on the current stage of the design project.

Finding a shape

Concurrent with the development of the technology, we started translating the basic concept into a shape. Many options were generated with various starting points, references, stories expressing a feeling of flying and driving, etc. Motives and intentions were also jotted down.

The sketches were discussed within the design team, as well as shared with the client's, involving them in the process. The sketches are not meant to present actual solutions, but rather show and provoke thoughts, insights and styling approaches.

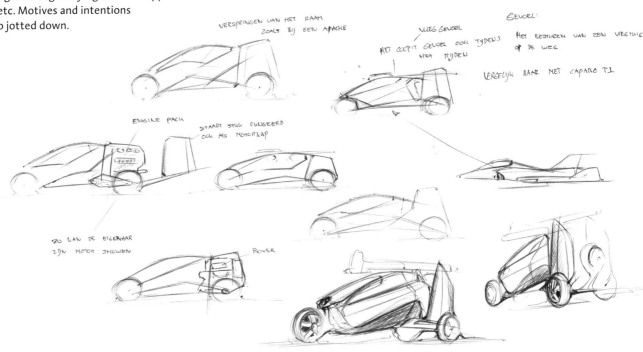

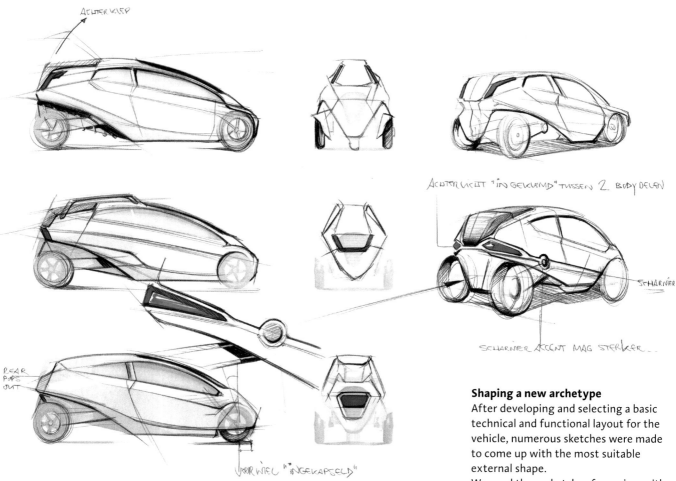

Technical consequences

The sketches of the first ideas attracted a great deal of interest. And due to these reactions, it became clear that an important requirement was placed on the product: the vehicle needed to be fully able to drive and fully capable of flying: in both capacities at least at 180 km/h. To achieve that, various alternative technical solutions were investigated for both driving and flying. In order to be able to discuss them, we roughly modelled the options in CAD and then sketched possible solutions in addition to that. It helped us quickly generate functional options, and at the same time we created a sense of what it would look like in the vehicle. By adding labels to the drawings, everyone could easily understand what the features and subsystems are, without having to visualize them in detail.

Shaping a new archetype

After developing and selecting a basic technical and functional layout for the vehicle, numerous sketches were made to come up with the most suitable external shape.

We used these sketches for review with the design team, trying to find a shape for this non-archetypical vehicle. It needed to be a credible road vehicle, as well as an air vehicle.

The sketches reflect the early stage of the design project, being bold, clear and not too elaborate. We used underlays to guarantee the right proportions and speed up the sketching process.

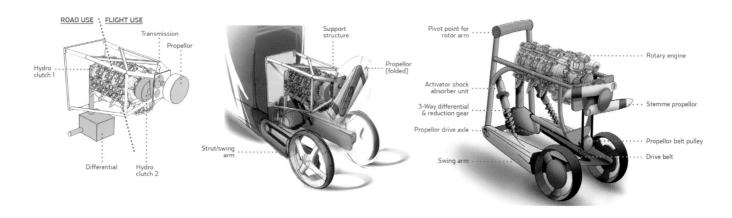

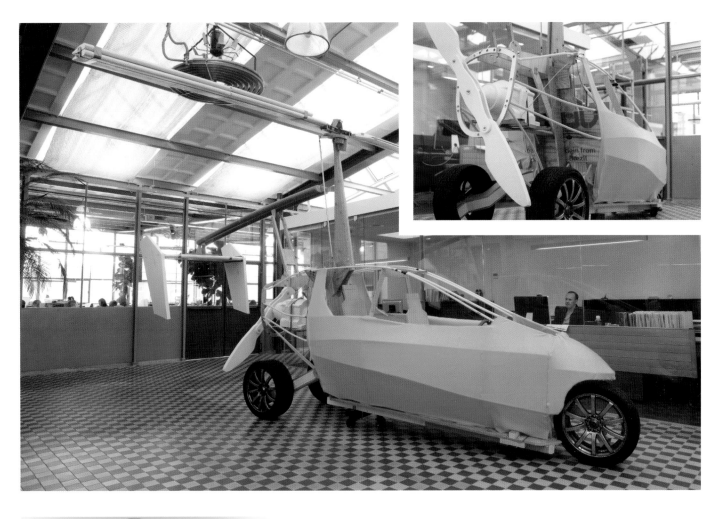

Rough models

With the use of simple materials, 'quick and dirty' models were made to focus only on the spatiality and the packaging of the design. At this stage the real scale of the vehicle could be experienced and the models served as a reality check for us, while also embodying what to expect in presentations to the client. In addition, it allowed us to take place in the design as a user and judge the accessibility of the controls, the dashboard and the lines of sight. At the same time, digital sketches were made to explore the best solution for steering in both the driving and the flying configuration.

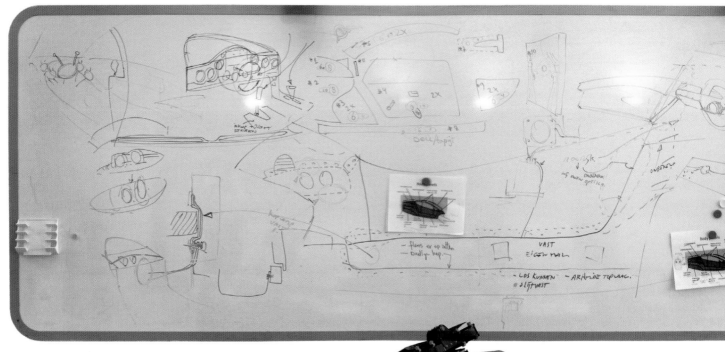

Visual dialogue

We used our massive 6 meter wide
whiteboards to create a visual pool of
thoughts. In contrast to a computer screen,
where space is relatively limited, this large
physical surface area really helps in showing
a lot of information at the same time. And
it allows for structuring, connecting and
clustering of the ideas.

Together with the client's team we were
sketching, modifying, erasing, and adding
printouts to create overview and insight.
It's really important to us to visualize during
meetings, in order to allow the dynamics of
ideas to generate, to discuss them and to
make sure we're all on the same page.

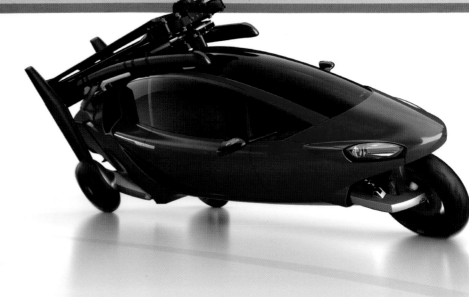

Almost real

In the product development process, we
try to have our visuals express the stage of
the project. At the start they should look
preliminary and sketchy, but nearing the
end of the design process we want them to
look a lot more realistic.

By then, details have already been designed
and we want them to be visible so they can
be evaluated. The image should reflect a
product photograph, as though the vehicle
already exists. A viewpoint has been chosen
to create a dynamic experience of the
vehicle.

We used a neutral background for the
image, so it's easy to use for multiple
communication purposes.

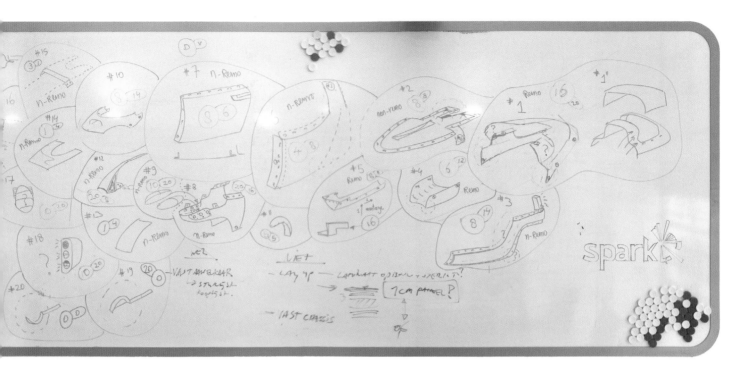

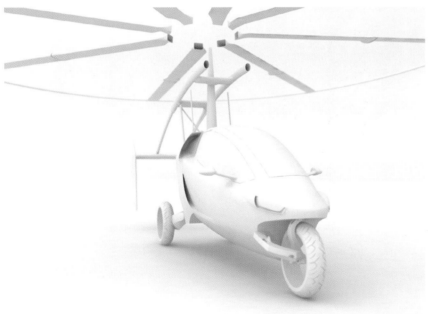

Presenting without shape

In early phases of the development process, we sometimes want to present concepts in a more or less abstract manner, i.e. show an overview of the complete product, the layout and structure, and the functional solutions. This way, we are not distracted by exact shape, colours or material expressions.

Showing something without a shape or colour isn't really possible, but we found that making renderings in plain matt white helps. It creates a more abstract image, which allows you to focus the discussion on the fundamental characteristics of the design.

It's like making a rough model in grey foam, lacking detail and without colour selection or differentiation, texture and finish. And even then, clients may still sometimes confuse this abstraction with an actual styling proposal!

Real

Images of the end result of the project – in this case a working (flying!) prototype – are very important in creating convincing communication towards investors and customers. It shows the feasibility of the product, possible uses and commercial value.

In the end, the product presents itself to the world.

Design Case

npk design, the Netherlands

Corporate identity and products for SKS Germany

SKS has been manufacturing bicycle accessories since 1932. As the new long-term design partner for SKS, and in cooperation with the company, npk design analysed their brand, their products and their end-users for a strategic reorientation.

The products serve three target groups: mountain bikers, racers and all road cyclists. All points of contact with consumers must be focused on providing consumer-oriented clarity: which product is meant for me?

In order to achieve this customer service target, we suggested three product lines (urban, road race en mountain) and developed an individual style guide for each. This style guide provides a starting point for product design, packaging, product graphics, website, catalogue, advertising and sales.

For the development of the design language of the products, the main focus has been on the users. On the basis of workshops, the brand identity, themes and values of SKS were linked to the results of research into target groups, trends and developments. Per target group, user personas were identified and mapped out. This approach led to the style guides for the three target groups.

We designed a range of mini pumps, floor pumps, mudguards and fenders for bicycles of which several are displayed in this case.

Because we took the time to jointly develop a clear vision for the future of the brand at the start of the project, we now completely see eye to eye with our client, often only needing a few words to understand each other.

ROAD

ALLROAD

MOUNTAIN

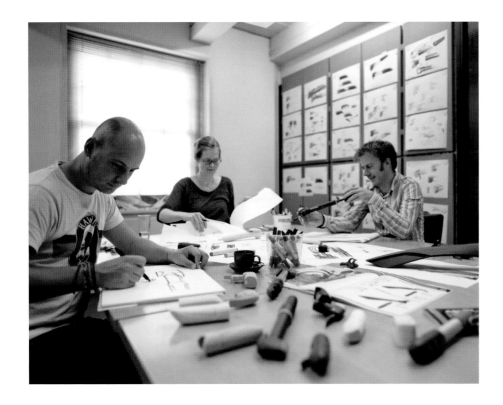

NOTE: npk design chooses to make many sketches, preferably together as a team. As these sketches could also be communicated to the client, the team strives to keep a consistent style in their sketches. Of course, each designer has an individual style, but their aim is to maintain a general npk design style.

During the project, sketches are attached to the wall, remaining visible while sketching, to reflect on at a later stage and to make ideas visible and 'contagious' within the company.

In the initial design phase, the client is shown these sketches in our conference room. Together with the client we discuss the designs and distill or combine potential ideas. While sketching on the spot, the next phase is then already initiated; the concept development.

In this phase, we process all the client's remarks and input from the sketch phase. We do this for several concepts, up to a certain level of detailing, more or less equal for each concept. In most of our projects, the transition from sketch to CAD is made somewhere during this phase. In order to continue exploring many details, handmade sketches on paper and vector sketches are made simultaneously.

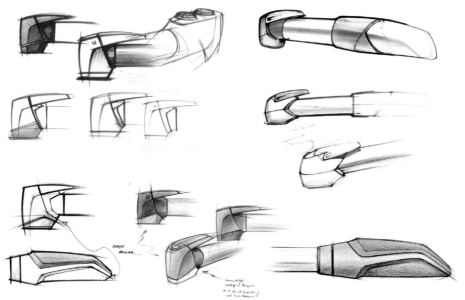

These sketches are also presented to the client. They no longer serve as a basis for making decisions, as the sketches in the initial design phase did. At this point, they serve to provide our client with insight into how we came to the CAD drawings. To save time, the CAD models are usually shown as screenshots.

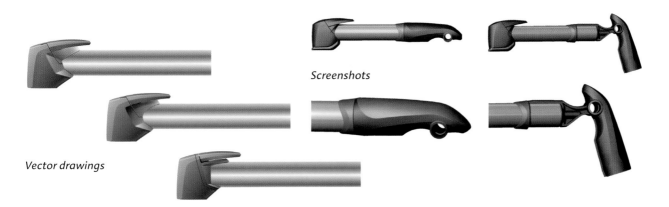

Screenshots

Vector drawings

On the basis of, say, three CAD models a final product choice is made. This is then further elaborated on, to make sure that all product details are of a high enough quality. We communicate the end result as a realistic rendering.

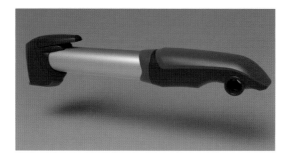

Product rendering

Some of the products are based on already existing parts from earlier products. The sketch shown below is based on new details and functionality. The main focus of this sketch was making the added features clearly visible for the end user. A high level of detail and material expression is communicated, as the process of ensuring that all the parts of these combined products are aligned and consistent, requires great attention to detail.

Product photograph

iF
product
design award

2012 ■

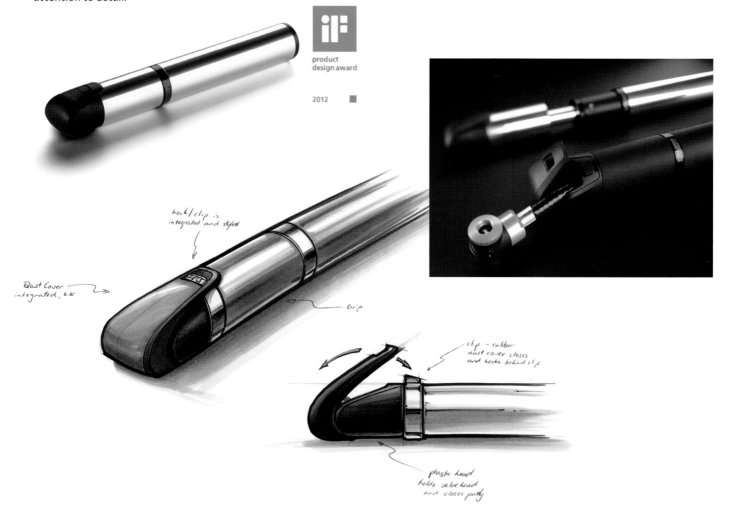

hook/clip is
integrated and styled

Dust Cover
integrated, 2k

Grip

clip - rubber
dust cover closes
and hooks behind clip

plastic head
holds valve head
and closes partly

The upper left image demonstrates the initial sketch phase for the design of a floor pump. To find ways of adding more value to elements of a new product, we try to show the effect of using different materials and different colours for certain parts while, at the same time, trying to reduce costs.

At the centre of this page, you can see a sketch that is clearly from a somewhat later design stage. The sketch is more refined. A shape exploration of the foot of the product is depicted, plus a side view. Products are a combination of different elements. Achieving consistency among all parts and details of the product is key to a successful design. In order to show how all the parts work together, we make these complete views of the products, demonstrating the relation between elements.

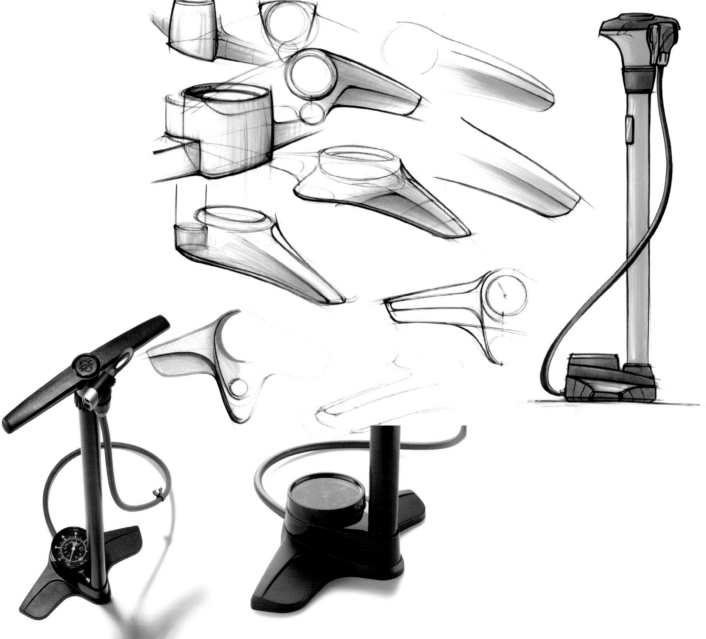

This page displays our previously described process for a product that was launched in 2012. It is a set of front and rear mudguards.

First, we concentrated on the rear mudguard, again producing dozens of sketches, which we considered together with the client. These first sketches are used for building all aesthetic aspects such as proportions, surfaces, rhythm, folding lines and treatment. They are also used for finding smart and feasible solutions to technical challenges.

After discussing these sketches, we eventually selected a sketch from an earlier project for SKS to use as a starting point to build on. In the earlier project, that particular sketch had been too high-end, but here it fell exactly into place. The sketch was so to the point, we were able to skip a complete development phase and immediately start with refining. Additionally, the CAD phase required only one round before reaching the final result.

Initial sketches – connector between the fender sides, aligned

Initial sketches – lines direct to rotation/ connection point

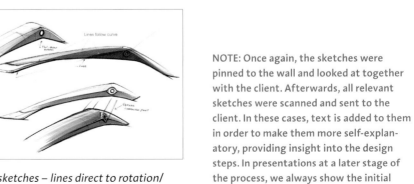

NOTE: Once again, the sketches were pinned to the wall and looked at together with the client. Afterwards, all relevant sketches were scanned and sent to the client. In these cases, text is added to them in order to make them more self-explanatory, providing insight into the design steps. In presentations at a later stage of the process, we always show the initial sketch that lead to the concepts.

vWe then took the design for the rear mudguard and distilled the front mudguard from it. In the case of this 29-inch front mudguard, we had to find a way to use the same tooling for the rubber components of the rear mudguard and still have a clear and consistent shape at the front.
These initial sketches show how folding lines and surfaces are being explored.

NOTE: The design is rendered attached to a bike and surrounded by neutral grey to connect it to its user context in terms of size and usage.

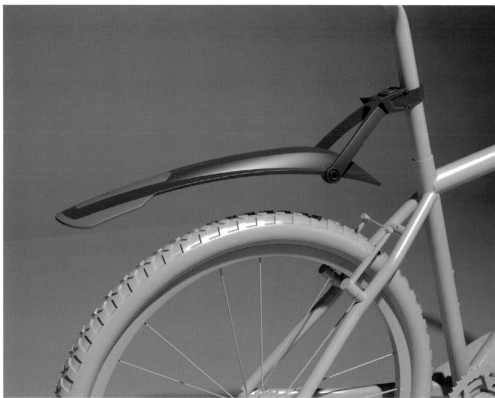

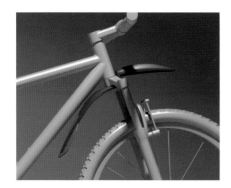

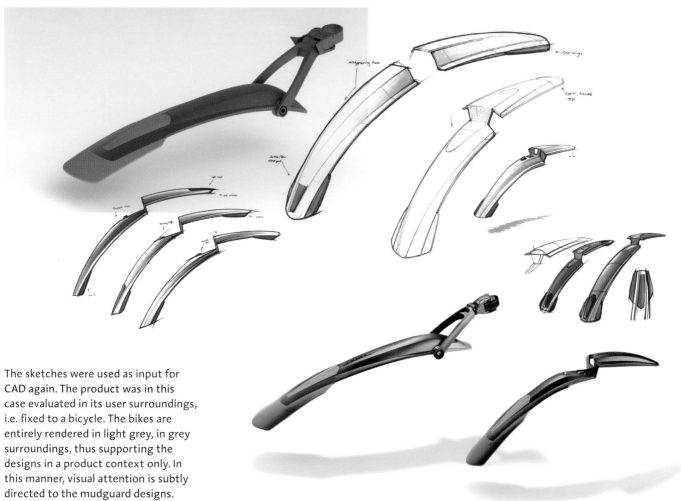

The sketches were used as input for CAD again. The product was in this case evaluated in its user surroundings, i.e. fixed to a bicycle. The bikes are entirely rendered in light grey, in grey surroundings, thus supporting the designs in a product context only. In this manner, visual attention is subtly directed to the mudguard designs.

Design Case

Reggs, the Netherlands

Vita-Q, Design and development of an anaesthesia and ICU ventilation unit for AlcmAir

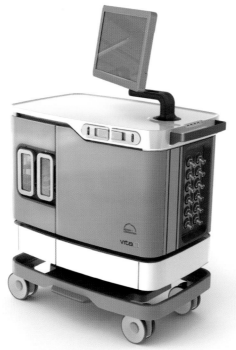

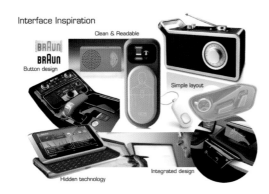

Interface Inspiration

BRAUN
BRAUN
Button design

Clean & Readable

Simple layout

Hidden technology

Integrated design

Sketch phase

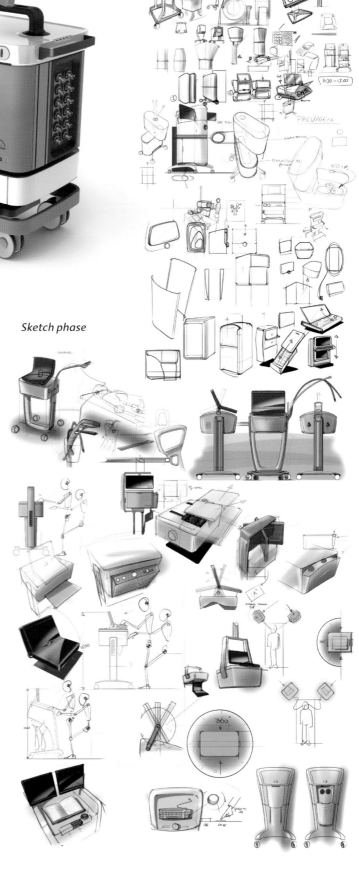

Design brief

Based on an innovative new system design for an anaesthesia appliance, AlcmAir asked Reggs to design the VitaQ with a focus on usability for the end user, the anaesthetist, in order to secure the best possible treatment for the patient. All in the name of VitaQ; Life and quality.

The VitaQ guarantees a safe and optimal treatment of the patient through technological accuracy and system speed. Reggs was responsible for Usability & Design in a co-design project with the client, AlcmAir, who are medical specialists and technology developers. Reggs engineered the mechanics and managed the prototyping. The user interface was designed during the product design phase and offers optimal flexibility to the user, from manual control to a full automatic self-learning expert system.

The client gave Reggs carte blanche to design a new anaesthetic machine.

NOTE: In order to get the right look and feel, Reggs made mood boards to make it easier to communicate these delicate matters to the client.

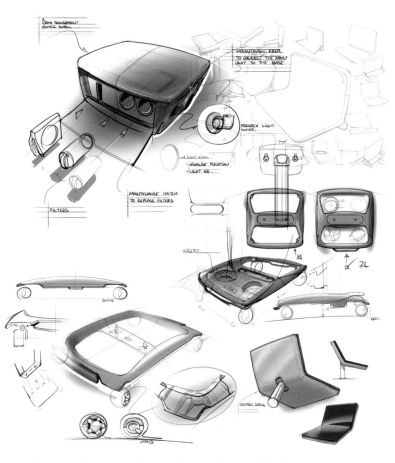

Ergonomic concepts for monitor, canisters and brakes

These first doodles and explanatory sketches are meant for ideation, but also for communicating technical, structural and ergonomic possibilities for internal communication. The sketches were also compiled into a presentation and were shown and presented to the client. The main reason to do so was to get a feel for what triggers the client.

We made the sketches here in order to explain to our customer the plan to add lighted rims around canisters and filters to light up when the product is in error or needs to be replaced, and other subideas. The sketches were interpreted correctly, as the client was closely involved in the process and design thinking.

Concept phase
During operations in the OR, we observed the working method and we interviewed several anaesthetists in order to come up with three concepts, all with a different approach to anaesthesia. The three rough concept presentation sketches were enlarged and printed on a 1: 1 scale. The prints were mounted at the correct height in the conference room where our client, a number of medical professional advisors and the design team, reviewed the style and their first impressions of the three different concepts regarding look and usability.

The goal was to evoke many reactions that we could use as input for the next design stage. We used clear and rough sketches, because they can be interpreted flexibly as to reflect the early stage of the design. The decision was made to continue with the concept on the right, due to its compact shape and flexible method of use.

First approach concept design

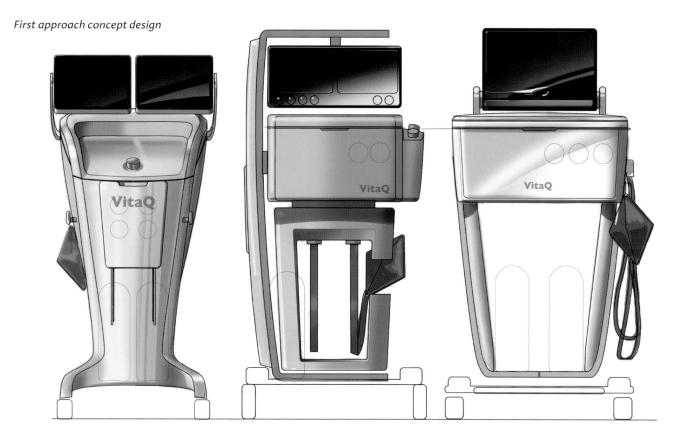

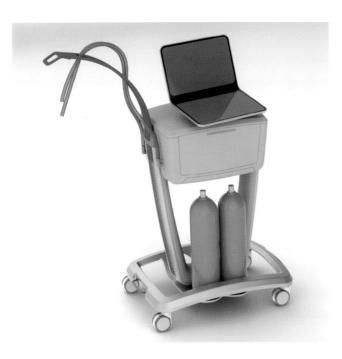

Designer-engineer communication
The exterior sketch phase ran parallel to the interior technical design phase, during which communication between engineers and designers was critical. At some points aesthetics dictated technology and at others it was vice versa.

This first design was used to make a first working model according to AlcmAir's system design. The most promising concept was debugged, modelled and rendered in CAD. The resulting images were communicated to the resale partner, with the message that we are in the process of designing a product that stands out in the market due to technical specifics, design and size.
It is more compact in size compared to the current products on the market today.

Quick ideas on where to place additional gas/co2 bottles and how to fasten them on the frame, etc.

Creating an anaesthesia workspace

During this phase, the configurations of the VitaQ and the add-ons were specified. We used sketches to visualize the possibilities and the consequences of choices. The sketches were presented to the client and discussed with the medical experts and the development partners. At this stage, the final requirements were defined. In 4 months' time, sketches were developed into a fully defined CAD specification and a second working prototype.

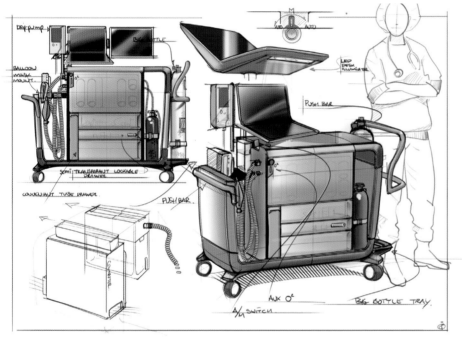

Worst-case scenario, if all requirements are implemented as requested

This sketch on the left we called 'the reality check'. During the process, the program of wishes and demands was altered; along the way, more demands were added. In this Reality Check Sketch, we implemented all of these added changes. We then presented this sketch to our client to show the consequences of implementing all their wishes.

After collaboration with our client, the decision was made to design a compact anaesthetic unit with a modular extension possibility to convert to an anaesthetic work desk. The technical aspects and the styling were merged into a CAD model and developed into a working prototype.

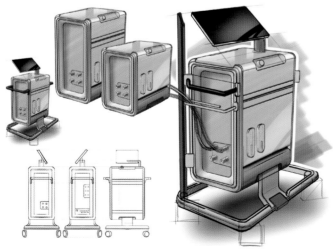

The compromise, full specifications

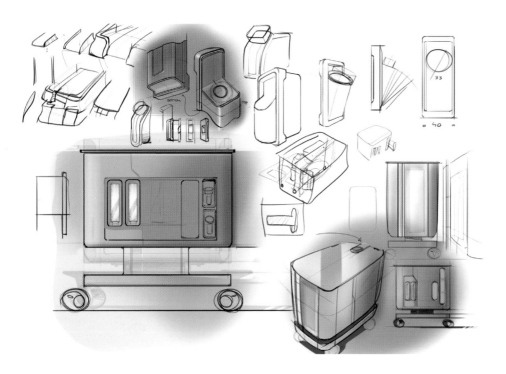

Pre-production phase

The second prototype was reviewed by the sales department. Additional requirements were added on the cleanability of the internal components and the necessary configurations. Reggs developed the internal parts of the machine with a high level of integration of all the functions. New design sketches were drawn up to make the VitaQ sexier. In this final set-up, the internal components were integrated in the design of the casing according the comments from the medical specialists.

Looking to streamline

Due to a dynamic range of demands, wishes, spaces, structural and technical limits, we were constantly sketching different solutions for different scenarios on different parts of the product.

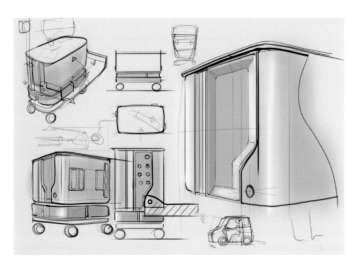

Front and side panel face design with ergonomics as key issue

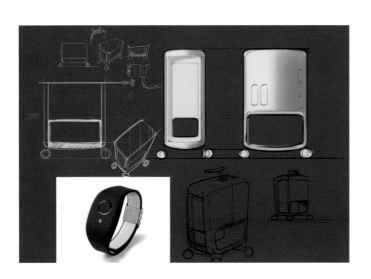

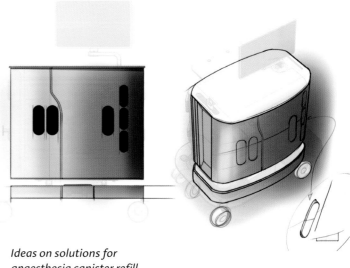

Ideas on solutions for anaesthesia canister refill, anti-leakage, safe storage, readable level indicator

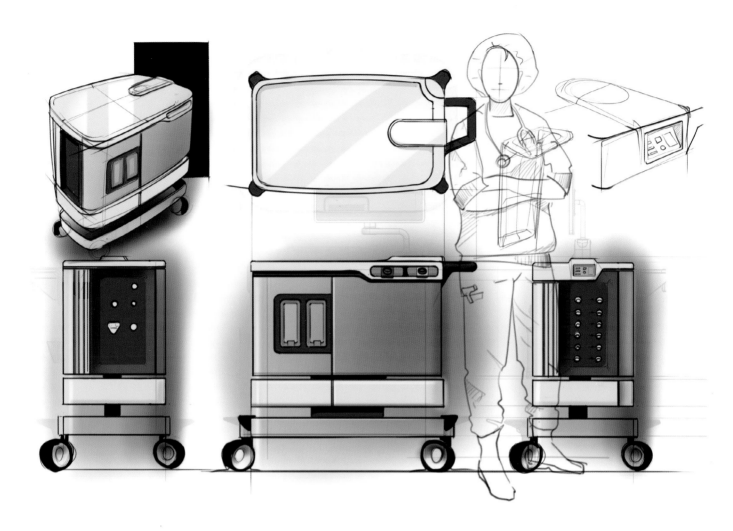

Pre-production model

After a positive evaluation of the prototype by our client AlcmAir, the medical specialists and the technical development partners, we continued with one more optimization round in the design.

The sketch above was presented to our client and after approval we started pre-production. This was the last and final sketched design proposal that we showed to the client. From this point on, we communicated with renderings retouched in Adobe Photoshop to prevent any miscommunication.

Based on the final design sketch, Reggs visualized the complete design with computer renderings, which were leading for all the development partners in the final technical development and specification of the VitaQ. Two pre-production models were presented during the Medica fair. A series of ten were manufactured for testing and CE marking. Sales and production start in 2014.

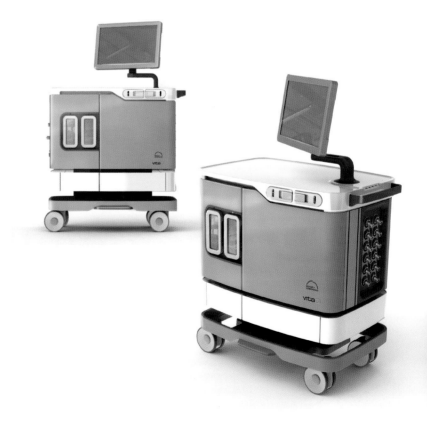

CHAPTER FIVE
Holistic approach to perception

Information exploration should be a joyous experience [5.1]

A presentation, especially a visually complex one with a combination of text, photographs, sketches and renderings, can have an impact on a person at various perceptual levels. This final chapter discusses the perception and creation of a visual presentation, taking these levels into consideration.

5.1 **The Process of Perception**

Perception can generally be described as "...the process by which an individual selects, organizes and interprets stimuli into a meaningful and coherent picture of the world..." [5.2]. When we see everything around us, our brain is bombarded with visual information: stimuli. This is far too much for our brain to process, so we make a selection of things we do and do not take note of. We tend to respond to meaningful stimuli and ignore or minimize others. Several people can perceive the same image quite differently, as our perception is not only dependent on what we see, but also on the rhetorical setting in which we perceive and on who we are. The nature of the setting interacts with our expectations and thus determines what will be regarded as exceptional or irregular. And in addition to that, a viewer has certain expectations, interests, motives and emotions.

Most psychologists describe the perception process in terms of three stages: select, organize and interpret [5.4].

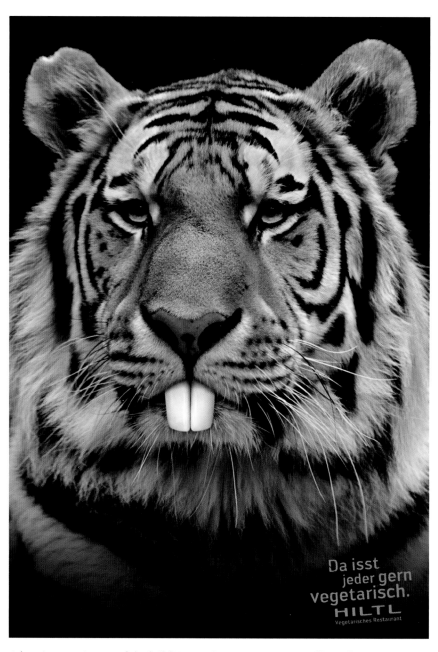

Advertisement image of the 'Hiltl Vegetarian Restaurant: Tiger' by Ruf Lanz, Switzerland

Selection of visual information occurs in the first split second, during which you decide "will I look at it or not", "am I attracted to it or not". This is where your reptilian brain comes in, supported by the Gestalt Principles.

To organize means to arrange various stimuli into meaningful patterns and classify what we see. This also occurs with the aid of the Gestalt principles, figure/ground perhaps being the most important one, after which further perception steps are taken.

Interpretation occurs according to our knowledge, assumptions, values and attitudes, including our learning and experiences from the past. We look for the intention of what we perceive. Interpretation is the most subjective process of perception, influenced by the viewer to the highest extent [5.5]. This is where semantics play a significant role and thus the importance of knowing one's the audience as well.

5.2 The AIDA model

A well-known model commonly used in advertisement shows similarities to the perception model above, namely the AIDA model, created by Elias. St. Elmo Lewis in the early 1900s. This approach is used to describe the different phases that occur when a consumer views an advertisement, and therefore helps develop effective communication to customers. It is one of the founding principles of marketing and advertisement [5.6]. AIDA is an acronym for Attention, Interest, Desire and Action. New phases such as Confidence, Conviction, Evidence or Satisfaction have later been added.

Attention: The ability to attract the customers'/viewers' attention.

Interest: Getting the viewer's interest goes deeper than the process of grabbing their attention. Here, framing can be applied by focusing on the advantages and benefits of the subject matter, or by making popular statements. Light-hearted facts, unusual headlines, are more easily digestible for a divers public than hard facts. This helps to highlight information that is relevant for the audience in an accessible and easily comprehensible manner.

Desire: This is related to the ability to persuade (rhetoric) the viewer that he/she in fact wants the product: "Jim, it has changed my life, how could I have ever done without it".

Conviction: This phase was added later on, as over time people grew sceptical of advertisement and demanded evidence [5.8]. Therefore, at this point, hard evidence is used to convince the viewer (logos in rhetoric).

Action: Prompting the viewer to act with information how he or she could do so. In marketing this means the that viewer buys the product; in crowdfunding it may mean that a person decides to back a product.

5.3 Three distances at which to look at things

Equally demonstrating similarities to the perception process in general, one can also detect 3 phases for perceiving (complex) visual information. Imagine you are at an exhibition or looking at poster presentations at a graduate exhibition. In these situations, the viewer (audience) will be overwhelmed with visual stimuli and will have to make a choice as to what to pay attention to and what to neglect. In these intense situations, you will probably experience 3 phases:

1 > **from a distance** > (split second) The viewer's choice; he or she decides what to go look at.

2 > **a little closer** > (few seconds) What is it? The visual information is organized by the viewer to extract meaning.

3 > **zoom in** > (after several seconds) I want to know more. Details are observed and the viewer becomes interested or even intrigued.

When you enter that exhibition room filled with poster design presentations, you will quickly scan the room to select the first object your eyes will rest upon. Your gut feeling will guide you. That first selection is made in a split second, and from a distance.

Shortly after, still within the first few seconds, you will probably seek an answer to the question "what is it?" or "what is it about?". You will probably start walking towards the poster to find out.

If you are satisfied with the answer and still attracted to the poster, you will want to know more. This 3rd phase occurs at a closer range. In this phase, you are likely to be interested in the visual and will be looking for more information. You will want to know more about the design, whether it is feasible, how it works exactly, will your expectations be met, etc.

A similar visual information-seeking mantra from the field of infographics is: Overview first, zoom and filter, then details on demand. [5.1]

It is important to realize that it is not only crucial to get the viewer's attention at first glance, but also to hold onto this attention throughout the three phases. In addition to the fact that it will probably not actually be possible to show everything at once, being aware of these different phases can help one 'dose' the information accordingly. Leave a little unexplained (maybe visually hinted at) so that the viewer will wish to continue to the next phase and will be satisfied once he/she arrives there. Knowledge of how to achieve a visual hierarchy or a narrative structure as described in Chapter 2 on Gestalt is crucial.

Narrative structure

Setting up a narrative structure can be of great help to presenting (complex) visual information. What are the main components of the story and how will they be sequenced on the page(s)? [5.3] This can be done by means of a plan sketch for a presentation. Analyse what your story is, and then find the best way to tell it by dividing it into easily digestible chunks, without loosing its depth. Define a hierarchy: what should stand out at first glance (from a distance), what should be visible to aid understanding of what it is (second distance), and what details will the viewer want to discover as he or she zooms in?

1 The viewers' choice

Of course, there is no general recipe for making a visual attractive or eye-catching. However, we can derive many aspects that attract from the reptilian brain theory, visual semantics and Gestalt principles. By creating a focal point (Gestalt) one's attention can be directed towards something. One can also play with the reptilian brain interests: Can I eat it? Can I have sex with it? Will it kill me? [5.9].

There are also some visual aspects that are known to attract attention, as demonstrated in the Gestalt chapter [5.10] [5.7].

Contrast: a sketch with stronger contrasts stands out among the rest. Be careful, however, to keep the visual balance intact; too much contrast (or any of the following aspects) creates a displeasing image.

Intensity: a sketch with many bright, saturated colours, thick lines that stand out, or more detail will attract attention. Indeed, a picture usually stands out more than a sketch.

Colour hue: some hues simply stand out or evoke a certain emotion or (semiotic) meaning.

Dissimilarity: something that is different will stand out. For example, a different sketching style, colour, etc. In addition, a familiar object in an unfamiliar situation or a novel product in familiar surroundings also attracts attention.

Size: obviously, the bigger the sketch, the more you will be forced to notice it.

Location in the layout: some areas automatically get more attention; the centre of an image and anything moving in the reading direction, for example.

2 What is it?

It is important to display a clear and visually interesting message. It is at this moment in the process, at which the main features of the design should stand out or at least be easy to understand. Do not try to display all the information at one glance, or with equal importance. Organize your info to guide viewers through the various stages of interest. Make sure there is a visual hierarchy: a focal point supported by accents. Furthermore, in combinations of sketches, show which one(s) is/are more important than others. A good thing to start with, is to try to capture the core of your design idea in just a few words/concepts and point out the main characteristics of the idea. Let the main info (features or uses) clearly stand out from a distance. It is also helpful to aim for neutral connotations in the design. This might sound obvious, but being highly involved in a design process, we have witnessed more than one student turn 'blind' to the most obvious information.

On the other hand, ensure that the presentation remains visually interesting, otherwise you might lose the attention of the viewer.

In case of complex information, a visual hierarchy is necessary for 'chunking down' complex information. Colour unity may adequately support this, as too much (visual) complexity or diversity will cause the viewer to lose interest. Limiting the number of different colours (and fonts) will help you create a sense of unity in the composition.

3 Find out more

Of course, the aspects described here are concerned with the presentation of a design, and not the design itself. It goes without saying that the idea itself should also have a certain quality for the viewer to become intrigued with it. If visual material is persuasive and convincing (rhetoric), the viewer will be more likely to be interested, and eventually intrigued. At this point, attention has wandered into the level of detail. Again, a visual hierarchy will support the visual hints of what to look at next.

Overall impression

Once you have pinpointed the main characteristics of a design, these aspects could also help in maintaining consistency throughout the presentation. The idea behind the design concept can usually be incorporated into the design of the presentation itself as well. If a certain look or feel is highly important in the design concept, the presentation could be created to have that look and feel itself. Layout decisions can be based on this so that the layout style is made to match the design proposal.

In a presentation in which all three levels are well-represented, the viewer will of course first perceive the info according to those levels. An effect that also occurs, in our experience, is that the viewer will then shift in terms of (mental) distances regarding the presentation. Zooming in and out at one's own pace enriches the viewing experience and causes a comfortable alteration in cognitive load. Appealing to different aspects of the brain, for instance experiencing beauty and semantic diversity at the same time, enhances the visual richness of the presentation.

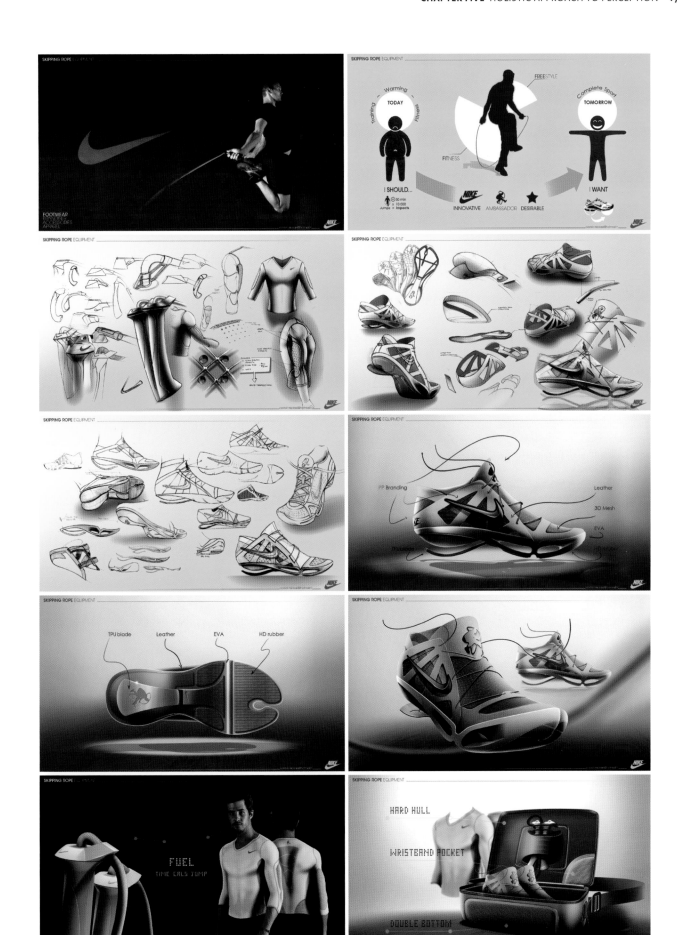

5.4 Cognitive load theory

Our brain constantly filters the visual
information it receives. The effort it
takes to do so is referred to as cognitive
load. As we have seen in the previous
paragraph, it is possible to present visual
information in a way that anticipates
this process and generates order before
people's brains try to do this themselves.
[5.3] If a presentation is organized in a
manner that enables the viewer to filter
out relevant information more easily, we
can actually save the brain some work.
This is what the Cognitive Load Theory
suggests. On the one hand, the brain
rejects excessively complex information.
However, as we concluded in the
Gestalt chapter, we cannot simply make
visual info as simplified as possible,
as the brain also rejects excessively
simplified information. It just cannot
stay interested. You need to ensure that
it is not too easy, but also not too hard
to find information. In other words,
you need to 'balance' the cognitive
load it takes to perceive a presentation.
However, as we have seen information is
not perceived the same by everyone. It is
hard to control the subjective influence
of the viewer, his/her earlier experiences,
tastes, etcetera. Again, this reveals the
importance of knowing one's audience,
as stated in the rhetoric chapter. Not
only in terms of knowledge of the
expertise needed for understanding
the message, but also in terms of visual
literacy, for example; a visually trained
person will have less trouble (cognitive
load) deciphering complex visual
information than, say, the audience of
a user (consumer) survey.

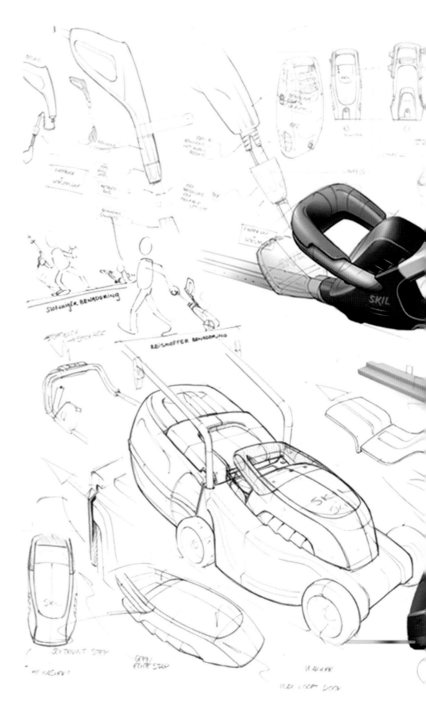

*Website images of FLEX/theINNOVATIONLAB®, the Netherlands,
revealing typical product design sketches and design processes*

*Text can be hard to read, attract too much attention
or be disregarded*

Text can be hard to read, attract too much attention or be disregarded

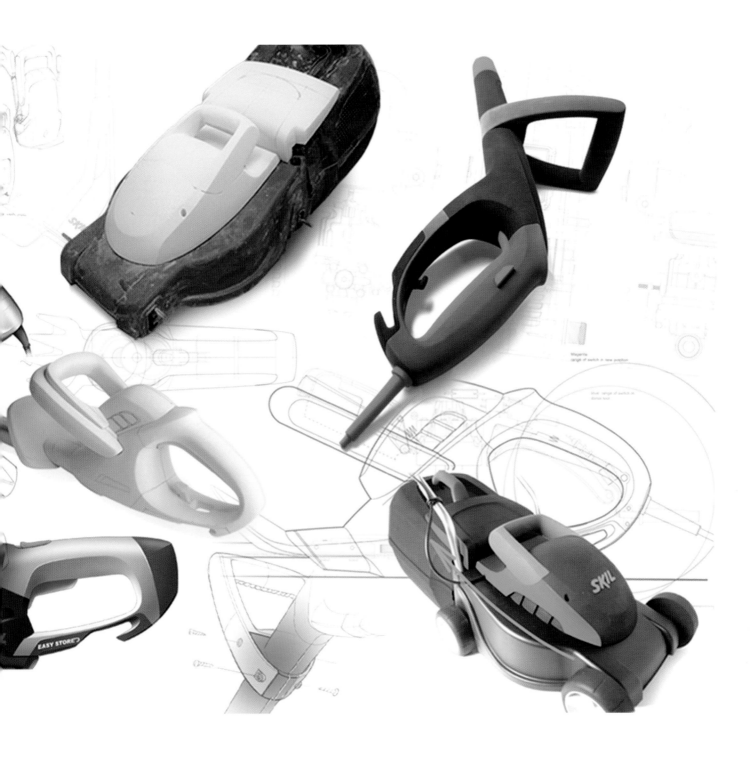

For instance, choosing a font for your (portfolio) presentation also involves Gestalt. Some fonts may be beautiful, but difficult to read. It is wise to avoid a font that is too decorative or starts to interfere with pattern recognition in the brain [5.9]. Do not pick your fonts too small either; if a text is (too) hard to read, its meaning will be lost.

Another note to make, is on that which you might call 'the contrast effect'. What is it that the viewer has seen just before? A mediocre presentation will be perceived as being of poor quality, if it is viewed right after one or two really appealing ones. The same presentation might be perceived much more favourably, if it is seen just after one or two presentations of bad quality.

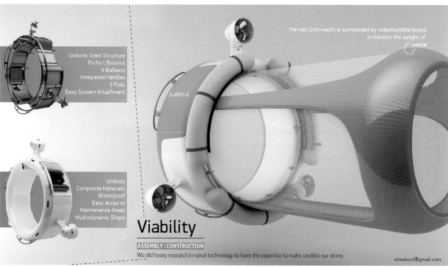

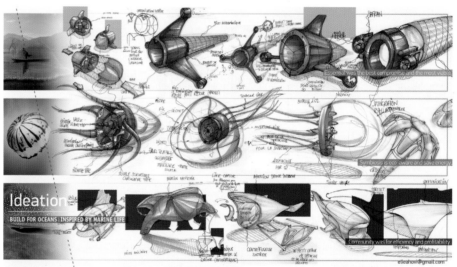

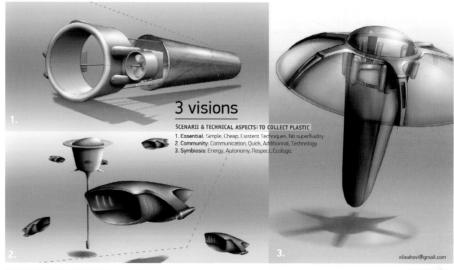

The Drone 1-001-1 is a marine drone equipped to collect the plastic waste in a trash vortex.

Images of the website portfolio of Elie Ahovi, IL, derived from the portfolio website www.behance.net

Design – Elie Ahovi, Adrien Lefebvre, Philomène Lambaere, Marion Wipliez, Quentin Sorel, Benjamin Lemoal 3D modelling – Quentin Sorel, Benjamin Lemoal Render – Elie Ahovi, Quentin Sorel, Benjamin Lemoal (started off as a student project at the ISD Valenciennes)

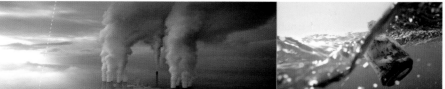

5.5 Why complex information should be beautiful

Emotions change the way the human brain solves problems. When people are afraid, or highly anxious, the mind is able to focus well on one activity; the one needed to survive the situation [5.11]. Anxiety narrows down the thought processes. Anxious people look for details. When someone is too stressed, this focus gets out of hand and we experience so-called 'tunnel vision'. This narrows our view in search of solutions to a problem.

But with just a moderate amount of stress, this focus of the mind may result in great efficiency. This is why some people set their deadlines at work a bit tight, which creates a certain level of stress; just enough to be effective for getting your work done.

The opposite of this focus, is a 'widening' of view, which is evoked by pleasant emotions. In such a situation, we are more susceptible to creative 'out of the box'-thinking. When you feel good, you are better at brainstorming, more creative and more imaginative [5.12]. When a pleasant atmosphere is created, brainstorming works better. Pleasant emotions, evoked by the beauty of a product, actually make finding out how it works easier. Not because the object works better or simpler, but because it causes us to be better at problem-solving. When we experience pleasant emotions, we are less annoyed when an attempt does not work, we are more tolerant and we simply look for alternative solutions.

Similar factors are at play in the perception of visual information. A visual presentation that is quite complex becomes more easily readable when it is aesthetically appealing. When looking at a presentation that we do not experience as appealing, we get annoyed more easily if it requires us to work in order to get the information we need. When we experience visual beauty, we are able to cope with more complexity.

The portfolio presentation displayed here is consistent in its look and feel. The visual information shows a pleasant variety of both catchy (big) and detailed information. The most important features stand out, also at a visceral level. It is recognizable, yet not completely clear at first instance. Its visual beauty overrides the non-understanding and makes it intriguing. Wanting to find out more, the viewer zooms in and is rewarded by finding out what the presentation is about.

References

[5.1] The Eyes Have It: A Task by Data Type Taxonomy for Information Visualizations – Ben Shneiderman, University of Maryland, 1996
[5.2] The concise Oxford Dictionary, Oxford University Press
[5.3] The functional art, an introduction to information graphics and visualization, by Cairo, Albert, NewRiders, 2013.
[5.4] http://socyberty.com/psychology/the-stages-of-human-perceptual-process
[5.5] www.reference.com/motif/science/perception-process-stages
[5.6] www.boundless.com/marketing/integrated-marketing-communication/ introduction-to-integrated-marketing-communications/aida-model
[5.7] http://advertising.about.com/od/successstrategies/a/Get-To-Know-And-Use-Aida.htm
[5.8] www.mindtools.com/pages/article/AIDA.htm
[5.9] 100 Things: Every Designer Needs to Know About People, Weinschenk, Susan, Ph.D., New Riders, 2011
[5.10] www.universalteacherpublications.com/mba/ebooks/ob/ch2/page3.htm
[5.11] Emotional Design, Norman, Donald A, Basic Books, New York, NY, 2004
[5.12] Psychologist All Isen in [5.11]

Design Case

LUNAR Europe GmbH, Germany
VELA cycle trainer, internal project of LUNAR Europe

LUNAR is one of the top ten design firms in the world.

Home fitness equipment usually looks as though it belongs in a torture chamber – chunky and heavy, it often leads a shadowy existence in the guest room or basement. That's hardly surprising in light of the fact that most gym equipment is exclusively developed for use in professional fitness centres. The designers at LUNAR deliberately set out to change this.
Accordingly, we have brought together the traditionally contrasting themes of fitness and living in the form of new design objects that are avant-garde and highly aesthetic.

Our goal was to create highly functional fitness equipment which, in addition to its sports use, will adorn any living room in the same manner that an aesthetic sculpture would. The objects thus combine 'life' and 'style'. The VELA exercise bike, for instance, has evolved into a strikingly filigree and expressive sculpture.

Images used for inspiration/association

We all want to feel good; we strive for health and fitness and want to live in a nice home. And we often lack the time, energy or desire to go to the gym regularly. With our objects and their intuitive, immersive approach we are bringing an entirely new kind of fitness studio into the home, while simultaneously enhancing people's living spaces.

Our design team's starting point was to unlearn and go beyond familiar patterns and paradigms. By removing all elements that are not integral to a traditional cycle trainer, we created a blank slate for its redesign. This blank slate allowed us to view things in a new context, turn them upside down and inside out, until we arrived at an idea that was both aesthetically avant-garde and functional.

NOTE: As the design was initiated inside LUNAR, the sketches and all visual material served as a way to ideate, test and evaluate ideas only within the design team.

Notice the communication value of the text in combination with the sketches. Text comments added extra communication features to the sketches. These handwritten texts served as an effective way to further explain ideas, communicate thoughts and possible choices.

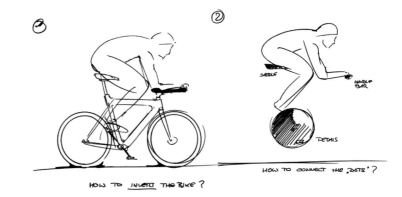

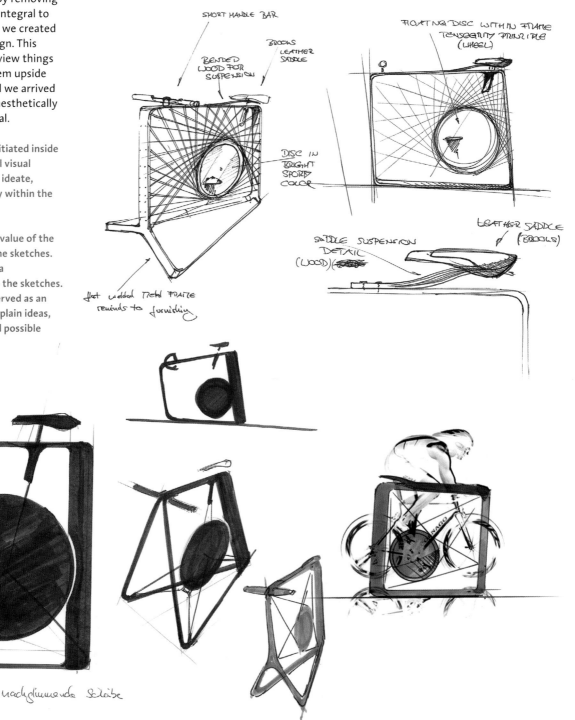

At first glance, the design had to be intriguingly beautiful to justify its presence at the centre of our homes. At the same time, all standard functionalities of a stationary bike needed to be kept or, preferably, enhanced. At the second or third read, the details needed to hint at the dynamics and motions of the sport. The result was a sculptural design that changes the paradigm of how we position stationary bikes in our homes, and exceeds the functionalities you'd expect to find with traditional exercise bikes.

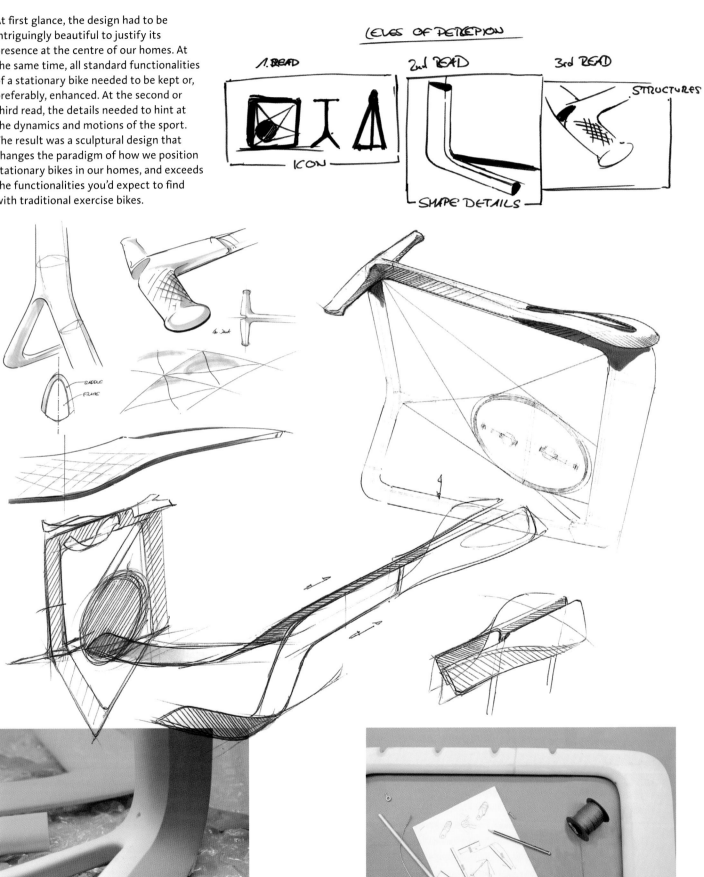

The ergonomic requirements of human body sizes were taken into account and, by doing so, we thought up new features that would facilitate the adjustability of the device.

The design process took into account three levels of perception, beginning with the iconic overall presentation, referred to as the 'first read.' This is about zooming out to see the basic geometric forms of a product. Imagine stepping into a room and seeing the bike from afar; this distant view needs to be designed carefully. Products with strong 'first read' qualities have an iconic appearance and LUNAR always strives to achieve this in their designs.
The 'second read' level considers individual parts of the design and is all about their detailing. Finally, the 'third read' level defines the textural elements of the design that can only be observed when viewing the final product very closely. Often it's this attention to detail that separates the mainstream from the great designs.

Refining the original design throughout all these levels meant going through various iterations and a variety of quick sketches, always on the lookout for better alternatives. When we work on design projects through all these levels, we are constantly refining and strengthening the original design intent all the way down to the individual product details (e.g. the handlebar and the saddle).

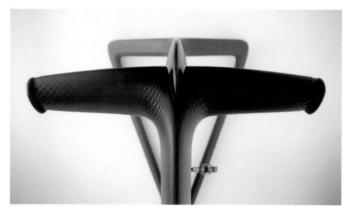

The shaping of details, such as the handlebar and the saddle

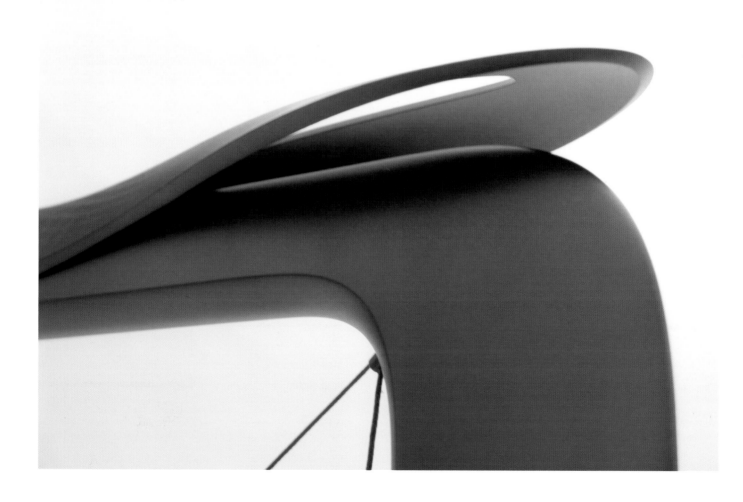

In the final stages of the project, we focused on defining the experience for the user. Designing an experience also means designing the interaction with the product, both physically and virtually. This works best when you consider the experience for different basic scenarios.

We removed everything from the training experience that is not integral to the scenario, thus creating a blank slate: what users want is to enjoy their training experience, while also aiming to exercise efficiently to build muscles and burn fat.

How could we provide both in one beautiful, immersive experience?

The starting point for VELA jumped out during the initial brainstorm sessions: there is really no need for a screen or display of measurements such as your heart rate. In order to tell users how fast they are going and if their performance results are meeting their goals, efficient training can and should be communicated in a very different manner: by means of beautiful projections around the bike with animations of movement to create an

Images used for inspiration/association

immersive training experience and provide performance feedback during the training. This is much closer to the natural experience of riding a bicycle outdoors.

For the visual design of the projections, we decided to work with tiny dot patterns. Though the form of a dot is primitive, accumulated dots are highly flexible and can carry a lot of information. We began by designing one scenario after another through sketches, mood boards and group discussions. We designed the interaction with VELA from a bird's-eye perspective, because this is the typical user perspective when sitting on the bike. We then digitized our ideas in Illustrator and Motion to define the size, colour and speed of the dots until we arrived at the animations that became part of our final design.

An animated film and several images were created to publicly communicate the design concept. With VELA, we've been able to transform the home exercise experience.

NOTE: LUNAR communicated imagery and a video as a showcase on their website to promote the design vision and attract potential investors. At the same time, these served as test material, and became a wonderful means for evoking responses from potential users.

LUNAR also placed the design in its user context; as the shape is highly innovative, this had to be done for the public to grasp its intended use. The film was a means to demonstrate the effect of the projections, and at the same time served as a teaser, making the public curious and wanting to find out more.

Design Case

Studio Tminus, California
NW100 for Altec Lansing

The design

The NW100 Concept for Altec Lansing was an exercise in creating a beautiful home audio solution that would bring together modern technology and the several years of Altec Lansing's heritage in high fidelity audio solutions. The design features clean, ceramic-like surfaces with iconic elements.

The design brief

Studio Tminus was commissioned to create something iconic that would drive a shift in design language and brand direction for Altec Lansing. This product would serve as a halo to shape the direction of the brand language for the future.

If one word were to describe the project, it would be 'clean'.

The early design process

Our design process is very visual. As the electronic packaging had already been more or less defined, we started with identifying threads of visual inspiration that could help drive the aesthetics of the design. We used inspiration boards with elements that formed themes to inspire initial sketches focusing on divergent, 'what if'-style thinking. The presented ideas ranged from "mild to wild", according to Spencer Nugent, and pushed our client to think outside the box with regard to what the final product would be. We believe it is our job to push the limits of what is possible, so that the outcome has a chance of being something different and memorable. It's at the fringes of divergent thinking that we sometimes find our best ideas.

MATERIAL

CONTROL

CONNECT

STATUS

Mood boards

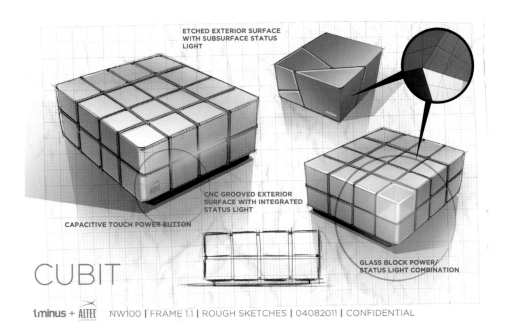

ETCHED EXTERIOR SURFACE
WITH SUBSURFACE STATUS
LIGHT

CNC GROOVED EXTERIOR
SURFACE WITH INTEGRATED
STATUS LIGHT

CAPACITIVE TOUCH POWER BUTTON

GLASS BLOCK POWER/
STATUS LIGHT COMBINATION

CUBIT

tminus + ALTEC LANSING | NW100 | FRAME 1.1 | ROUGH SKETCHES | 04082011 | CONFIDENTIAL

The Frame 1.1 concept presentation is typically the first compilation of concepts that we show a client for which the focus lies on fairly rough and quick sketches that pull aesthetics and suggested functionality from inspiration boards compiled prior to this frame of the project.

Rough sketches keep the ideas loose and fresh without appearing final. We feel it's important to communicate the stage of an idea through the level of finish in which it's presented to a client. This way, there are no unrealistic expectations of finality at the start of a project.

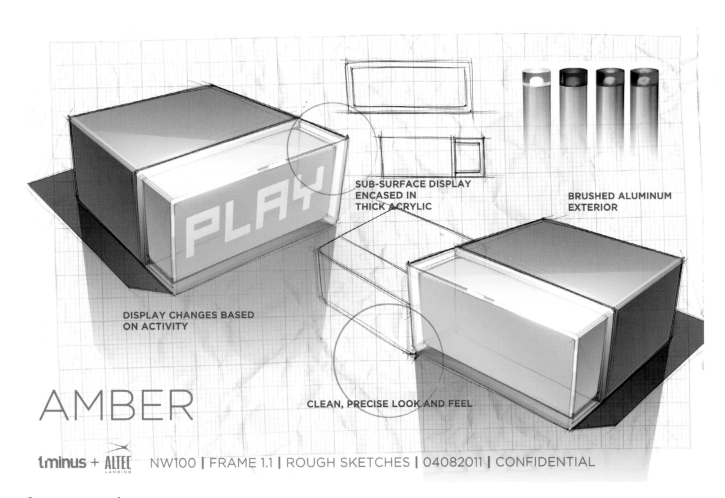

SUB-SURFACE DISPLAY
ENCASED IN
THICK ACRYLIC

BRUSHED ALUMINUM
EXTERIOR

DISPLAY CHANGES BASED
ON ACTIVITY

AMBER

CLEAN, PRECISE LOOK AND FEEL

tminus + ALTEC LANSING NW100 | FRAME 1.1 | ROUGH SKETCHES | 04082011 | CONFIDENTIAL

Concept presentation

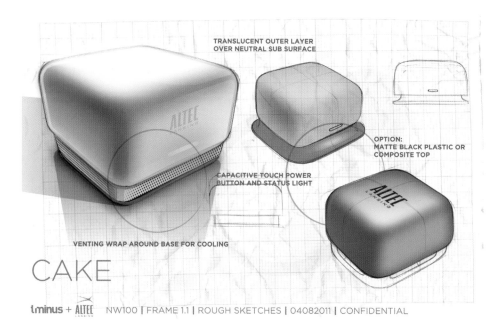

TRANSLUCENT OUTER LAYER
OVER NEUTRAL SUB SURFACE

OPTION:
MATTE BLACK PLASTIC OR
COMPOSITE TOP

CAPACITIVE TOUCH POWER
BUTTON AND STATUS LIGHT

VENTING WRAP AROUND BASE FOR COOLING

CAKE

tminus + ALTEC NW100 | FRAME 1.1 | ROUGH SKETCHES | 04082011 | CONFIDENTIAL

This concept presentation is an example of where the intent is to show the client potential directions for the outcome of the design. Some details we may include are key functional ideas, breakup of parts, materials and finishes and at times usage and use cases.

NOTE: The background of crumpled engineering paper intends to communicate the raw, unfiltered nature of the idea, despite being a hand-drawn sketch with some computer renderings done in Adobe Photoshop.

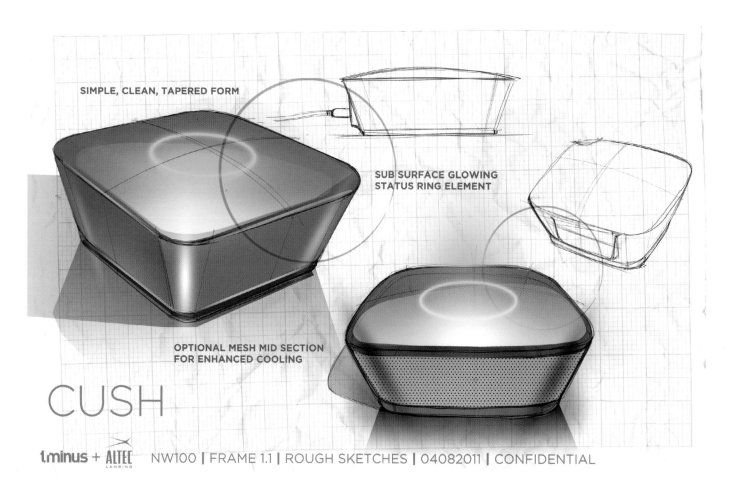

SIMPLE, CLEAN, TAPERED FORM

SUB SURFACE GLOWING
STATUS RING ELEMENT

OPTIONAL MESH MID SECTION
FOR ENHANCED COOLING

CUSH

tminus + ALTEC NW100 | FRAME 1.1 | ROUGH SKETCHES | 04082011 | CONFIDENTIAL

Concept presentation – continuation

NOTE: In this Design Case, the first concept presentation slides all have a similar, repeated type of layout. Two bigger, more elaborate sketches are positioned diagonally and surrounded by smaller, less shaded ones. Some text is added, and all sketches are placed against wrinkled paper. Notice how this facilitates the comparison between them and distinguishes this group from slides in later presentations.

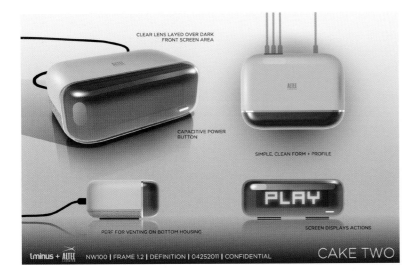

CLEAR LENS LAYED OVER DARK
FRONT SCREEN AREA

CAPACITIVE POWER
BUTTON

SIMPLE, CLEAN FORM + PROFILE

PLAY

PERF FOR VENTING ON BOTTOM HOUSING

SCREEN DISPLAYS ACTIONS

tminus + ALTEC NW100 | FRAME 1.2 | DEFINITION | 04252011 | CONFIDENTIAL

CAKE TWO

After discussing the merits and drawbacks of each concept, a few were picked from about 20 ideas to move on to the next frame of refinement and thinking.

At this point, elementary CAD models were created to accurately capture volumes of the final idea concerning a rough engineering package and to communicate the proposed proportions of each idea more accurately.
Even though the ideas are more refined in the manner in which they are presented, there is still divergent thinking at this phase, albeit somewhat more focused.

NOTE: the background is now cleaner and simpler. This communicates a shift in confidence regarding the ideas presented, as the project progresses toward the final concept.

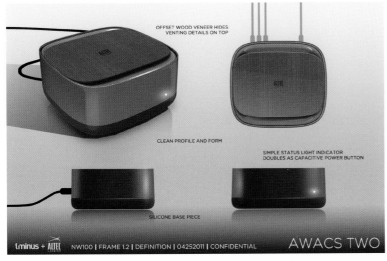

OFFSET WOOD VENEER HIDES
VENTING DETAILS ON TOP

CLEAN PROFILE AND FORM

SIMPLE STATUS LIGHT INDICATOR
DOUBLES AS CAPACITIVE POWER BUTTON

SILICONE BASE PIECE

tminus + ALTEC NW100 | FRAME 1.2 | DEFINITION | 04252011 | CONFIDENTIAL

AWACS TWO

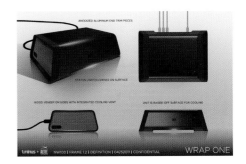

ANODIZED ALUMINUM END TRIM PIECES

STATUS LIGHTING SHINES ON SURFACE

WOOD VENEER ON SIDES WITH INTEGRATED COOLING VENT

UNIT IS RAISED OFF SURFACE FOR COOLING

tminus + ALTEC NW100 | FRAME 1.2 | DEFINITION | 04252011 | CONFIDENTIAL

WRAP ONE

These renderings show materials, finishes and overall breakup of parts and highlight the key features within the constraints of the engineering package, based on the requirements provided by the client.

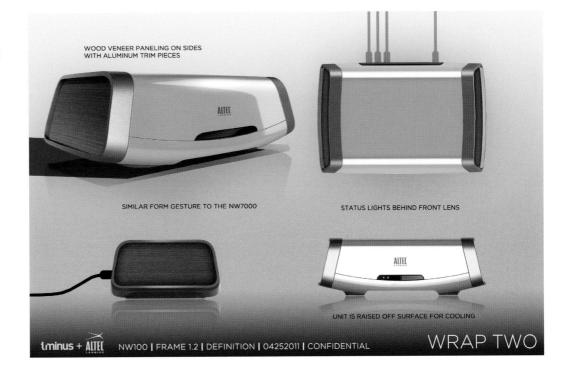

WOOD VENEER PANELING ON SIDES
WITH ALUMINUM TRIM PIECES

SIMILAR FORM GESTURE TO THE NW7000

STATUS LIGHTS BEHIND FRONT LENS

UNIT IS RAISED OFF SURFACE FOR COOLING

tminus + ALTEC NW100 | FRAME 1.2 | DEFINITION | 04252011 | CONFIDENTIAL

WRAP TWO

FRAME 1.2 CONCEPTS

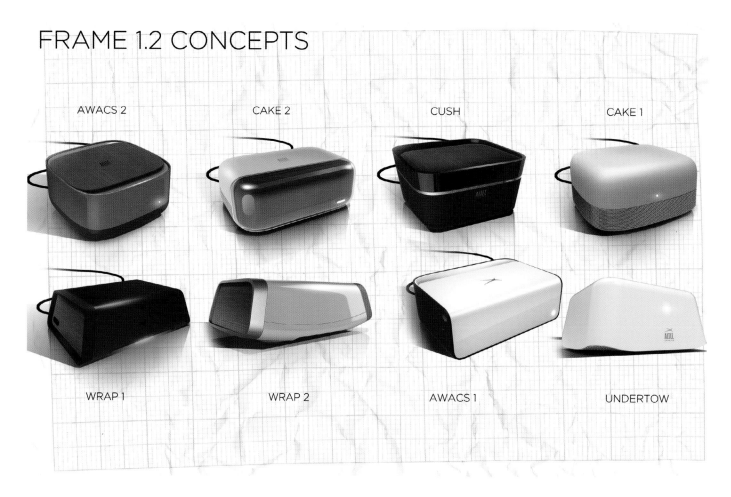

AWACS 2 CAKE 2 CUSH CAKE 1

WRAP 1 WRAP 2 AWACS 1 UNDERTOW

Above shows a presentation page depicting a compilation of the ideas presented in Frame 1.2. The client requested a display of the concepts generated so that he could present them to the executive management.

This shows the evolution of the ideas in a somewhat linear fashion.

CAD screenshots

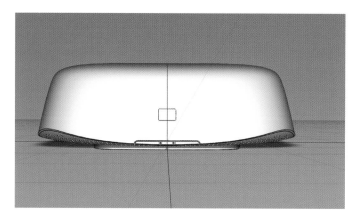

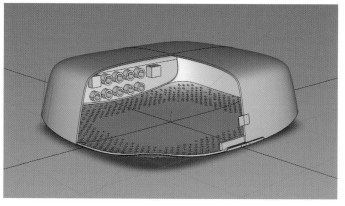

LIGHTING OPTION A

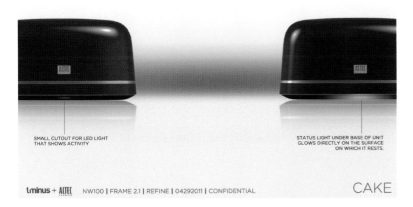

SMALL CUTOUT FOR LED LIGHT
THAT SHOWS ACTIVITY

STATUS LIGHT UNDER BASE OF UNIT
GLOWS DIRECTLY ON THE SURFACE
ON WHICH IT RESTS.

tminus + **ALTEC** NW100 | FRAME 2.1 | REFINE | 04292011 | CONFIDENTIAL

CAKE

CAKE ONE

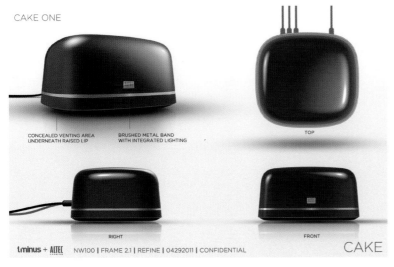

CONCEALED VENTING AREA
UNDERNEATH RAISED LIP

BRUSHED METAL BAND
WITH INTEGRATED LIGHTING

TOP

RIGHT

FRONT

tminus + **ALTEC** NW100 | FRAME 2.1 | REFINE | 04292011 | CONFIDENTIAL

CAKE

In Frame 2.1, two clear directions were chosen and presented. The concepts Cake and Undertow were chosen to move forward with and to be refined. If you look closely, you'll see that the concept CAKE was modified to be a bit more refined and embody a retro future style.

The surfacing and quality of the Undertow concept was also refined to appear more ceramic and simple in nature. Simple surfaces can be deceptively complicated and incredibly difficult to execute well.

The Frame 2.1 presentation is the final step in idea visualization prior to moving on to the prototype, evaluation and final production phase. At this point, any changes to either idea would be minimal and limited to functional adjustments within the driving constraint of the established aesthetic.

tminus + **ALTEC** NW100 | FRAME 2.1 REFINE | 04292011 | CONFIDENTIAL

CAKE

BIBLIOGRAPHY

Adams, Sean, Morioka, Noreen, Stone, Terry, *Color design workbook,* Rockport, 2006

Bergson, Henri, *The Creative Mind: An Introduction to Metaphysics* (*Introduction à la metaphysique*), 1903

Bertin, J. (1967). *Sémiologie Graphique.* Gauthier-Villars. Bron: webite boom.beeldtaal /extra_theorie /visuele_morfologie

Boeijen, Annemiek van, Daalhuizen, Jaap, Zijlstra, Jelle, Schoor, Roos van der, *Delft Design Guide,* BIS Publishers, 2013

Broek, Jos van den, Willem Koetsenruijter, Jaap de Jong and Laetitia Smit, *Beeldtaal Perspectieven voor makers en gebruikers,* Boom uitgevers, Den Haag, the Netherlands, 2010

Cairo, Albert, *the functional art, an introduction to information graphics and visualization,* NewRiders, 2013

Cooper, G, *Cognitive Load theory as an aid for instructional design*, paper in the Australian Journal of Educational Technology, 1990

Eissen, Koos and Roselien Steur, *Sketching, Drawing Techniques for Product Designers,* BIS Publishers Amsterdam, the Netherlands, 2007

Eissen, Koos and Roselien Steur, *Sketching, the Basics,* BIS Publishers, Amsterdam, the Netherlands, 2011

Ensenberger, Peter, *Focus on composing photos,* Elsevier, 2011

Hashumoto, Ala, and Mike Clayton, *Visual Design Fundamentals, a Digital Approach,* Course Technology, Boston, MA, 2009

King, D. Brett, *Max Wertheim & Gestalt theory,* Transaction Publishers, 2006

Lidwell, William, Kritina Holden and Jill Butler, *Universal Principles of Design,* Rockport Publishers, Gloucester, MA, 2003

Munsell, A. H., A pigment color system and notation, 1912

Norman, Donald A, *Emotional Design,* Basic Books, New York, NY, 2004

Shneiderman, Ben, The Eyes Have It: A Task by Data Type Taxonomy for Information Visualizations, University of Maryland, 1996

Verbruggen, Jeroen K., Creative Reflexion in industrial Design, *FLEX/theINNOVATIONLAB®*, Delft, the Netherlands, 2012.

Water, John van de, *Je kunt China niet veranderen, China verandert jou,* Uitgeverij 010, 2011

Weinschenk, Susan, Ph.D., 100 Things: Every Designer Needs to Know About People, New Riders, 2011

Roukes, Nicholas, *Design synectics*, Riders, 1988

The concise Oxford Dictionary, Oxford University Press

Yarbus, Alfred L., *Eye movement and vision*, 1967

URLs

www.advertising.about.com/od/successstrategies/a/Get-To-Know-And-Use-Aida.htm

www.andyrutledge.com/gestalt-principles-3.php

www.auto.howstuffworks.com/under-the-hood/auto-manufacturing/reptilian-brain-car-manufacturing2.htm

www.beeldtaal.boom.nl

www.blog.xlcubed.com/2008/05/gestalt-laws-charts-and-tables-the-way-your-brain-wants-them-to-be/

www.boundless.com/marketing/integrated-marketing-communication/ introduction-to-integrated-marketing-communications/aida-model

www.ccsenet.org/journal/index.php/elt/.../8353

www.char.txa.cornell.edu/language/element/element.htm

www.colormatters.com

www.colorvoodoo.com/cvoodoo2_gc_lookin.html

www.colourlovers.com

www.core77.com

www.coroflot.com

www.crystalinks.com/reptilianbrain.html

www.daphne.palomar.edu/design/gestalt.html

www.en.wikipedia.org/wiki/Euclid%27s_Elements

www.facweb.cs.depaul.edu/sgrais/gestalt_principles.htm

www.graphicdesign.spokanefalls.edu/tutorials/process/gestaltprinciples/gestaltprinc.htm

www.graphicdesign.spokanefalls.edu/tutorials/process/visualanalogy/visanalogy.htm

www.hinduism.about.com

www.informationisbeautiful.net

www.interaction-design.org/encyclopedia/gestalt_principles_of_form_perception.html

www.jesus-is-savior.com

www.library.iyte.edu.tr/tezler/master/endustriurunleritasarimi/T000560.pdf (apple)

www.math.ubc.ca/~cass/Euclid/papyrus/papyrus.html

www.mindtools.com/pages/article/AIDA.htm

www.nl.wikipedia.org/wiki/Framing

www.psychology.about.com/od/sensationandperception/ss/gestaltlaws_3.htm

www.quicksprout.com/2013/08/01/7-conversion-optimization-lessons-learned-from-eye-tracking/

www.read.uconn.edu/PSYC3501/Lecture02/-prof. Heahter Read.

www.reference.com/motif/science/perception-process-stages

www.socyberty.com/psychology/the-stages-of-human-perceptual-process

www.universalteacherpublications.com/mba/ebooks/ob/ch2/page3.htm

www.webdesign.about.com/od/color/a/aa072604.htm

www.webdesign.about.com/od/color/a/bl_colorculture.htm

www.wikipedia.com

www.wired.com

www.wnd.com/2012/09/black-clouds-and-black-flags-over-obama/

FEATURED DESIGN CASES

ArtLebedev Studio, Russia
Istanbul Isiklarius traffic lights for ISBAK, 2011
www.artlebedev.com
Art director: Artemy Lebedev, Timur Burbayev
Designers: Alexey Sharshakov, Andrey Fabishevsky, Vasily Markin,
Maria Borzilova, Sushi Chao, Philipp Gorbachev
Design Case chapter 3

Audi Design, China
A car for Beijing, 2012
www.audi.com
Student-designer: Ma Ke, Beijing University of Technology,
company mentors: Fabian Weinert and Wouter Kets
Design Case Introduction

VanBerlo, the Netherlands
Embrace for Durex. 2013
www.vanberlo.nl
Designers: Noud Claassen, Sander Thijssen, Teun van Wetten,
Rens Hoeke and Jeroen Thoolen
Design Case chapter 3

Fabrique in collaboration with Mecanoo Architects, the Netherlands
Development of Train Station Furnishings and Equipment,
for ProRail, NS and Bureau Spoorbouwmeester, 2008-2013
www.fabrique.nl
Designers: Thomas-Luuk Borest, René Bubberman, Jeroen van
Erp, Merijn Hillen, Jurgen Kuivenhoven, Chris Nijkamp, Jasper
Tonk, Francesco Veenstra
Design Case chapter 3

fuseproject, California
Nivea design language and packaging for Beiersdorf AG,
Germany, 2013
www.fuseproject.com
Design director: Yves Behar
Design Case chapter 2

LUNAR Europe GmbH, Germany
VELA cycle trainer, internal project of LUNAR Europe, 2012
www.lunar.com
Designers: Florian Wuebert, Haneul Yoo, Matthis Hamann
Design Case chapter 5

npk design, the Netherlands
Corporate identity and products for SKS-Germany, 2010-2013
www.npkdesign.nl
Designers: Janwillem Bouwknegt, Guyout Duquesnoy, Martijn
van Gelderen, Marte den Hollander
Design Case chapter 4

Pelliano, the Netherlands
Suits, accessories and packaging, 2013
Designer(s): Marin Licina
Design Case chapter 1

Reggs, the Netherlands
Vita-Q, Design and development of an anaesthesia and
ICU ventilation unit for Alcmair, 2014
www.reggs.com
Designers: Wolter Prinsen, Karin Dijkstra, Imre Verhoeven
Design Case chapter 4

Spark design & innovation, the Netherlands
Personal Air and Land vehicle for PAL-V Europe N.V., prototype
2012
www.sparkdesign.nl
Spark design & innovation : Robert Barnhoorn, Sander Havik,
Anke Kempen, Rogier van Rossen, Eric Verberkmoes, Antony
Weinbeck
PAL-V Europe NV: Chris Klok, Mike Stekelenburg
www.pal-v.com
Design Case chapter 4

Studio Tminus, California
NW100 for Altech Lansing, 2011
www.studiotminus.com
Designers: Spencer Nugent – Designer, Studio Tminus
John Muhlenkamp – Designer, Studio Tminus
Glen Oross – Creative Director, Altec Lansing
Design Case chapter 5

Van der Veer Designers, the Netherlands
Design language and logo for VDL Bus & Coach, 2012
www.vanderveerdesigners.nl
Designers: William van Beek, Gert-Jan van Breugel, Rik de Reuver
Surface Modellers: Bas Kleingeld, Albert Nieuwenhuis, Eric van
Stuijvenberg, Gert-Jan van Breugel
Design Case chapter 4

WAACS Design, the Netherlands
My Grip for Bruynzeel, 2011
www.waacs.nl
Design Case chapter 2

Waarmakers, the Netherlands
Be.e; frameless biocomposite electric scooter, 2013
www.waarmakers.nl
Designers: Maarten Heijltjes & Simon Akkaya
Design Case chapter 2

Marcel Wanders, the Netherlands
Dressed Tableware for Alessi Italy, 2012
www.marcelwanders.com
Design Case chapter 3

IMAGE CREDITS

Chapter one

Advertisement of the True Colours campaign for Faber-Castell by Ogilvy and Mather, 2011.

Chameleon on the branch by Tambako the Jaguar, (Wikipedia Commons) 2012.

WWF advertisement of the Red Tuna campaign by Ogilvy, France, 2011.

Lilli Doll by Haba, Germany, 2014.

Advertisement of the "Don't talk while he/she drives" campaign for the Bangalore Police Dept., by DDB Mudra Group, India, 2010.

Design Case Pelliano

Advertisement image of the I'mperfect campaign: Photography by Sascha Varkevisser, the Netherlands.

Chapter two

Beginning image of the two boxes, creator not found.

Design and image of the Brand design for Grolsch beer by FLEX/theINNOVATIONLAB®, the Netherlands.

Image by HEMA, the Netherlands, 2011.

Pubic awareness campaign for separating household refuse and recycling for the City of The Hague, by Noclichés, the Netherlands, 2011.

Stratigraphic Porcelain Project for ceramic 3D printer by Unfold Design Studio, Belgium, 2012. Photography : (top) Unfold, (bottom) Kristof Vranken.

Icons by Designmodo.

"Boring still life objects turned into erotica" by Blommers / Schumm for Baron, the Netherlands, 2012.

'Heroes of The Invisible' vase, photography and design by FAT (Fashion Architecture Taste), UK, 2008.

Euclid's Elements Image by Bill Casselman, Dept. of Mathematics, University of British Columbia, Vancouver, Canada.

Design Case fuseproject

Images by Beiersdorf A.G, Germany.

Design Case Waarmakers

Torpedo by Jerry Koza, Trash Me lamp by Victor Vetterlein, Still image of video clip Neem me mee by Gers Pardoel, Saddle image by Wrenchmonkees.

Chapter three

Road sign "fuel pump" by Samukunai.

Modern Dresser Wayne pump at a BP service station in Greece by Aaron Lawrence.

Korean road sign "Notice of Service Area" by P.Cps1120a (Wikimedia Commons), 2012.

Rio 2016 Olympic Games Sport Pictograms by the Rio 2016 Design Team, 2013.

GC-R-155L shopping cart by Scaffoldmart, N.C., USA.

Design and image External hard drives for Freecom and Vitality cookware range for Tefal by FLEX/theINNOVATIONLAB®, the Netherlands.

Latex and garlic, a visual analogy by Francois Audet, 2007.

Code of arms of Gelre by the 15th century Huldenberg Armory by Arch (Wikimedia commons).

Advertisement image of the "Imagine" Campaign for LEGO, by Jung von Matt, Germany, 2012.

Advertisement of the "Big movies, mobile size" campaign for Vodafone by Schultz and Friends, Germany, 2010.

Icons by Designmodo.

Image by Google.

White flag by Jan Jacobsen (www.worldpeace.no).

Swiss flag at Piz Languard hut by Ian Lord (on Flickr).

Design and image of the Vitality cookware range by FLEX/theINNOVATIONLAB®, the Netherlands.

Logo of Apple Inc.

Design Case Marcel Wanders

Pages of the Alessi brochure VIEWON FW2012, images Marcel Wanders / www.alessi.com, video stills of the Alessi promotion video "Fall Winter 2012 Collection", video Giacomo Giannini, screen dumps of the Alessi webshop 2013.

Chapter four

Image Aristotle, part of the Ludovisi Collection, at the National Museum of Rome, by Jastrow (Wikimedia Commons).

Tarta Ergonomic back rest design and images by Tarta S.r.l., Italy, 2013.

Vendinova SOUP-SERVER, design and images by VanBerlo, the Netherlands.

Biolite HomeStove and CampStove design and images by Biolite, USA.

Website image Icelandic Water Ltd., 2014, by Kjartan Pe(accentigu)tur Siguro(o)ssen.

Images of the Nike Epic Sportpack for Nike by Phil Frank, Washington.

CBR600FD body conversion kit, design and sketches by Felix Danishwara, CA.

Image of Grolsch bottle by Grolsch beer.

Homepage image by Studio Massaud, France. www.massaud.com

Image of the red Lely baler machine, design by FLEX/theINNOVATIONLAB®, image by Lely.

Website image by Granstudio, Italy. www.granstudio.com

Website image by MINIMAL, IL. www.mnml.com

Brainstorm sketches by Carl Liu.

Homepage image of 5.5 designstudio, France. www.5-5designstudio.com.

iDuctor presentation, design and images by FLEX/theINNOVATIONLAB®.

Packaging for spices for Verstegen, design and images by FLEX/theINNOVATIONLAB®.

Drinking bottle for HERO, design and images by FLEX/theINNOVATIONLAB®.

Chapter five

Advertisement image of the "Hiltl Vegetarian Restaurant: Tiger" by Ruf Lanz, Switzerland.

Portfolio images of Mickael Castell, France. Student project at the DSK ISD at Pune, India.

The Nike logo is a registered Trademark of NIKE, Inc.

Brand language for Skil, design and images by FLEX/theINNOVATIONLAB®, the Netherlands.

Images of the website portfolio of Elie Ahovi, IL.

Design – Elie Ahovi, Adrien Lefebvre, Philomène Lambaere, Marion Wipliez, Quentin Sorel, Benjamin Lemoal 3D modelling – Quentin Sorel, Benjamin Lemoal Render – Elie Ahovi, Quentin Sorel, Benjamin Lemoal. Started as a student project at the ISD Valenciennes.